CANADIAN
SHIELD

CANADIAN SHIELD

The Rocks That Made Canada

Fitzhenry & Whiteside
www.fitzhenry.ca

Published in Canada by Fitzhenry & Whiteside, 195 Allstate Parkway, Markham, Ontario L3R 4T8

Published in the United States by Fitzhenry & Whiteside, 311 Washington Street, Brighton, Massachusetts 02135

10 9 8 7 6 5 4 3 2 1

Library and Archives Canada Cataloguing in Publication
Eyles, Nick, 1952-
Canadian Shield : the rocks that made Canada / Nick Eyles;
photographs and illustrations by Arnold Zageris, Tessa Macintosh and Ed Bartram.
ISBN 978-1-55455-140-8
1. Geology--Canadian Shield. 2. Canadian Shield. I. Title.
GB132.C36E95 2011 557.14 C2010-905747-3

U.S. Publisher Cataloging-in-Publication Data
Eyles, Nick.
Canadian Shield : the rocks that made Canada / Nick Eyles ; photographs and
illustrations by Arnold Zageris, Tessa Macintosh, and Ed Bartram.
[160] p. : col. ill., photos. ; cm.
Summary: Tracing the geologic evolution of the Canadian Shield.
ISBN-13: 978-1-55455-140-8 (pbk.)
1. Geology, Stratigraphic – Proterozoic – Canada. 2. Canadian Shield.
I. Zageris, Arnold. II. Macintosh, Tessa. III. Bartram, Ed. IV. Title.
551.710971 dc22 QE653.E9547 2011

Fitzhenry & Whiteside acknowledges with thanks the Canada Council for the Arts, and the Ontario Arts Council for their support of our
publishing program. We acknowledge the financial support of the Government of Canada through the Book Publishing Industry
Development Program (BPIDP) for our publishing activities.

Design by Kerry Designs
Cover images courtesy of Arnold Zageris
Printed in Canada

INTRODUCTION

*A*s Canadians we have a very tangible sense of living on the edge of a vast, barren interior dominated by the Canadian Shield—a largely empty immensity of lakes, bogs, rivers, forest and protruding ribs of hard, crystalline Precambrian rock. The Shield covers more than half of Canada's total land area and yet was only formally named in 1883.

The Shield has long cultural roots: it was first tentatively explored by humans eleven thousand years ago when the last great ice sheets withdrew; its economic fortunes changed as Europeans penetrated its vast, remote rock formations for furs and metals; and it was transformed in the twentieth and twenty-first centuries into a national icon.

Geologically, the rocks of the Shield are a huge mosaic brought together by plate tectonic forces over the past 4 billion years. Remnants of mineral-rich rocks from the deep sea form monuments to the death of oceans squeezed between colliding land masses and folded into huge mountain ranges. Now worn down to a low lying plain, the Shield has been subsequently dented by meteorites, flooded by tropical seas and scraped clean by glaciers. Knowledge of how, where and when the Shield was built has shaped geologist's views of how continents worldwide grow as part of a grand cycle of continental collisions and breakups. This is one of Canada's singular contributions to human knowledge about our planet.

Regarded as "wild land" and of no value, much of the Shield was given away in 1670 to a single London-based fur-trading enterprise, the Hudson's Bay Company, which jealously guarded its northern domain until 1869. This two-hundred-year monopoly created a virtual government over a huge piece of North America. Without the HBC, much of this land would have passed into American hands, and there would have been no "Canadian" Shield or country called Canada.

As a nation, we are indebted to hard rock.

CHAPTER 1:

A HARD LAND

Every country or culture has a single
unifying and informing symbol at its core.
—Margaret Atwood, 1972

The Canadian Shield, as its military connotation implies, is a hard place that at first glance repels. Its crystalline Precambrian rocks extend over more than half the total land area of Canada—some 4,828,000-square-kilometres of lakes big and small, bogs, rivers, forest and protruding knobs of hard rock scraped clean by glaciers. Early settlers drawn from the farm fields and teeming cities of Britain and France viewed the barren, rock-strewn Shield with awe and much puzzlement. That such an extensive territory could be essentially of no use—just infertile wasteland—was astonishing to them.

People scratch into the lichen-covering on the rock, perhaps a symbolic sentiment for the rock itself. As with the ever-changing Shield, it is gradually reclaimed to a more natural state.

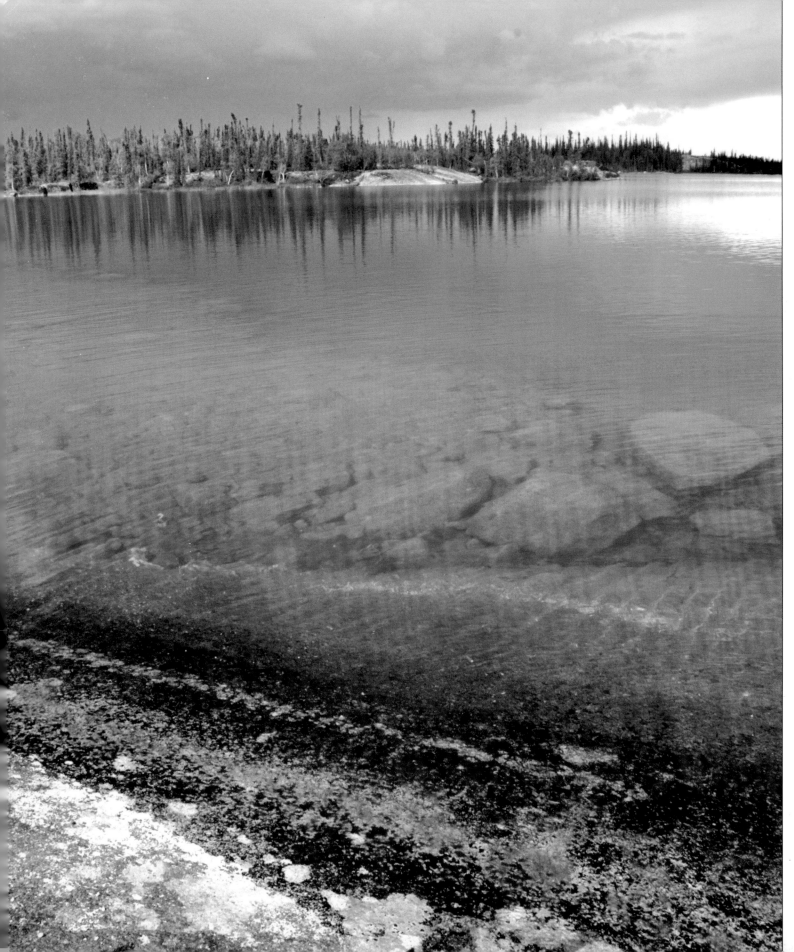

John Florio's 1580 translation of the journal of Jacques Cartier evokes this emptiness: "If the soile were as good as the harboroughes are, it were a great commoditie: but it is not to be called a new Land, but rather stones . . . for in all the Northe Llande I didde not see a Car loade of good earth . . . To be shorte, I believe this was the lande that God allotted to Caine." In his 1822 *Narrative of a Journey across the Island of Newfoundland,* W.E. Cormack had a similar reaction: "Primitiveness, omnipotence, and tranquillity were stamped upon everything so forcibly, that the mind is hurled back thousands of years, and the man left denuded of the mental fabric which a knowledge of ages of human experience and of time may have reared within him." In 1945, more than four hundred years after Cartier's observation, Hugh MacLennan repainted a picture of immensity and waste: "Nowhere has nature wasted herself as she has here. There is enough water in the Saint Lawrence alone to irrigate half of Europe, but the river pours right out of the continent into the sea. No amount of water can irrigate stones."

Today, Quebec and Ontario have the lion's share of the Shield (29 per cent and 18 per cent, respectively), followed by Nunavut and the Northwest Territories (both 16 per cent), Manitoba (9 per cent), Newfoundland (6 per cent), Saskatchewan (5 per cent) and Alberta (1 per cent). The Shield still remains a difficult place to travel across, even in an age of easy global

A storm brews over transparent waters of Rae Lakes near a small Tlicho Dene community of Gameti. The First Nations have always considered themselves as part of the land.

(right) Just a stone's throw from Great Slave Lake on waterways that stretch to Great Bear Lake and beyond, sits the Tlicho Dene community of Behchoko, perched atop pink granite outcrops called whalebacks.

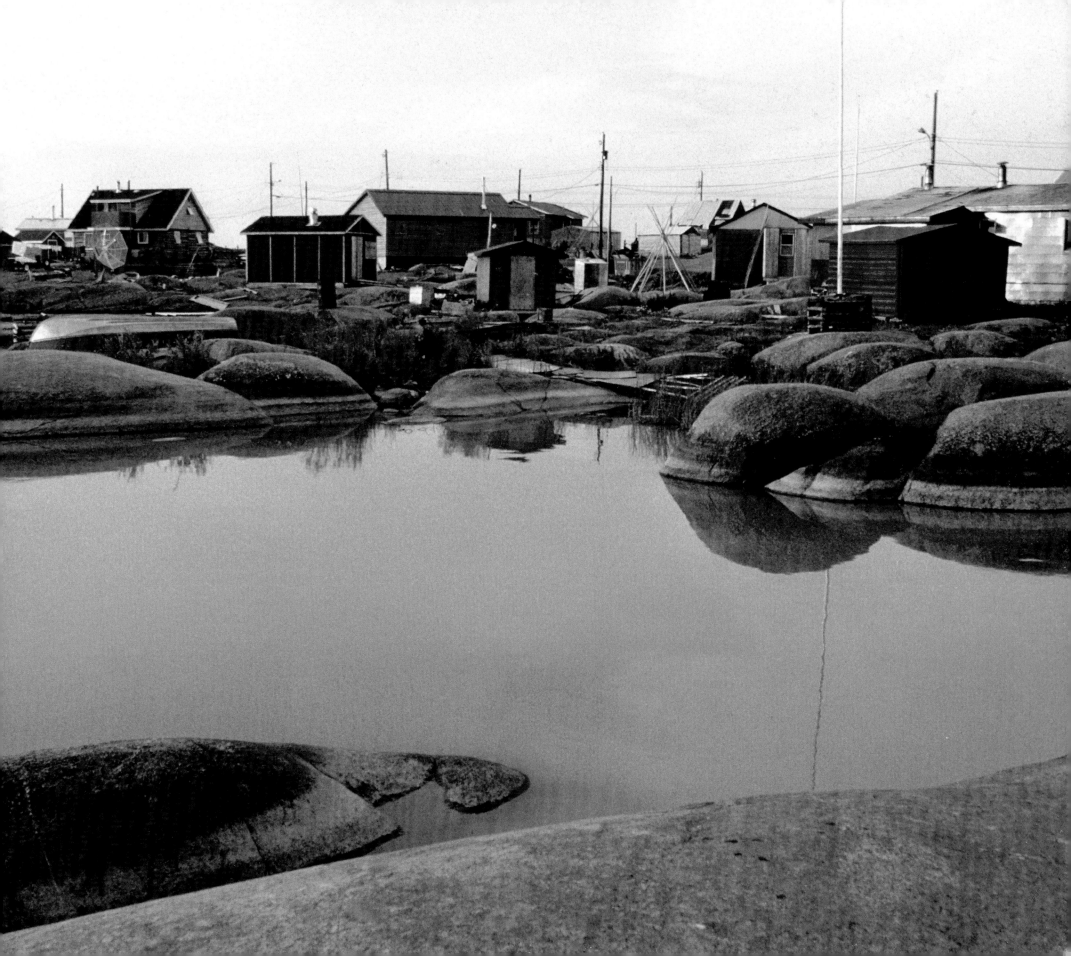

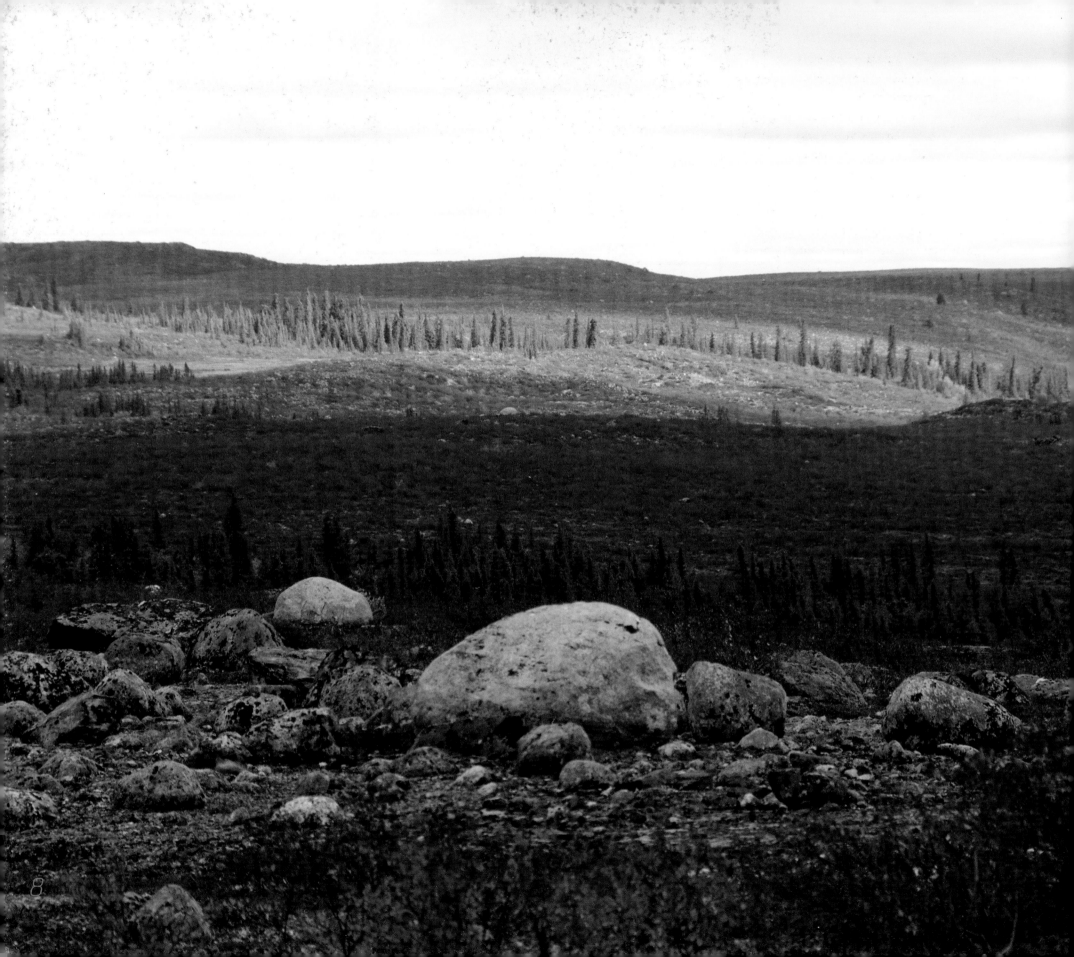

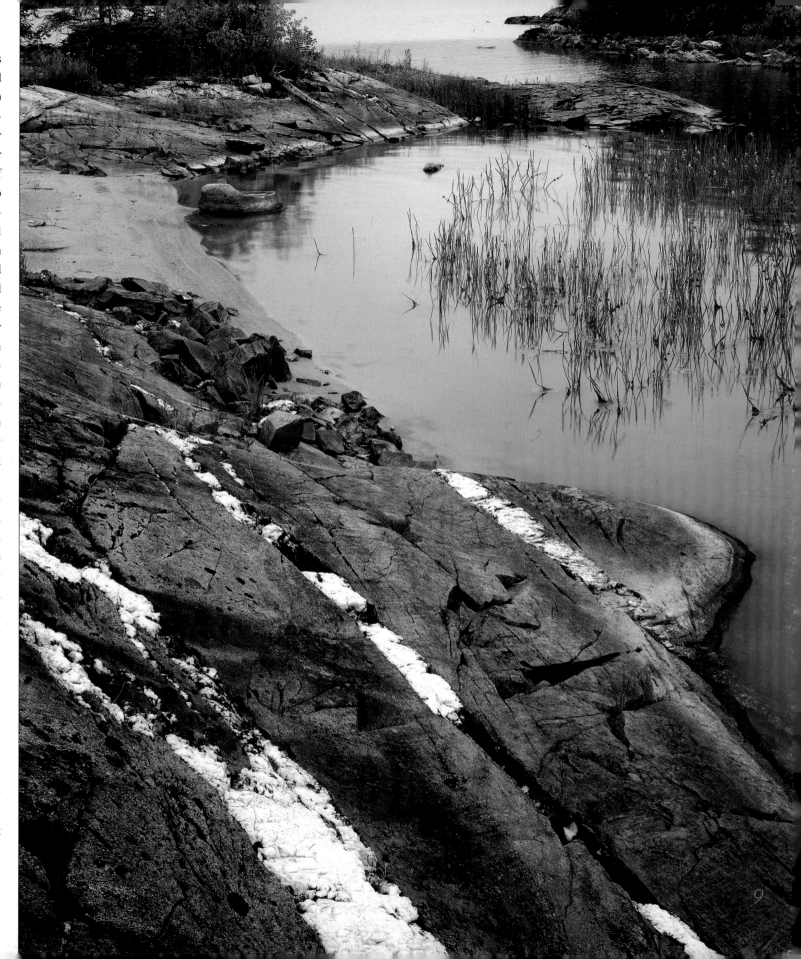

transportation. Much of its northern extent is underlain by frozen sediment and rock (called "permafrost"). Except for a shallow (< 1 m) "active zone" that thaws during the brief summer months, the ground remains frozen year round by ice in the form of veins and larger zones of massive ice. In the treeless tundra of the Far North, this frozen carapace extends to depths of 700 metres or more. It thins southward and is about 60 metres deep at Churchill but frozen ground survives even farther south as islands of icy rock and sediment preserved below an insulating cover of peat bogs and below cool, north-facing slopes. Some of the Shield's rocky expanses consist of *felsenmeer* ("rocky seas") where rock has been broken apart by the stresses of water repeatedly freezing and thawing in cracks. In some places, the ground is patterned by crude polygons of cobbles (called "patterned ground") —evidence that stones have been pushed to the surface by deep winter freezing. That is why the Shield has been called "the land that grows stones."

The Shield's unforgiving landscape is intensified by its climate. Short summers are marked by temperatures as high as 35°C, typical of regions in continental interiors far away from the modifying effects of oceans. Average January daily minimums along the far northern limits of the Shield, on Baffin Island, are as low as –25°C, with July maximums averaging only

The innate beauty of the Barren Lands of the Northwest Territories is wonderfully on show here at Gots'okati.

(right) Quartz veins are encouraging and over the last hundred years this area of the Abitibi has seen many prospectors scouring with pick and hammer, searching for a hint of visible gold. Some have been rewarded.

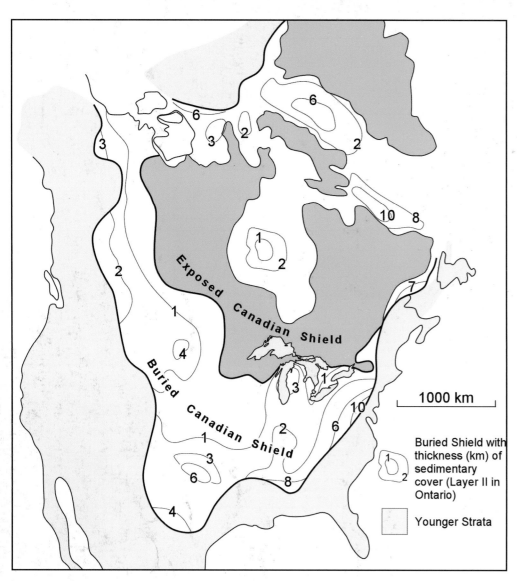

The Shield is a vast area of exposed old hard rock located at the centre of Canada. It disappears below younger cover rocks around its outer margins. In fact, the "Canadian" Shield can be traced deep underground where it stretches far south into the United States, and eastward into Greenland which was once part of North America before it broke away some 80 million years ago.

5°C. In summer, the southern margin of the Shield near Ottawa (remote from the influence of the Great Lakes) has July average maximums over 25°C, while the winter minimum in January averages –15°C.

The Shield is generally off limits to farming—apart from a few regions, especially where glacial lakes left extensive clay plains behind. And this is not just because of a lack of soil. The growing season is simply too short, as the northern limit of 120 frost-free days per year hugs the southern edge of the Shield.

(right) Treeless and barren these cold and windswept mountains offer little sustenance for the hardiest of plants and animals. Even the persistent lichen cannot be seduced

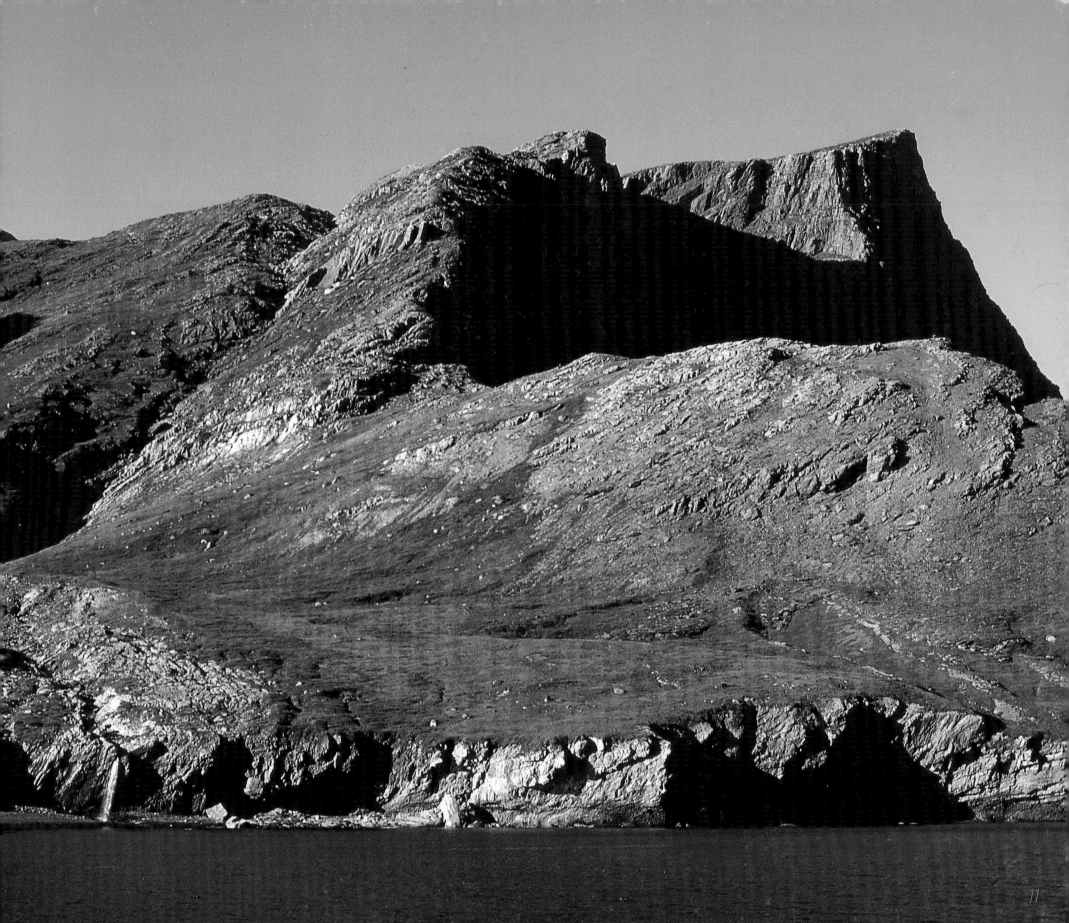

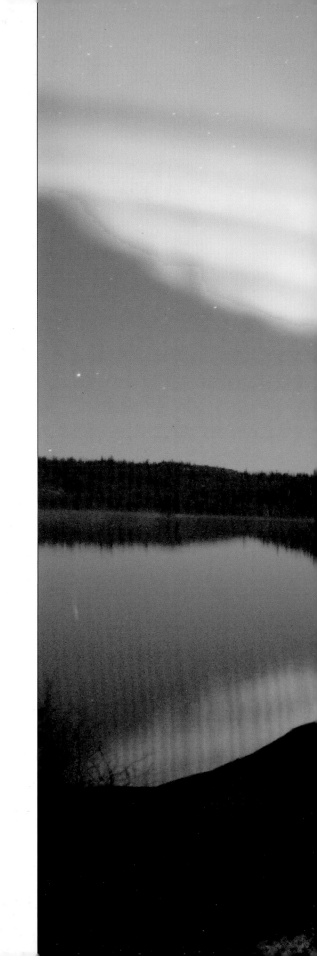

CHAPTER 2:
NAMING THE UNKNOWN

*I*n the nineteenth century, there were not many scientists in Canada, and only a small number of those took any interest in landscapes. The now iconic name, "Canadian Shield," was in fact introduced by a European geologist, the Austrian Eduard Suess, in his famous book *The Face of the Earth* (Das Antlitz der Erde), published in 1883. Suess named it so because he thought it had a dome-like form resembling a warrior's shield laid on the ground. In fact, later topographical surveys revealed it to be shaped more like a horse shoe.

In September's crisp air, Aurora Borealis is reflected in the still waters of Blachford Lake, cradled by moon-lit whalebacks.

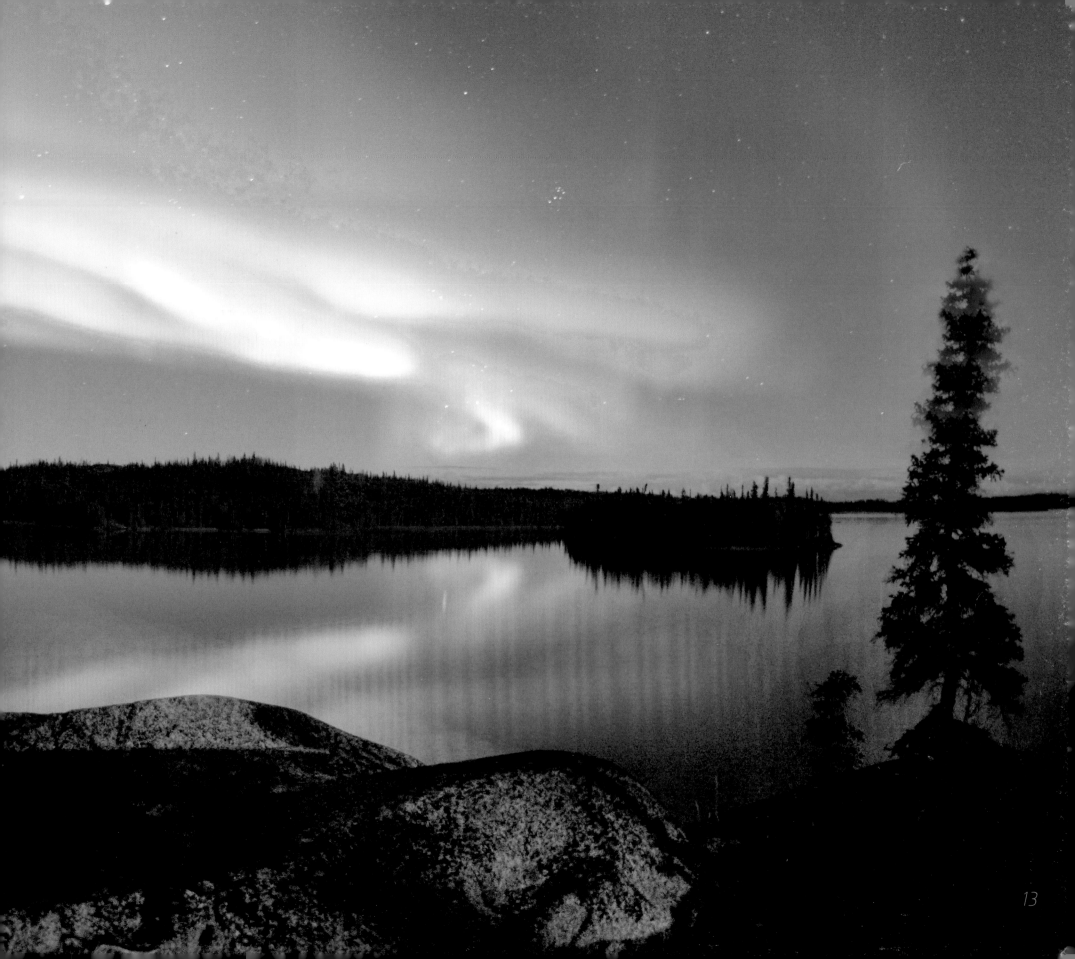

13

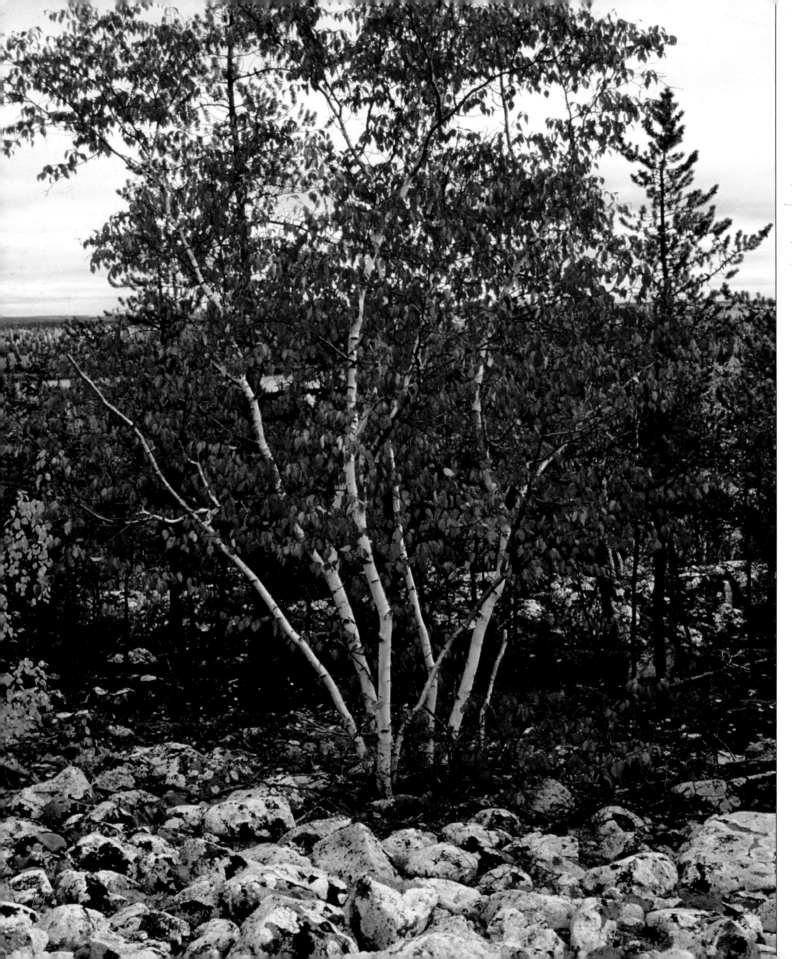

Before 1883, the area now known as the Shield was widely referred to as "Rupert's Land." According to the terms of a 1670 Treaty, all lands draining north to Hudson Bay were granted by Charles II to the Hudson's Bay Company. The region included what is now northern Quebec, Ontario north of the Great Lakes drainage basin, Manitoba, much of Saskatchewan, southern Alberta and parts of Nunavut and the Northwest Territories. The area was named after King Charles II's cousin, who was the first governor of the new trading company.

Referred to as the Laurentides in eastern Ontario and Quebec in the mid-nineteenth century, the Shield was simply called the *pays d'en haut* (the "upper country") by French-Canadian voyageurs who sped across its glistening highways of rivers and lakes with valuable loads of beaver pelts. Much later, in the 1870s, the territory was seen as a last gasp for new settlers who had missed out on good farmland in central Canada. After post-Confederation railroads pushed across the Shield in the late nineteenth century, the area eventually became known as a magnet for prospectors looking for mineral riches, a reputation that endures to this day.

For Canadians, the Shield still remains largely out of sight and out of mind—up there somewhat south of the Arctic. To many, it is "cottage country" or "up north"—and home to relatively few people living in widely scattered mining and lumbering communities that are subject to the inevitable boom and bust cycles

Rising out of a glacial till of lichen covered granite boulders, a fiery autumn birch goes not quietly into winter's long dark night.

(right) Over a billion years ago in Georgian Bay's Sans Souci area the Grenville Orogeny pushed, stretched, and folded rock into these flowing patterns.

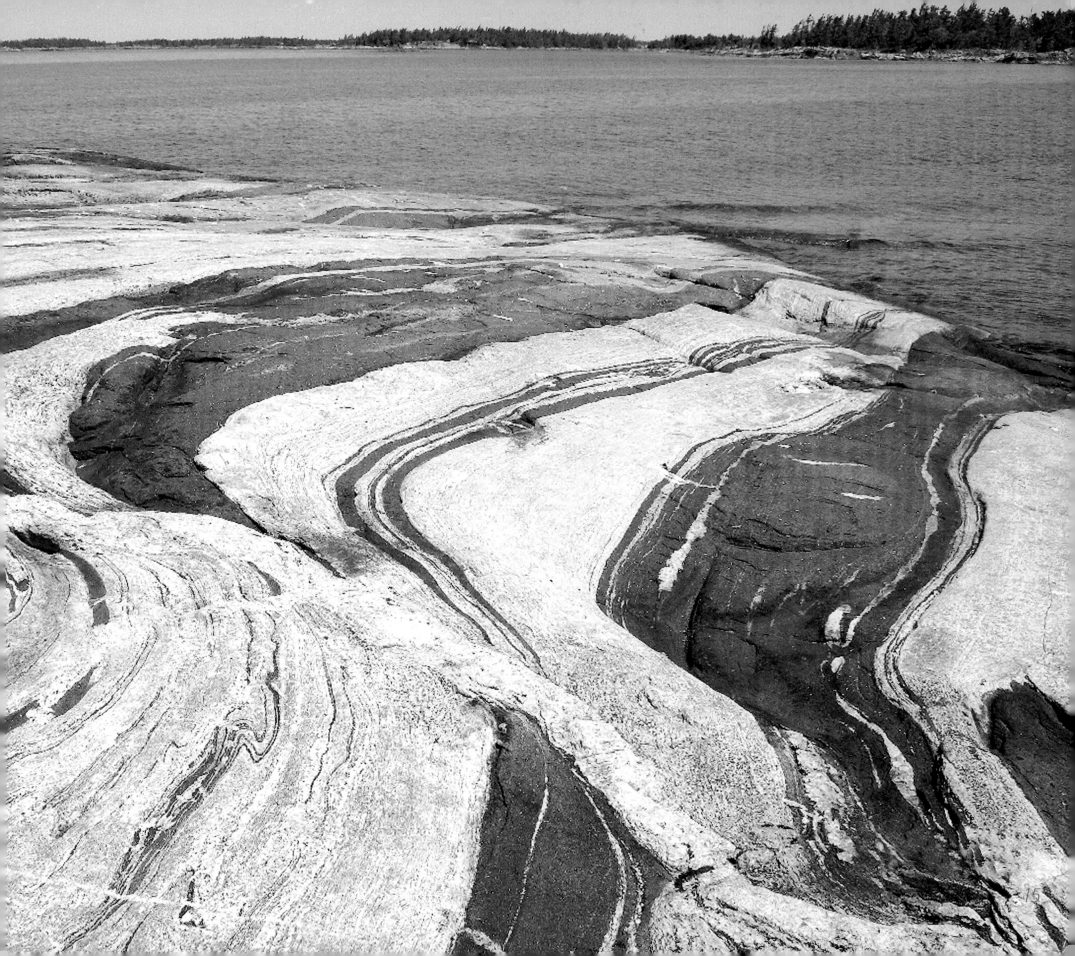

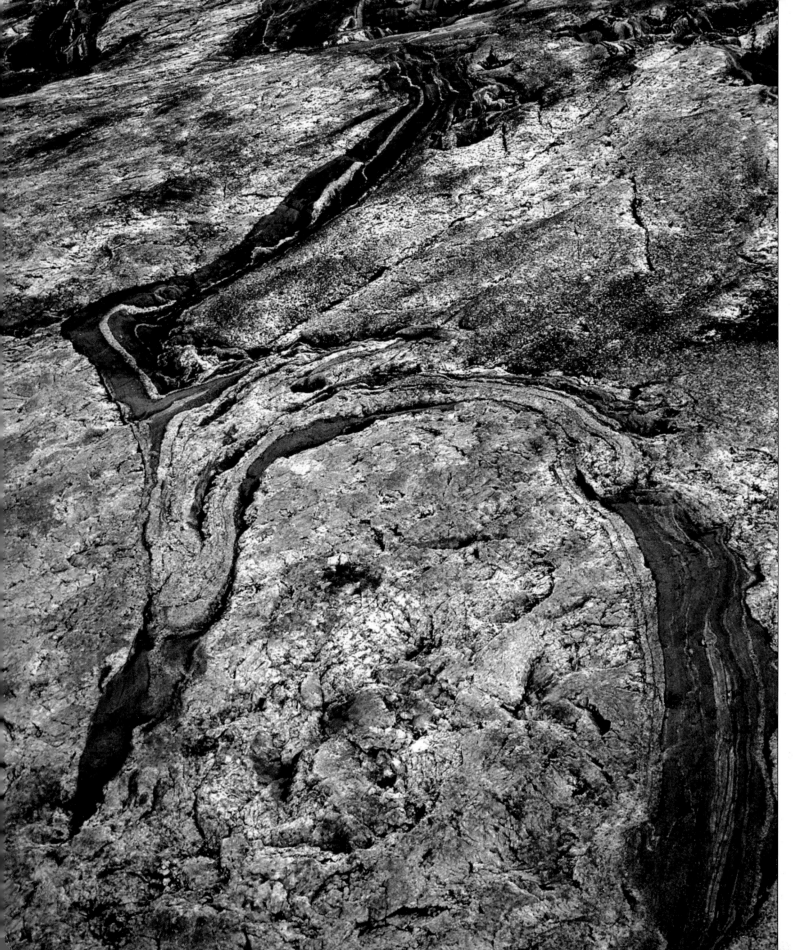

of commodities. More than a few of these communities have become ghost towns and have been reclaimed by the bush.

In 1961, historian W.L. Morton wrote: "The line that marks off the frontier from the farmstead, the wilderness from the base land, the hinterland from the metropolis, runs through every Canadian psyche." There is indeed a strong sense in central Canada of living along the southern edge of a vast vacuum, the empty heart of the country. Perhaps this is because the southern boundary of the Shield is so sharp and lies almost within view of the cities and towns where more than 80 per cent of us live. There is an abrupt contrast between the barren and largely vacant Shield and the densely settled farmland regions to the south. These differences were vividly captured by A.P. Coleman in 1913 when he wrote: "After passing the boundary of the Archean, the traveller is struck by the change of scenery, rounded hills of reddish gneiss rising irregularly above valleys occupied by a lake; for the region stretching two thousand miles to the north of the Paleozoic border is typical "rocky lake" country, with thousands of rock-rimmed bodies of water, summer playgrounds for the city dweller and tourist."[1]

A glimpse into the past can be found in these swirls of fire-formed rock melded under intense heat and pressure. Below the Earth's thin crust the process continues still.

(right) Pitted with myriad lakes cradled in the Canadian Shield, paddlers glide seemingly suspended over pristine waters of a rock strewn lake bed.

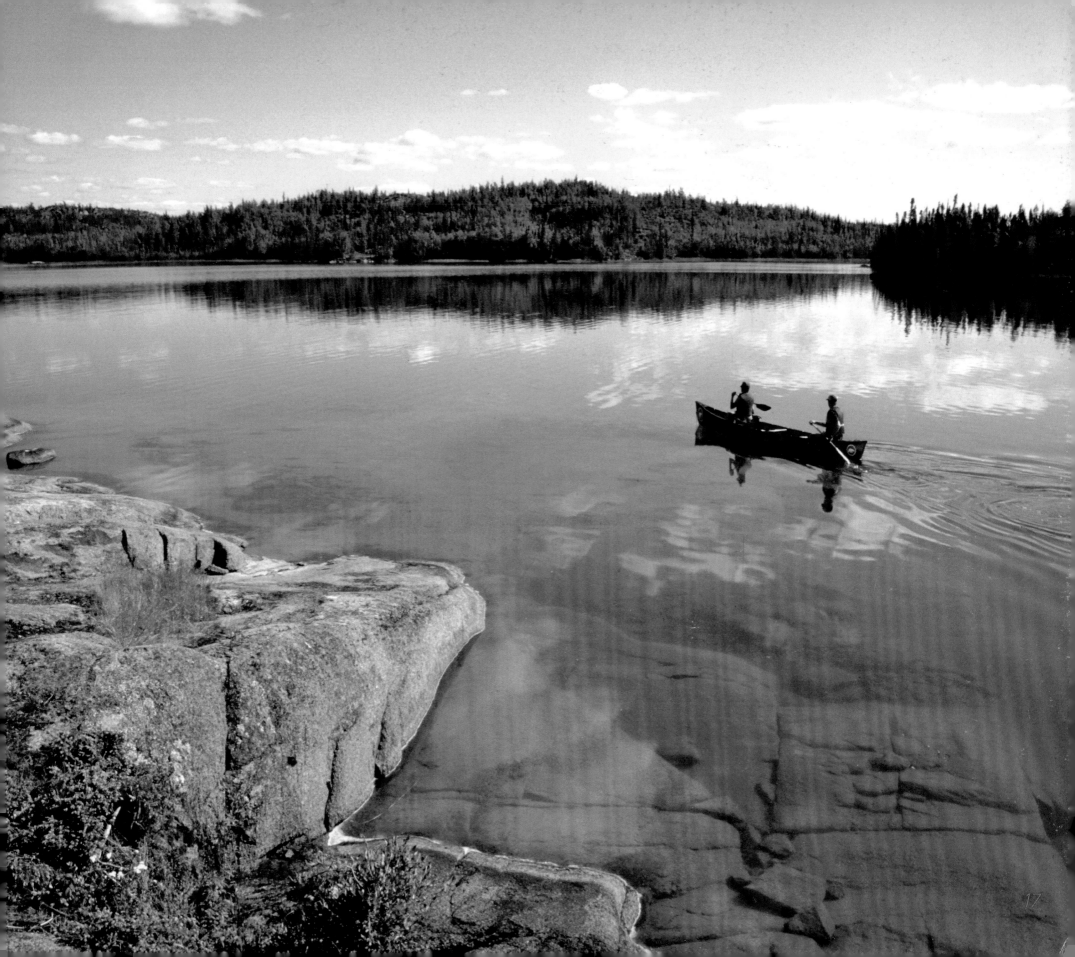

THE WORLD'S OLDEST LANDFORM

*We are living on the largest shield in the world
and our rock crumbles over the ages
one particle at a time.*
—Agnes Whitfield

*The plane was suddenly immensely precious to me, a familiar
friendly oasis in the immensity of Canada that was beginning to roll
itself out before me.*
—Hammond Innes, *The Land God Gave to Cain*, 1958

Seen in its entirety from space, the Shield is like a horseshoe partially encircling the central depression of Hudson Bay. The Bay is a large basin where the Shield sags downward and is covered by younger rocks and thick glacial deposits. Across most of its surface, the Shield lies between 300 and 500 metres in elevation with its higher parts (up to 1,000 metres above sea level) in the west and south. The regional drainage divide that separates the waters running to Hudson Bay from those that drain to the Great Lakes and the Mackenzie River lies very close to the Shield's southern rim. Its surface is also tilted upward to the east with a high

This nearly 600 m high cliff on the north side of a tickle (a narrow passage between two land masses) extends as deep into the sea as the land mass above it.

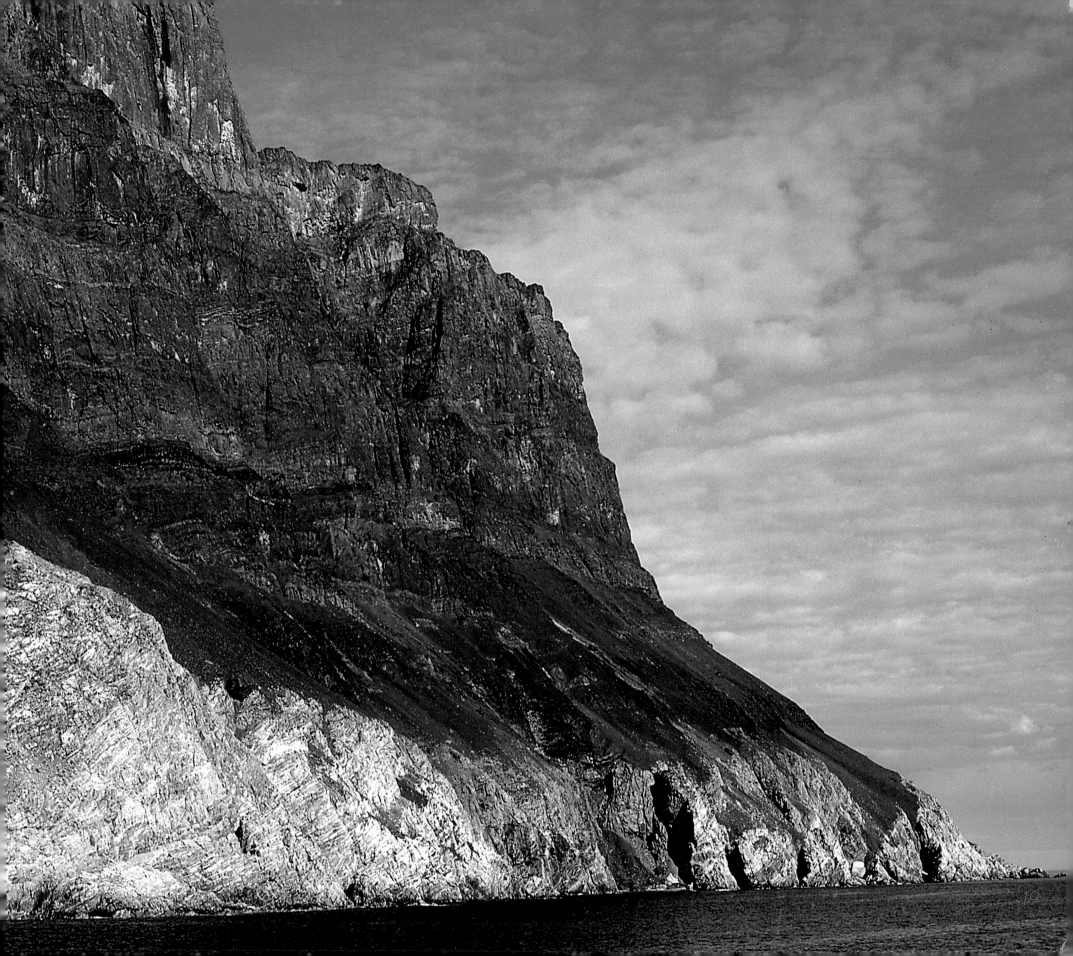

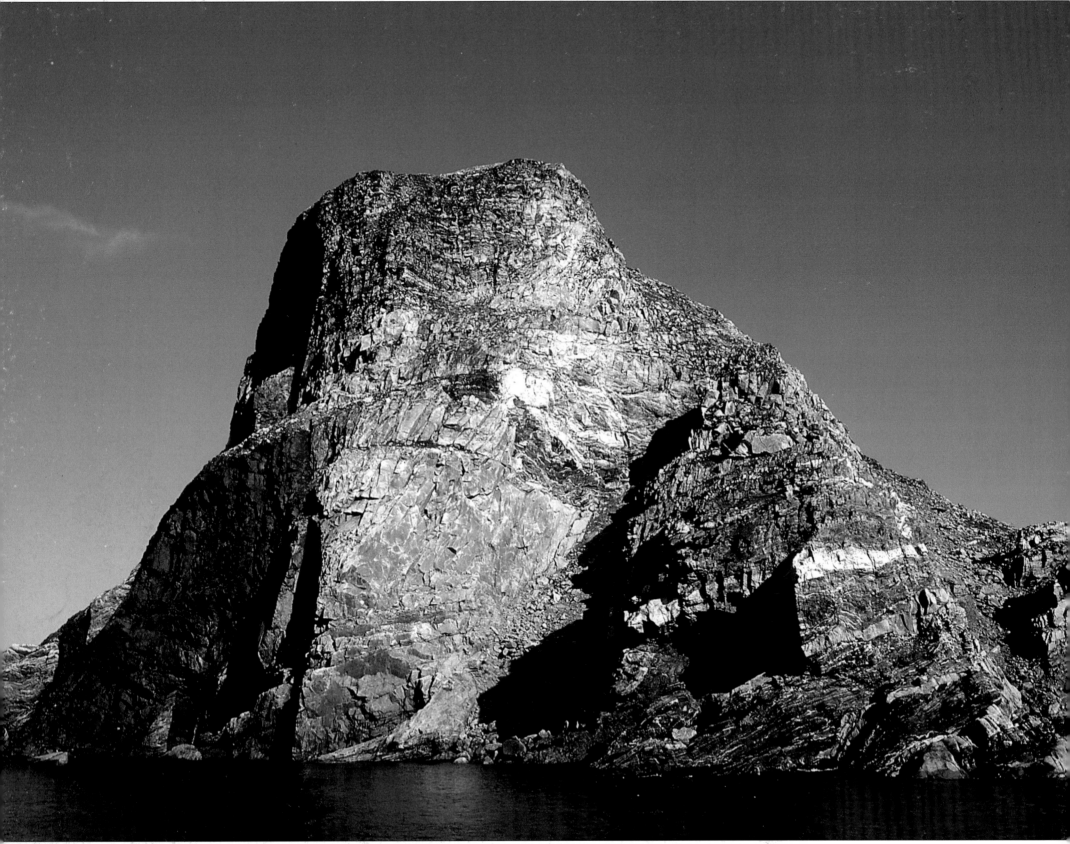

plateau in central Quebec, culminating in a raised rim in eastern Baffin Island (up to 2,100 metres above sea level) and in the impressive Torngat Mountains on the peninsula between Ungava Bay and the Atlantic Ocean in northern Labrador (1,600 metres above sea level). This tilting is the result of a slow uplift that occurred after 180 million years ago as the Atlantic Ocean opened up from a narrow crack or rift and North America began to move west from Europe. Hot rock welling up along the rift created a new ocean floor crust and in the process warmed the edge of the Shield. The Shield slowly rose, and in the process created the great plateau on which enormous ice sheets were born during the successive ice ages of the last 2 million years.

The "Great Precambrian Peneplain"

Scientists who study landscapes are called *geomorphologists*. They have their own language to describe the planet's varied landforms created through the action of water, wind, and ice. John Richardson, a naturalist who was part of John Franklin's two arduous land expeditions (1819–22 and 1825–27), was the first to note the sharp southern boundary of what he called the *Archean peneplain*. Archean was then simply used in the sense of something of great age and the word peneplain means "almost a plain." Altogether it refers to a surface of low, undulating relief created by erosional flattening of high mountainous areas. Davis invented a Dar-

Fighting and resisting, 200 m tall Blue Bell Island still pokes its head up from under the Labrador Sea. Geologists claim it to be nearly 4 billion years old.

(right) Left by glaciers 10,000 years ago, this boulder is nestled in a crevice slowly succumbing to the elements. If left untouched it should see another ice age before it moves again.

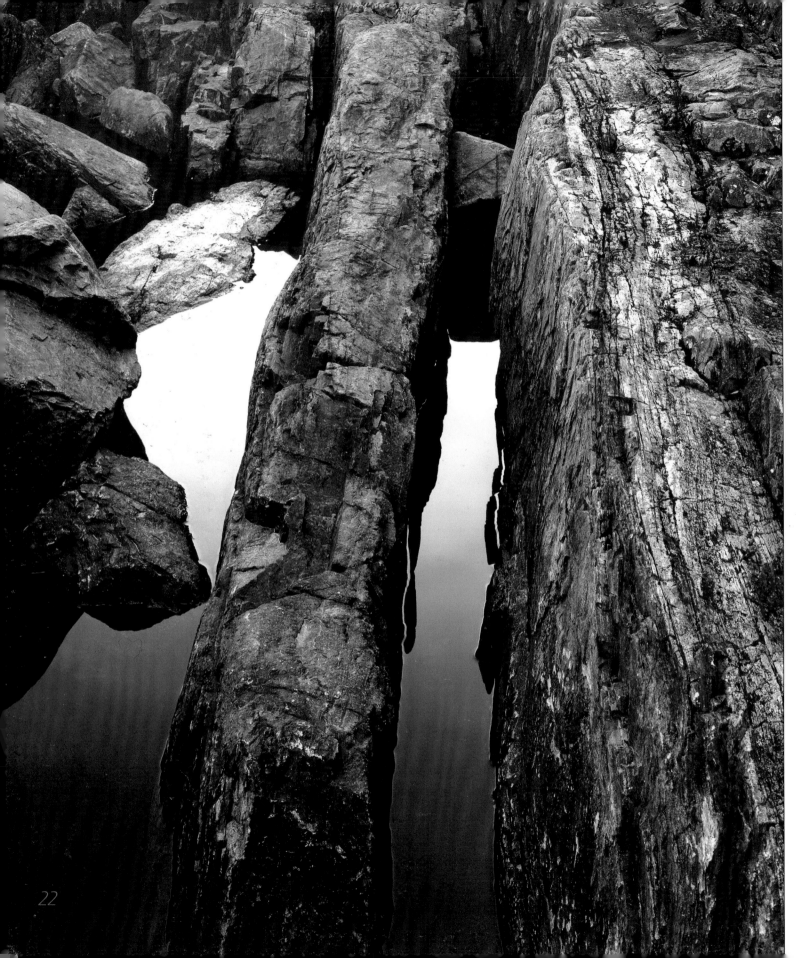

winian evolutionary scheme to explain the development of landforms, ranging from youthful mountains to mature, subdued peneplains, this last term being classically represented by the Canadian Shield.

In actual fact, the Shield peneplain is anything but flat, consisting instead of rounded, gently undulating, residual hills called *monadnocks* that rise above the surrounding plain[2]. This surface has been compared to "an ocean of rocky waves whose crests all rise to the same height. The distant skyline is practically horizontal except for the occasional monadnock or rock knob."[3] The ocean metaphor reappears many times in descriptions of the Shield.

In the 1880s, a key unanswered question was, How old is the Shield peneplain and how did it form? More precisely, was it simply eroded flat by rivers or scraped off by glaciers? The answer was rather surprising and lay in the results of geological mapping across the Shield and the younger Paleozoic sedimentary rocks that cover its outer margins. The geologist A.C. Lawson made an important observation in 1890, when he recognized that "the early Paleozoic rocks were laid down on a surface which did not differ essentially from that presented by the exposed Archean surface of the present day." In other words, the peneplain we see today is essentially the same surface over which the Paleozoic seas had begun to wash more than 600 million years before. F.D. Adams also wrote, in 1893, that the peneplain, considered by most to be the result of erosion during Pleistocene glaciations over the past 2 or 3 million years, was in fact much older than the Paleozoic rocks that lay on top of it. In 1901, A.W.G. Wilson concluded too, that "the ancient . . . surface . . . is a denuded peneplain dating from before early Cambrian times."

The great antiquity of the Shield was con-

It's what makes us — water, rock, and air.

firmed in 1930s, by which time the study of landforms had become more sophisticated. Through the work of H.S. Cooke and R. Blanchard, it became clear that the Shield was indeed very, very old. J.W. Ambrose finally concluded in 1964 that the topography of the exposed portions of the Shield was not much different from that of the parts still buried below the younger Paleozoic rocks on its outer margins. He argued that the entire Shield had once been buried under younger strata and was slowly being stripped of the cover, thus revealing an *exhumed* peneplain. Geomorphologists still accept this explanation. Indeed, the Canadian Shield is one of the oldest parts of the Earth's surface. But a big problem still remains. How did it actually form?

A billion years ago, what we call the Shield looked very different. In fact, mountains dominated the scenery of central and northern Canada. Just as high and extensive as the Himalayas today, these were the product of an immense collision between the Shield and what is today the northern part of South America. Mountain building events such as these are referred to as "orogenies" by geologists (it means literally "to build relief"). This particular geologic incident is called the Grenville Orogeny. But as tall as they were, the impressive Grenville Mountains were gone 200 million years later, wiped clean off the face of the planet and replaced by the peneplain of the Canadian Shield. Rivers likely played a major role in the destruction of the Grenville Mountains for huge volumes of sandy debris were moved by giant, westward-flowing rivers to the then western coast of North America which lay almost where modern-day Calgary lies. There the debris formed a new coastal plain. This old

Facing a timeless and mortal enemy, ocean waves batter a resisting shore. Ice and tides also help in the destruction.

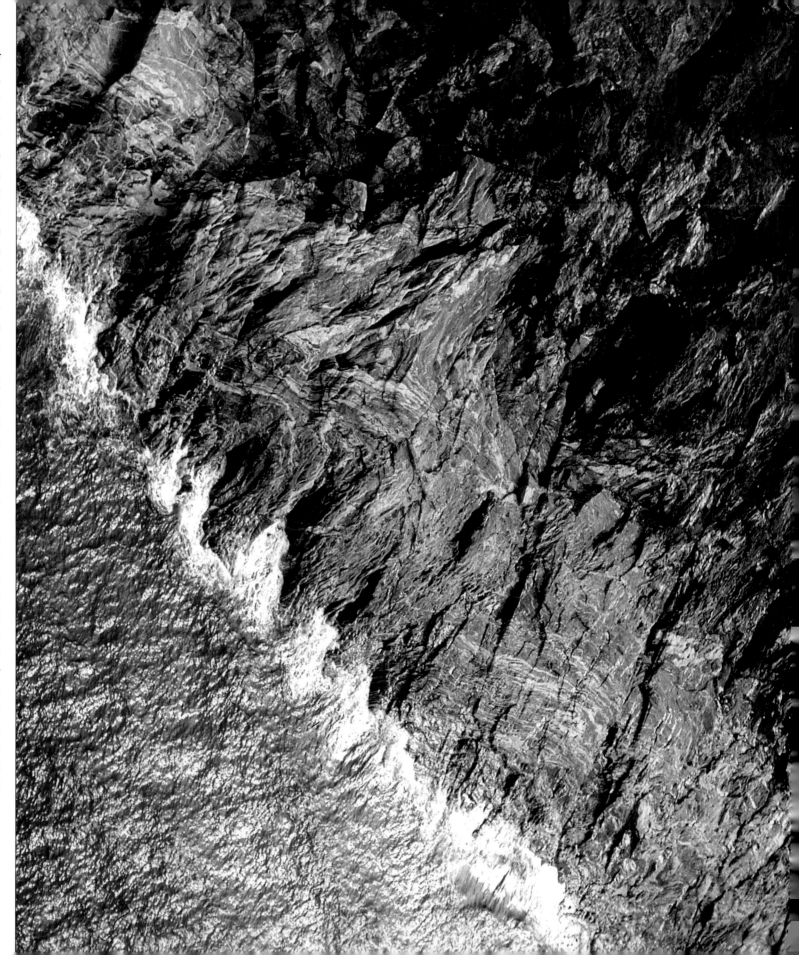

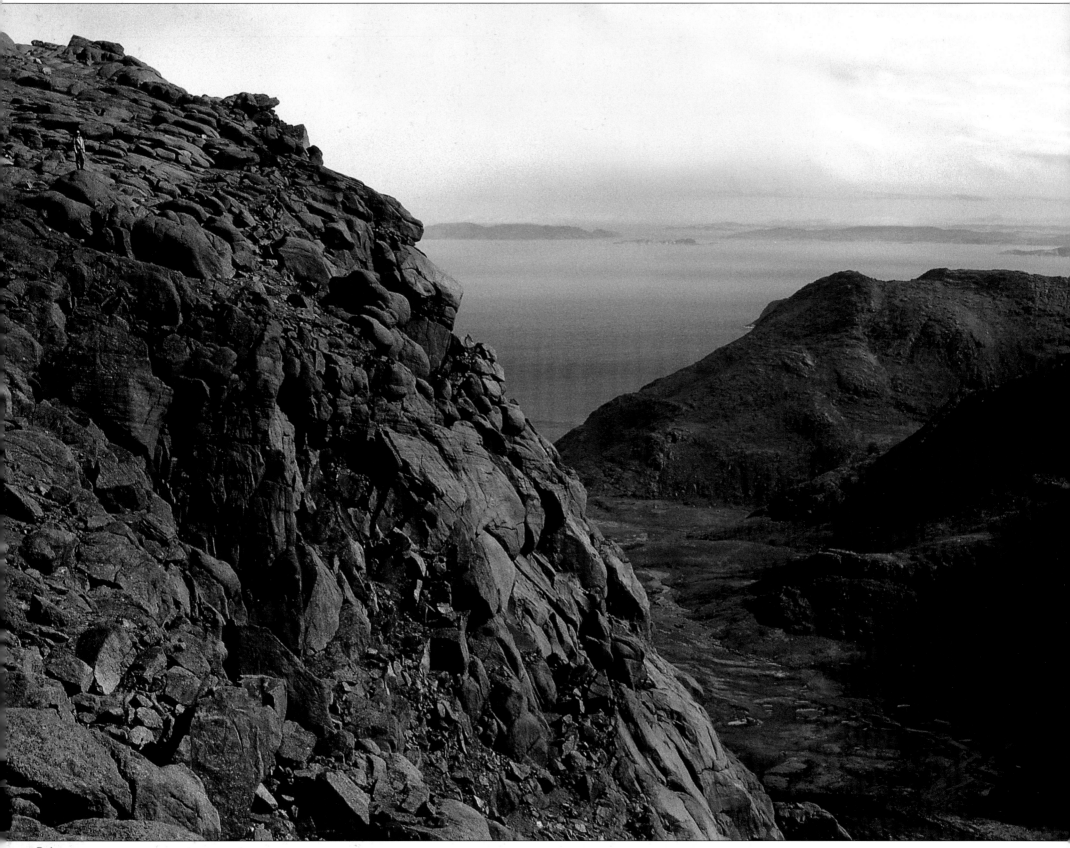

coastline is now buried under the Rockies, but it has been revealed through deep imaging. So, the Shield as we know it today was largely formed some 600 million years ago.

Geomorphologists are still debating about the precise *degree* of alteration that has occurred since. In the early 1970s, William White made the case that the Shield had been deeply eroded by ice sheets of the last 2 to 3 million years, but this view proved very unpopular. By and large, glaciers sandpapered the Shield and locally dug deep into its surface in areas where there was weaker fractured rock, but overall didn't have much of an effect. Certainly, the Great Lakes basins have been glacially scoured (to below sea level), and the same is true for the deep narrow fjords along the Shield's eastern rim. However, Hudson Bay is not the result of glacial excavation. Instead, it is a "sag basin" formed by the downward bending of the Shield's surface. Conversely, the Shield also displays what are called *arches*, or upwarps— gentle creases that may have formed in the peneplain when Africa barged into North America some 440 million years ago (the Appalachian Orogeny).

Much of the Shield that we see exposed today in central and northern Canada was once buried several kilometres under great thicknesses of sedimentary rocks such as sandstones, shales and limestones. These Paleozoic "cover rocks" were the product of warm shallow seas that flooded across the ancient peneplain at a time when central North America lay in the tropics from 600 to about 300 million years ago. These seas hosted a wide variety of marine

Perched on the edge, these boulders will move inexorably to the sea.

(right) Shattered by heat and frost, lichen and moss grab hold and benefit from slowly released minerals.

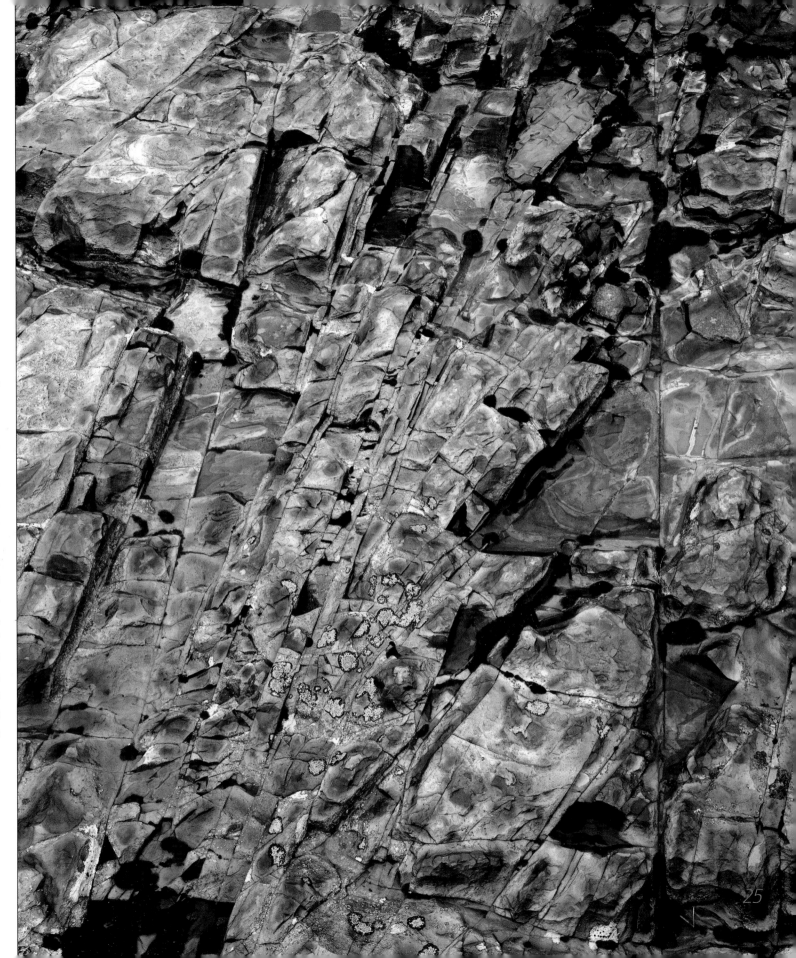

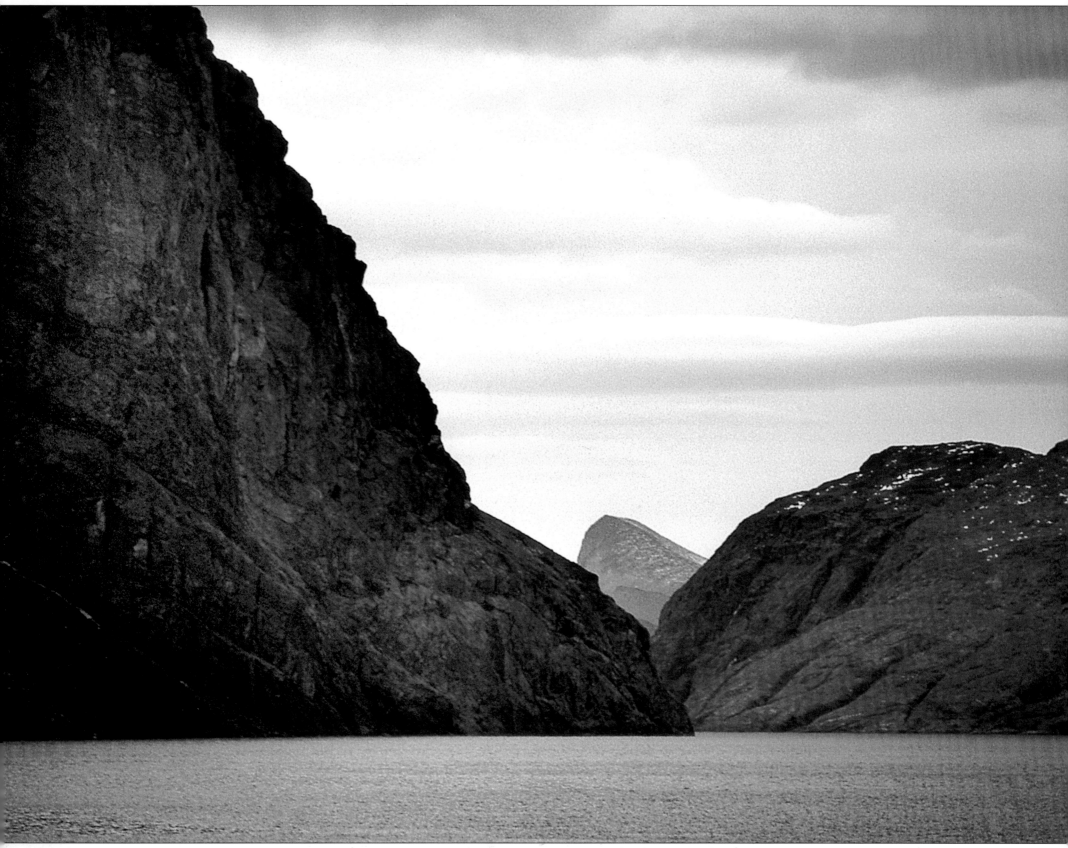

organisms so the rocks are richly fossiliferous; limestones are often made up entirely of the fossil remains of shellfish. Isolated patches ("outliers") of such rocks still occur in areas of the north that survived erosion, including James Bay, Hudson Bay and Timiskaming. Farther south the edge of the Shield disappears entirely below the cover of sedimentary rocks. It can be traced deep underground as far south as Texas. Its rocks are exposed in the floor of the deep slash we call the Grand Canyon and in part of the eastern US, in the mountains of Virginia, where it has been thrust up and buckled during the Appalachian Orogeny. The Canadian Shield actually underlies much of North America. Even Greenland is a part of the Shield that broke away from North America some 80 million years ago.

Some have argued that much of the exposed Shield was deeply weathered in warm climates that prevailed for millions of years before the ice ages, a time when dinosaurs ran around western North America. Great thicknesses of weathered debris (known as "regolith") are indeed typical of shields in Africa, South America, and Australia and result from the slow decomposition of rock by groundwaters. In Canada, any such weathered debris was stripped off by glaciers to reveal fresh rock below. Parts of this ancient regolith still survive in places but such occurrences are rare.

The deepest glacial scratches on the Shield are out of sight, underwater, in the glacially carved basins and troughs on the floors of the Great Lakes and the lesser lakes littered

300 m cliff faces such as this continue straight down for 300 m under the surface of the sea as well.

(right) A well-exposed Nunavik shoreline gives evidence of the eroding power of ice and waves.

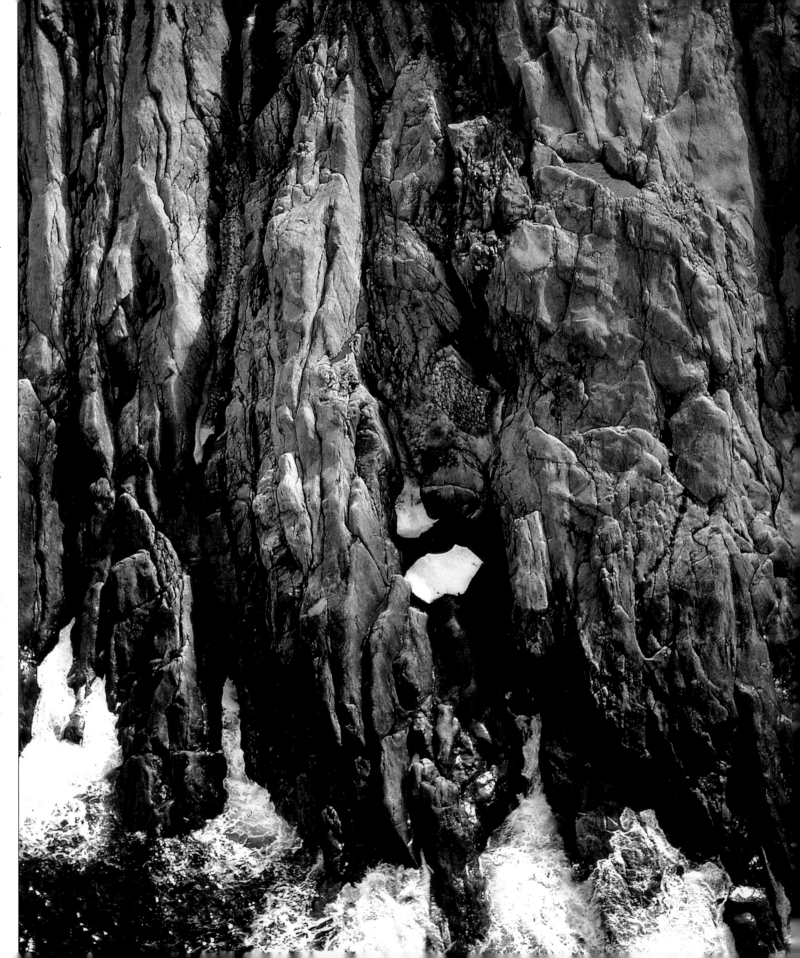

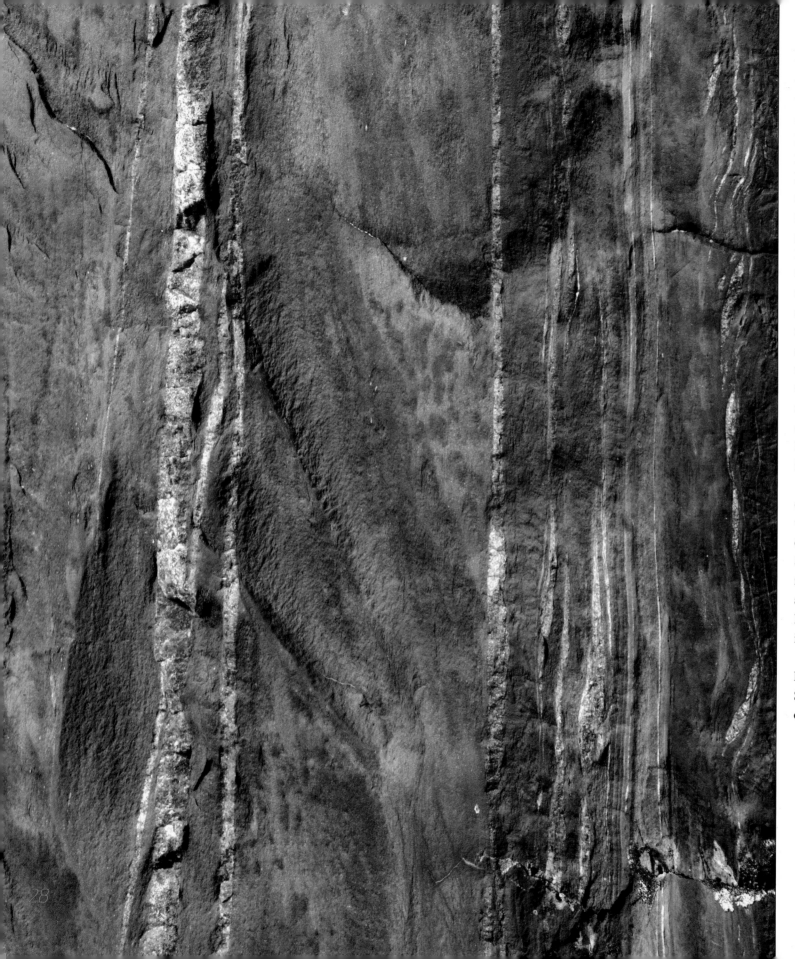

throughout the Shield. These troughs are scattered along the outer margins of the Shield just where it disappears below its protective cover of Paleozoic rocks. Coronation Gulf near Nunavut, Great Bear Lake, Great Slave Lake, Lake Athabasca, Lake Winnipeg, the Great Lakes, and the St. Lawrence Valley have been cut deep into the Shield, recording the flow of ice radially outward from the great gathering grounds on the plateau of Keewatin, west of Hudson Bay and Labrador/Quebec to the east. Of these ice-scoured lakes, Great Slave Lake is the deepest (614 metres). Lake Superior, the deepest of the five Great Lakes, has a maximum depth of 405 metres with the deepest part of the lake 215 metres below sea level. Along the outer raised rim of the Shield in Atlantic Canada and north, deep valleys called *fjords,* now flooded by the ocean, were glacially cut, creating a spectacularly scenic landscape of high plateau bounded by great cliffs that plunge into deep water.

All said, the Canadian Shield is a landform called a peneplain consisting of the stumps of worn-down and weathered mountains; molars of once-sharp tectonic teeth. The peneplained Shield has since been covered by thick Paleozoic sedimentary rocks, exhumed, weathered, and then scoured by glaciers of the last few million years. To walk over its surface and admire its rocks is to gaze far back into geologic time.

Our Shield has been a witness to a lot of Earth history, but the human footprint on the Shield has only occurred in the last split second of geologic time.

An abstract painting created by the Shield's iron rich sediments shot through with ribbons of quartz.

(right) Due to its hardness, this granite sill is outlasting the softer furrowed rock behind.

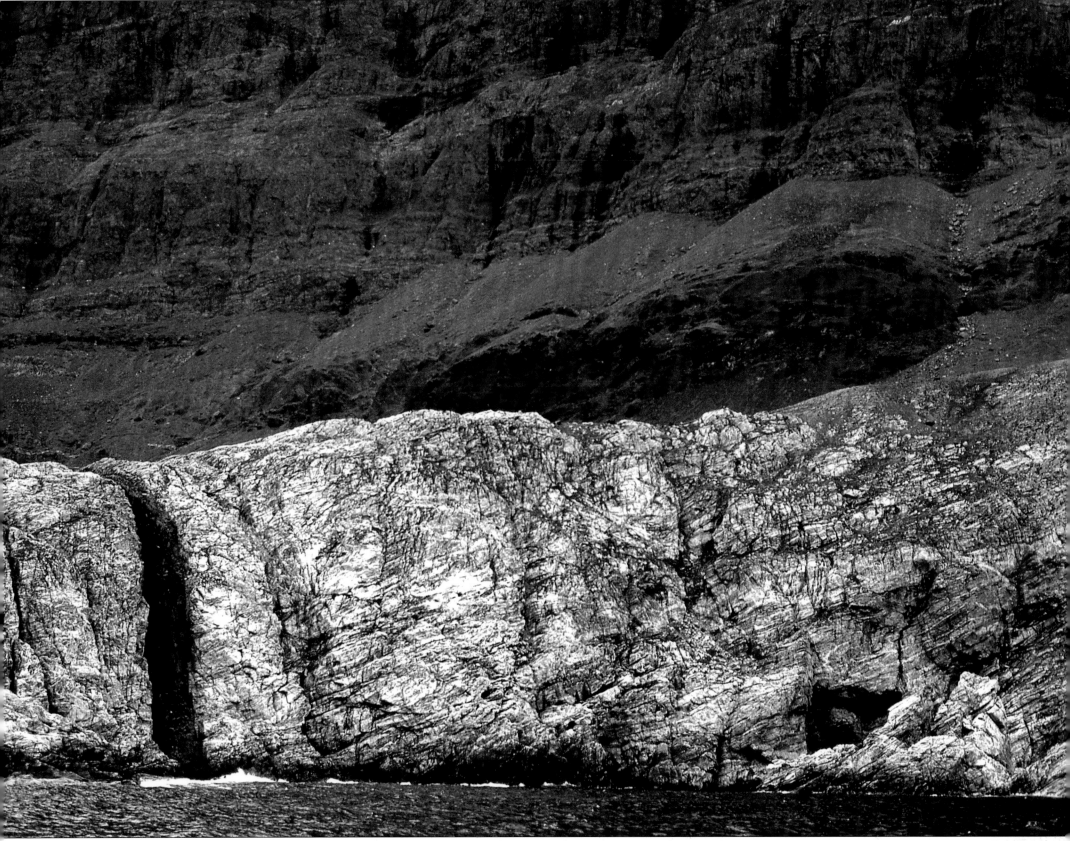

CHAPTER 4:
THE ICE SHEETS MELT AND HUMANS ARRIVE

The land has moulded the people, not the people the land.
—D.M. Lebourdais

Humans are late comers to the Shield simply because for much of its very recent history it has been off-limits to habitation. For the last 2 to 3 million years, the Shield has experienced long freeze-thaw cycles represented by alternating ice ages, when it was buried under thick ice, and warm interglacial periods like were witnessed these last 10,000 years. We know of at least 50 such cycles (from sediments left deep on the floors of oceans) but only the last few are actually recorded in Canada; the latest ice sheets did a pretty good job of eroding the deposits left by earlier ones.

Inuit use stone building blocks to create human-like Inuksuit as way markers and sign posts. This group indicates a good fishing place at the mouth of the river in Kugaaruk.

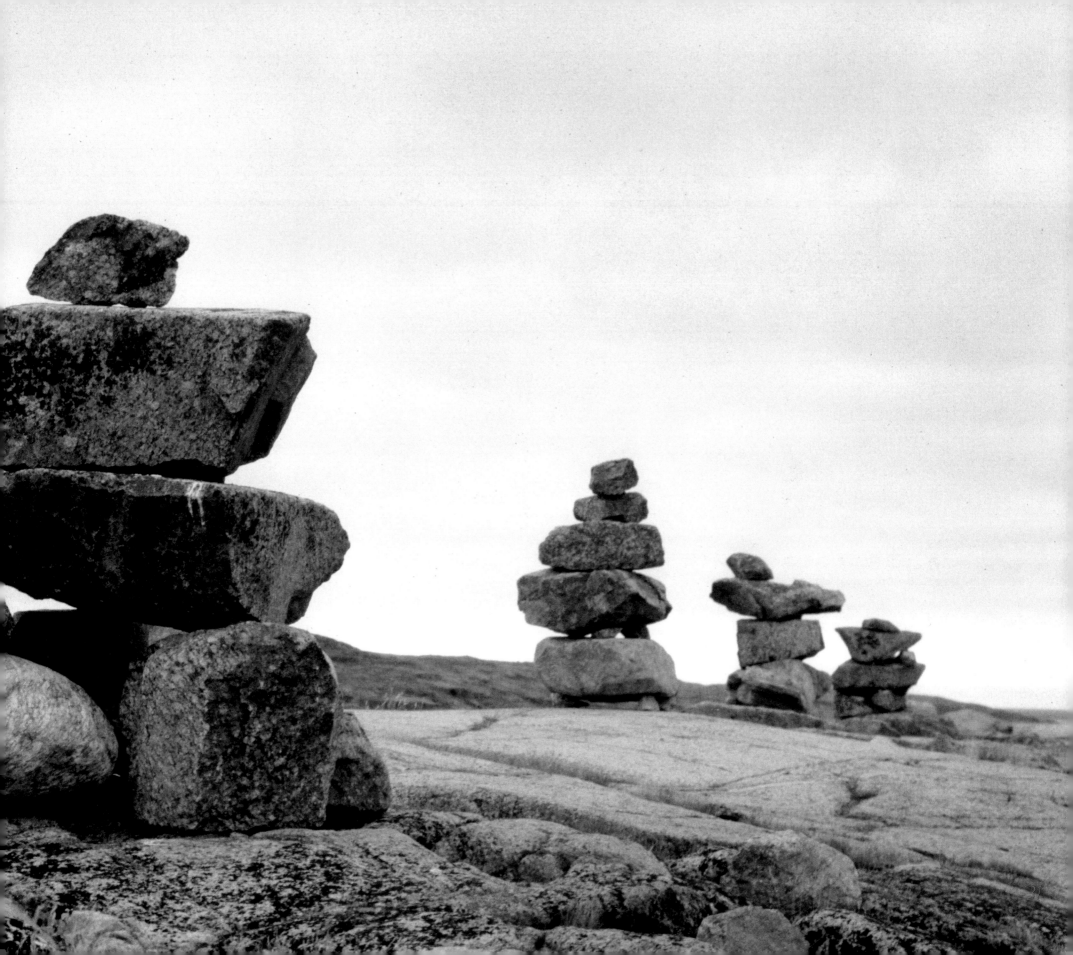

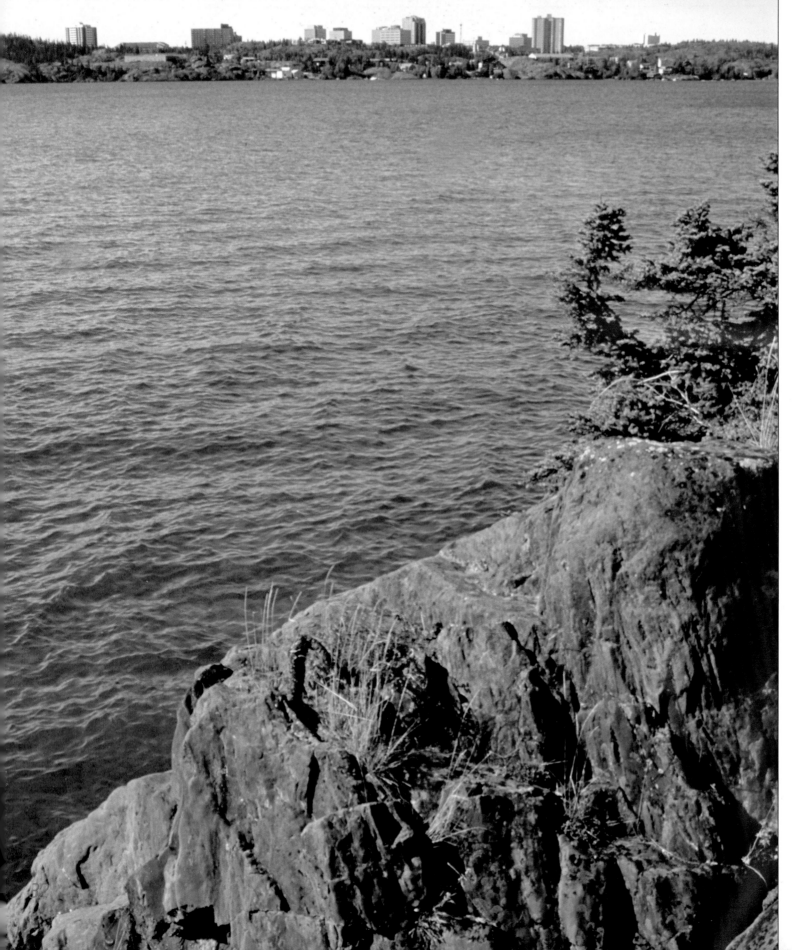

The last and latest ice mass (the Laurentide Ice Sheet) first formed about eighty thousand years ago, the beginning of what is called the Wisconsin Glaciation, and lasted until six thousand years ago in the north. Bits of it still survive on Baffin Island. The Shield was buried under glacial ice as much as three kilometres thick. So great was the weight of ice that the Earth's crust was pushed down several hundred metres (by a process called *glacioisostatic depression*). As the ice sheet began to melt and retreat, an inhospitable zone of large lakes and scrubby tundra developed around its margins, unclaimed as yet by trees. The still deeply frozen ground thawed only during the summer, leaving a morass of boggy terrain. Ice still blocked what is now the St. Lawrence, damming up water that would otherwise have flowed into the Atlantic, creating enormous glacial lakes called Agassiz, Algonquin and Iroquois. These are truly the "Greater Lakes" because they were much larger than their modern successors. Cold, fast-flowing rivers moved water into and out of the glacial lakes. In the east, cold waters of the Champlain Sea invaded the southern edge of the Shield.

A land of cold climate, lingering glaciers, exposed muddy sediment and scrubby trees not unlike the Far North today. Not a very hospitable place for humans—but there was suffi-

Plunked on a granite belt amidst metamorphosed volcanic greenstone, Yellowknife began as a gold mining town in the early 1930s. The city has now reinvented itself as the diamond capital of North America.

(right) Some of the oldest rocks on the planet recording the beginning of plate tectonics are found in the rolling hills near Gameti, close to Great Slave Lake in the Northwest Territories.

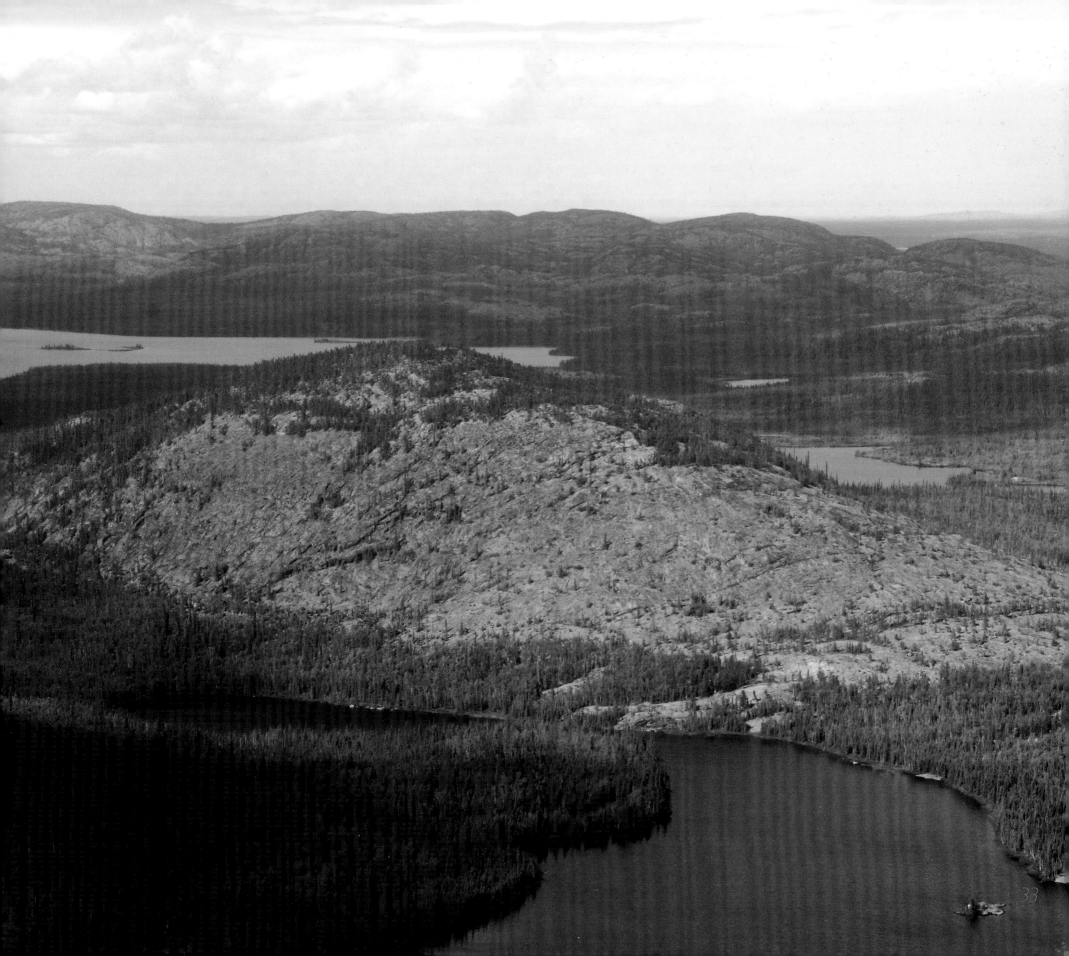

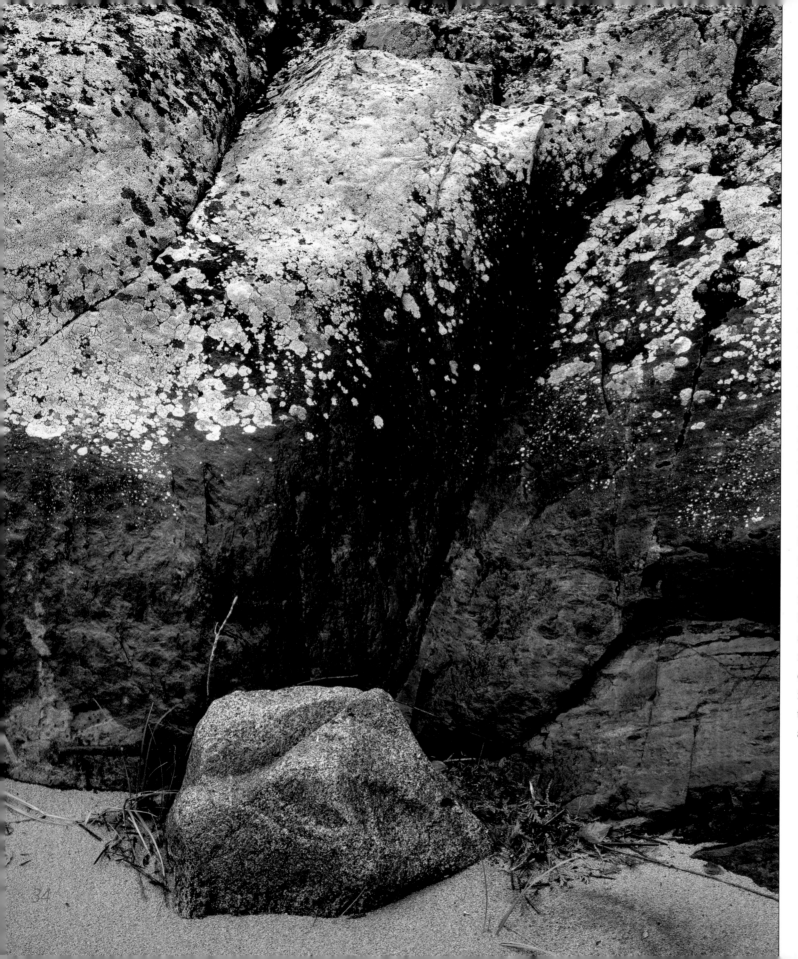

cient food in the form of big game.

The earliest people in central North America lived at what is known as the Meadowcroft site near Pittsburgh, about sixteen thousand years ago. They were a hardy people, part of a Paleo-Indian culture descended from those who had crossed from Asia into what is now Alaska. They had made that journey by taking advantage of shallow water across the Bering Straits at the height of the last ice age. At the time, huge volumes of water were locked up as snow and ice in ice sheets, causing sea levels to drop to about 150 metres lower than they are at present. At some point between eleven thousand and ten thousand years ago, the Paleo-Indians from the Pittsburgh area ventured northward into central Canada, where they entered a strange new water world of large lakes created by the disappearing ice sheet. Camping along the shores of glacial Lake Algonquin, they followed caribou and possibly mammoths.

It was a time of rapid and substantial change in the geography of central Canada. Many First Nations creation stories tell of the Great Spirit, who dived into water to bring up mud to fashion a new Earth. This may reflect the fact that as the Earth's crust rapidly recovered from bearing the great load of the ice sheet, large glacial lakes drained and new land did appear dramatically out of the waters. Dramatic changes in coastlines would also have occured within individual lifetimes, and similar, though less drastic, changes still occur today in the Far North, where coasts uplift by as much as one metre every century. An uplift

Lichens get a foothold on a nurturing and hospitable rock just above the waterline.

(right) Black bands appear to float in the granite as pools of water reflect the surrounding pines.

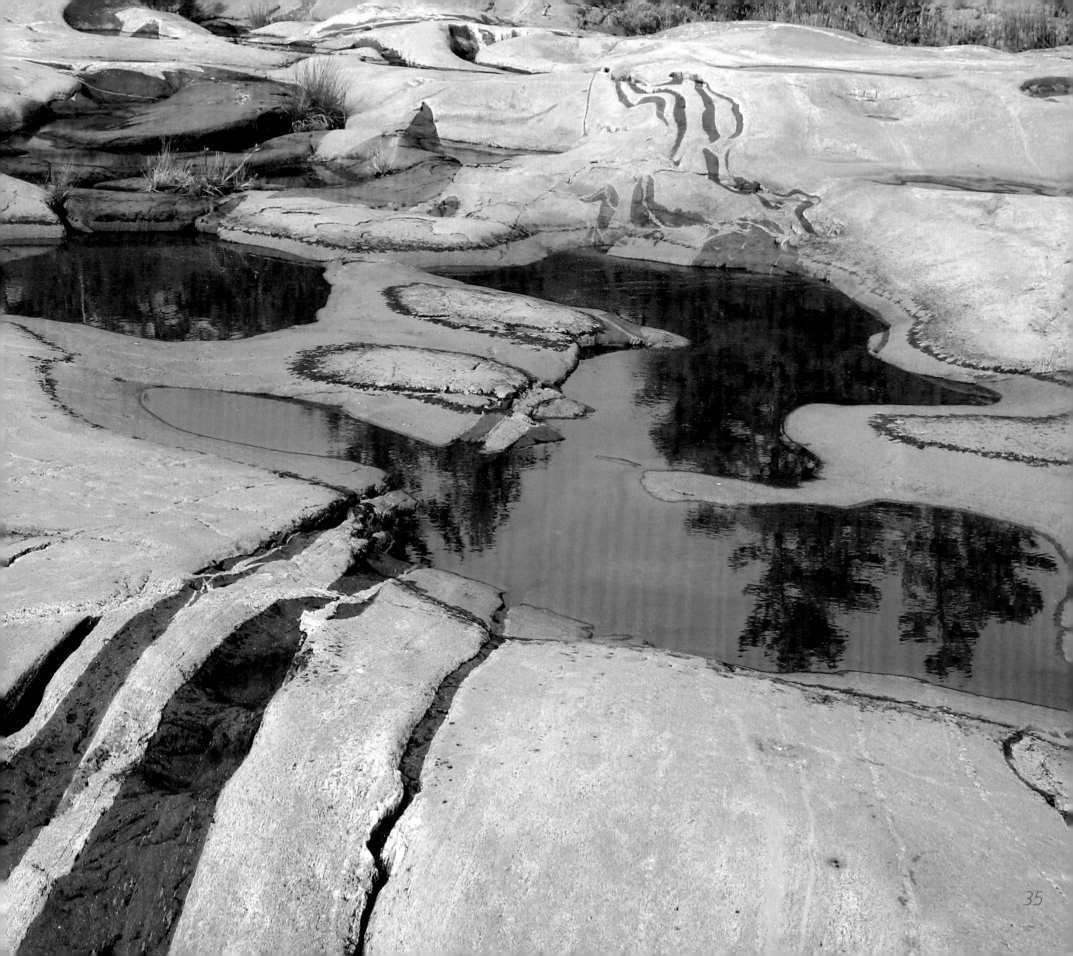

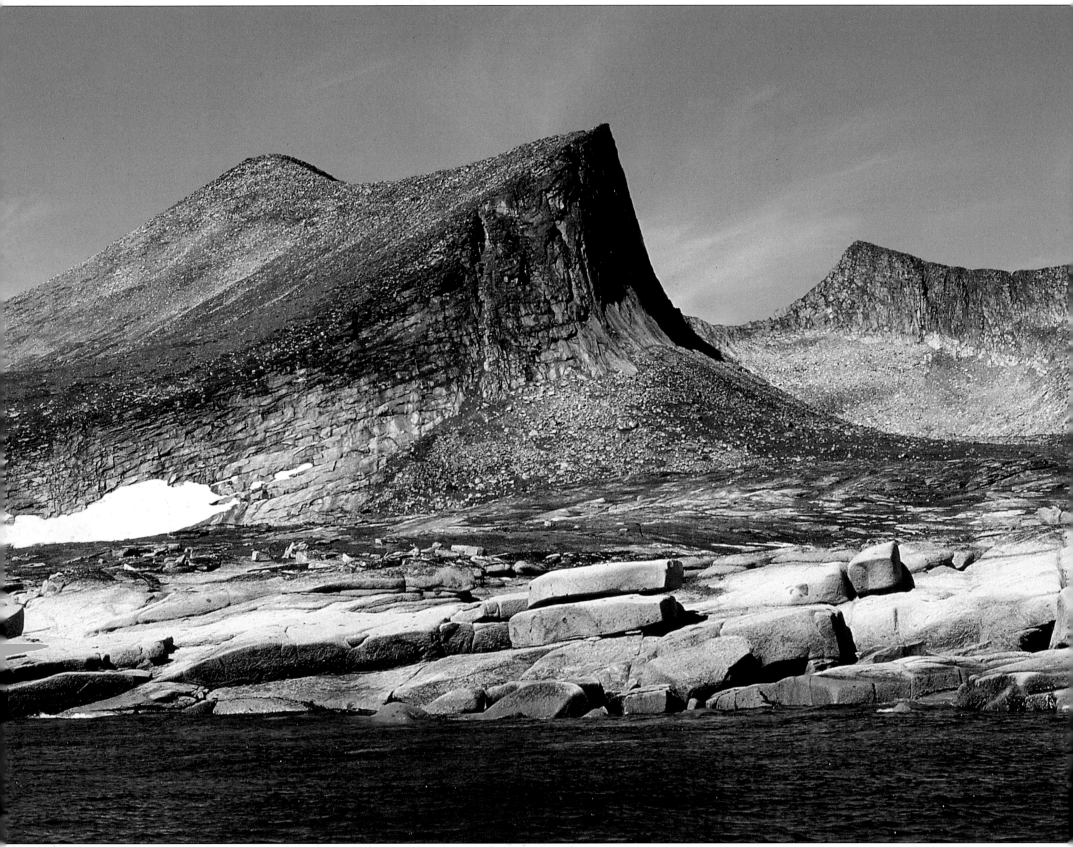

of about 300 metres is yet to occur in the coming thousands of years around the margins of Hudson Bay where the ice sheet was thickest. Eventually, Hudson Bay and James Bay will be dry land once more—as they were before the last glaciations.

Paleo-Indians were slowly replaced by the much more numerous Archaic people as the climate warmed and the ice sheet finally disappeared from the Shield about six thousand years ago. Warmer temperatures allowed trees to invade the Shield, making land travel difficult, so waterways became the key to human colonization of the northern interior. The birch tree provided an excellent means of transportation: the birch bark canoe. Canoes and snowshoes were key technological innovations that allowed northern peoples to avoid taking long treks through the bush in summer and prevented them from becoming immobilized in winter by deep snow. This common transportation was amazingly long lived and survived until the very last years of the nineteenth century, when the railroad snaked across the southern Shield. Archaic Aboriginal sites are widely scattered across the North but are most often found where the migration paths of caribou cross major rivers, as caribou and fish were the main components of the diet. Major forest fires probably caused some groups to migrate and this, in turn, resulted in cultural exchanges. These fires also allowed moose populations to increase to the point where they became more

Here on White Bear Island, flat stones have given Indigenous people a place to eat and skin seals. Many such places have also been used to bury the dead.

(right) On an island on Lake Superior gulls have nested using the cleaved rock for a firm purchase. Benefiting from the rock and guano, lichens and moss grow in abundance.

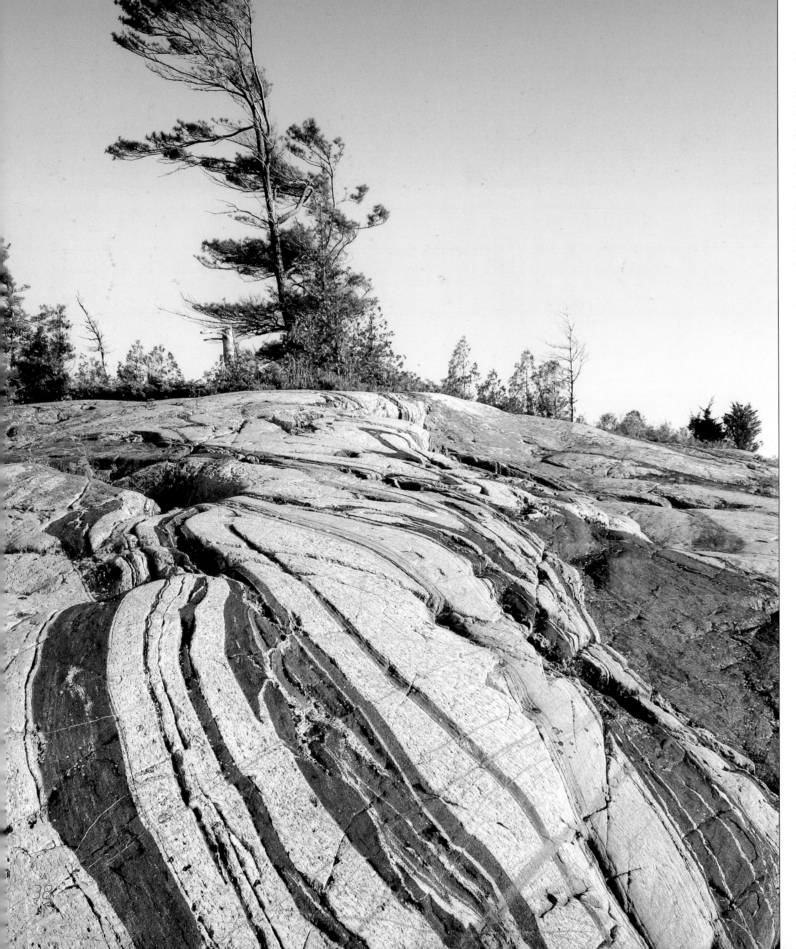

important than caribou in some areas.

There was—and still is—a close relationship between First Nations people and the landscape. One First Nations belief is that rocks are inhabited by *maymaygwayshiwuk* who appear every now and again to torment humans. However, prominent rocks and cliffs were regarded as sacred places. Sleeping Giant near Thunder Bay, Dreamer's Rock on Manitoulin Island, the sacred Grandfather's Rock at Orillia and the Petroglyphs near Peterborough are just a few of many sacred sites scattered across the Shield. Manitoulin Island on the southern margin of the Shield in Lake Huron is also considered to be the home of *Gitchi Manitou,* who created the four sacred elements of fire, water, wind and earth.

Special sacred sites were often marked by petroglyphs—images painted on rocks with red ochre. (Red ochre was made from powdered hematite [iron oxide] and mixed with animal grease.) Using this thick paint, Native artists recorded feats of endurance, conquests in battle or narrow escapes from demons. One of the most famous and impressive sacred rock-art sites on the Shield is found at Agawa Rock on the shore of Lake Superior. Agawa Rock is a 30-metre-high cliff made of 3-billion-year-old granite with 35 rock paintings made of ochre scattered along its base. These commemorate an Ojibwa war party victory over the Iroquois. The spiny-backed water

The arching rhythms of banded gneiss and the white pines shaped by the prevailing west wind create the archetypal Georgian Bay landscape seen here on Bartram Island.

(right) The banded gneiss on the edge of Bartram Island creates colourful abstract patterns that plunge beneath the waters of the Bay.

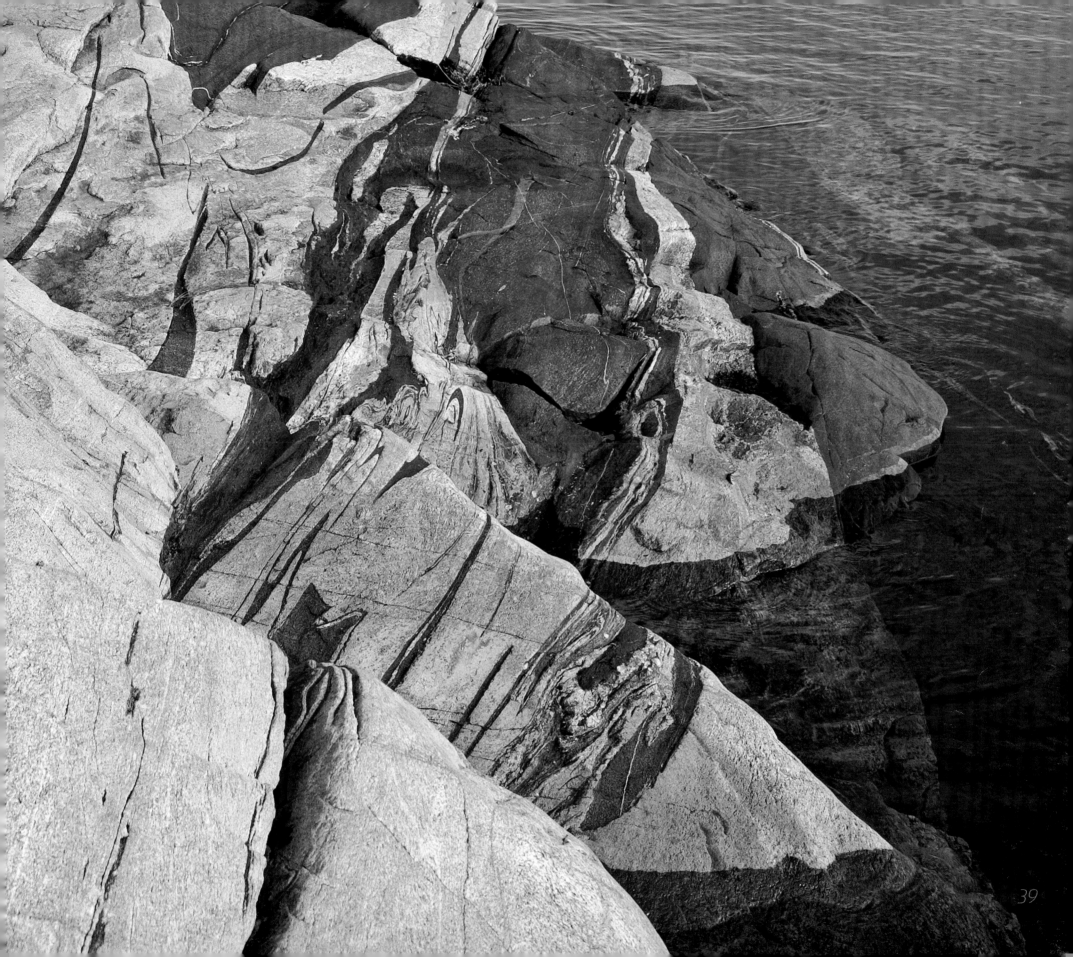

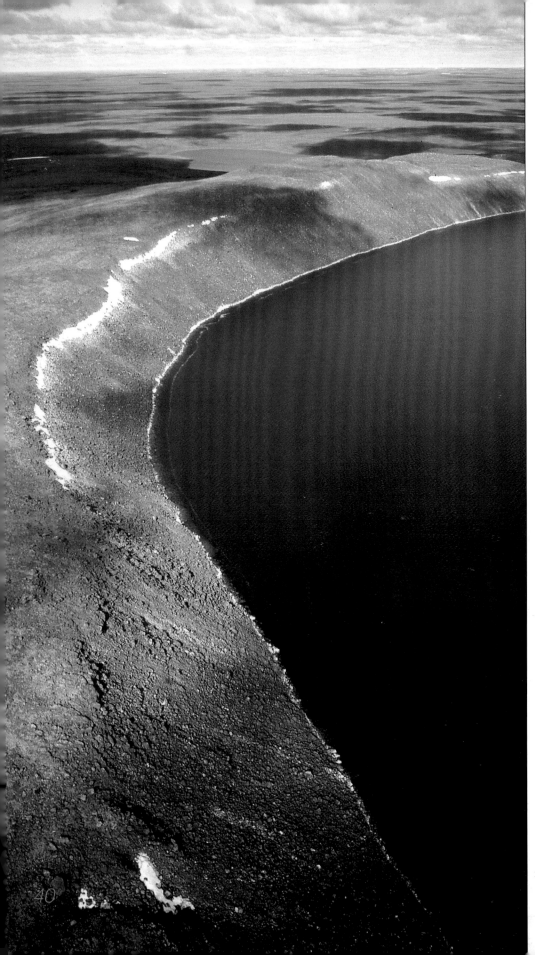

spirit *Misshepezhieu* (the Great Lynx) is shown near a canoe carrying warriors and two serpents. The Ojibwa viewed the Great Lynx as an aquatic monster that had been killed in a cave that collapsed when hit by lightning sent by Ojibwa Thunderbird protectors. This was an act of revenge for the murder of a baby near Agawa Rock. Travellers, including the voyageurs of the later fur trade, would leave offerings of tobacco in rocks as payment for a safe crossing of the lakes and as insurance for the next journey.

Even in the early 1600s, when European contact was increasing, the wild northlands were only sparsely populated by small, migratory bands of Algonkian-speaking Native trappers and hunters. Their culture had changed little over the preceding millennia. The lack of fertile soil and the few frost-free days prevented any agriculture from being carried out, so these nomadic groups clung to the Shield by trading pelts for corn, tobacco and dried meat from the sedentary, Iroquoian-speaking Huron Confederacy to the south. The Huron constructed large, palisaded settlements, each of which was home to hundreds of people. They also grew large amounts of maize, squash and fruit on the light, sandy soils of the plains, between Lake Huron and Lake Simcoe, that had once been the floor of glacial Lake Algonquin. In 1635, this Huronia District was known as the "granary of the Algonkians,"

Standing on the Nouveau Quebec crater rim one feels that the lake is but a stone's throw away. It extends 100 m out and 120 m down.

(right) The outer reaches of the islands off Parry Sound form treeless shoals which often emerge as huge whale backs. The water is so clear that the eye can trace the striated patterns well below the surface.

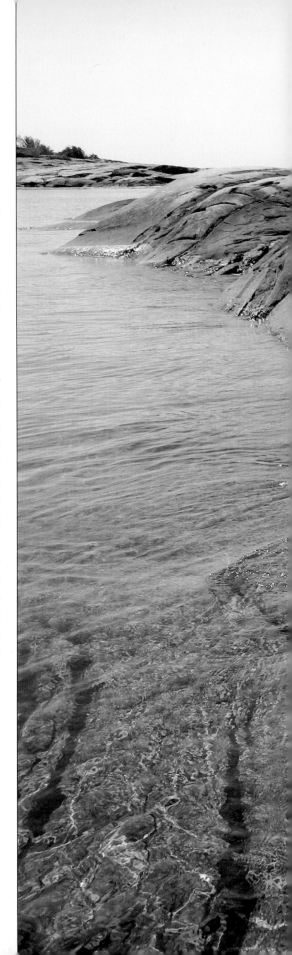

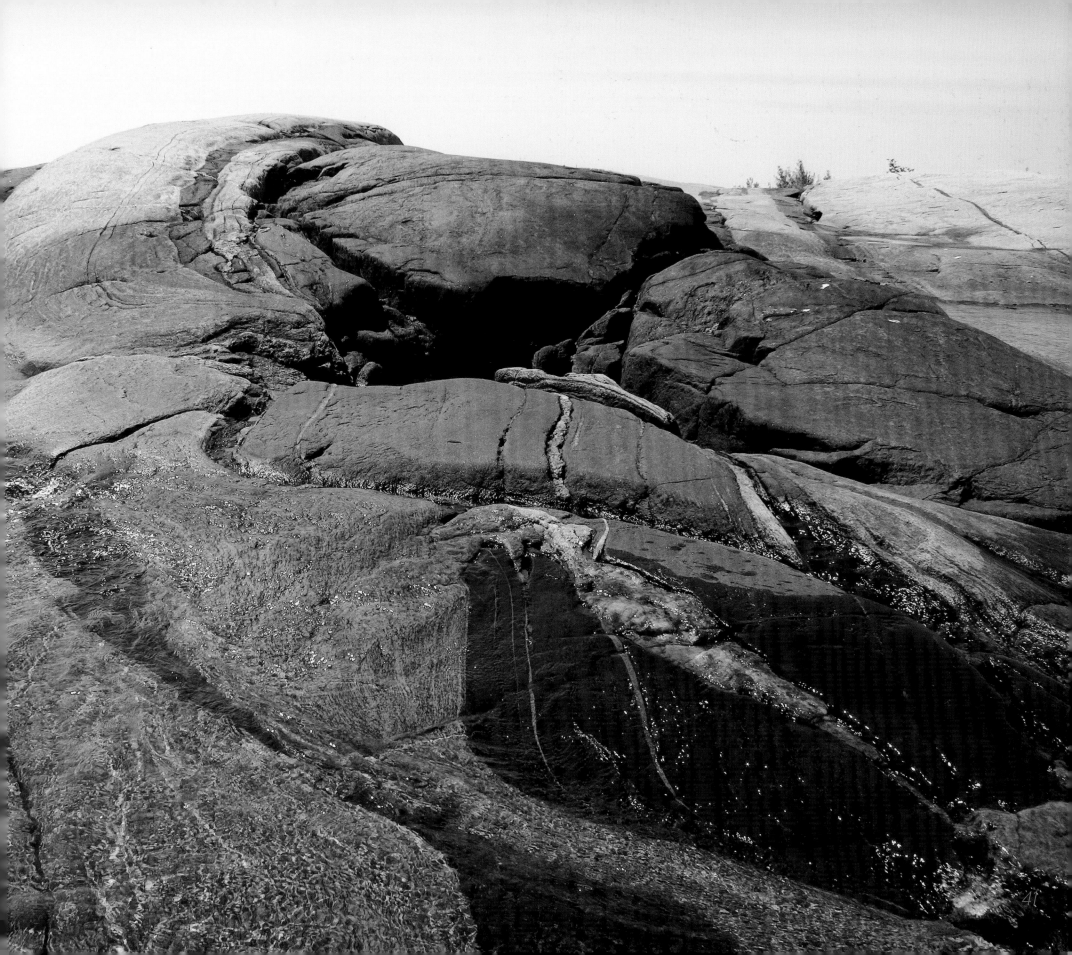

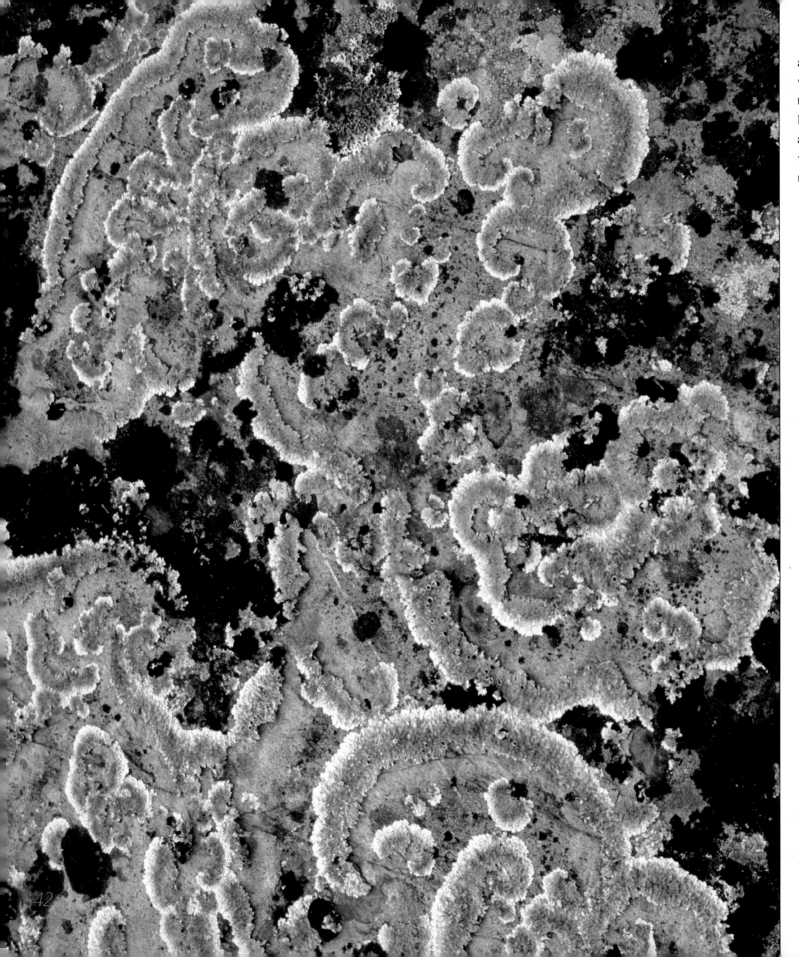

and a necessary storehouse it was, since corn was an essential commodity to hunters and trappers. It was nutritious, and because it was light in weight, it was easily moved by canoe and carried on winter snowshoe treks. Its advantages soon came to be appreciated by Europeans as well.

Like a microcosm of the Shield itself, this expanding sunburst lichen gives an impression of the lakes, rivers, rock and forest of the Slave geologic province.

(right) The Labrador coast has a history of upheavals and depressions, leaving the shore tattered and worn. This drowned coastline is a tribute to these slow repetitive titanic forces.

42

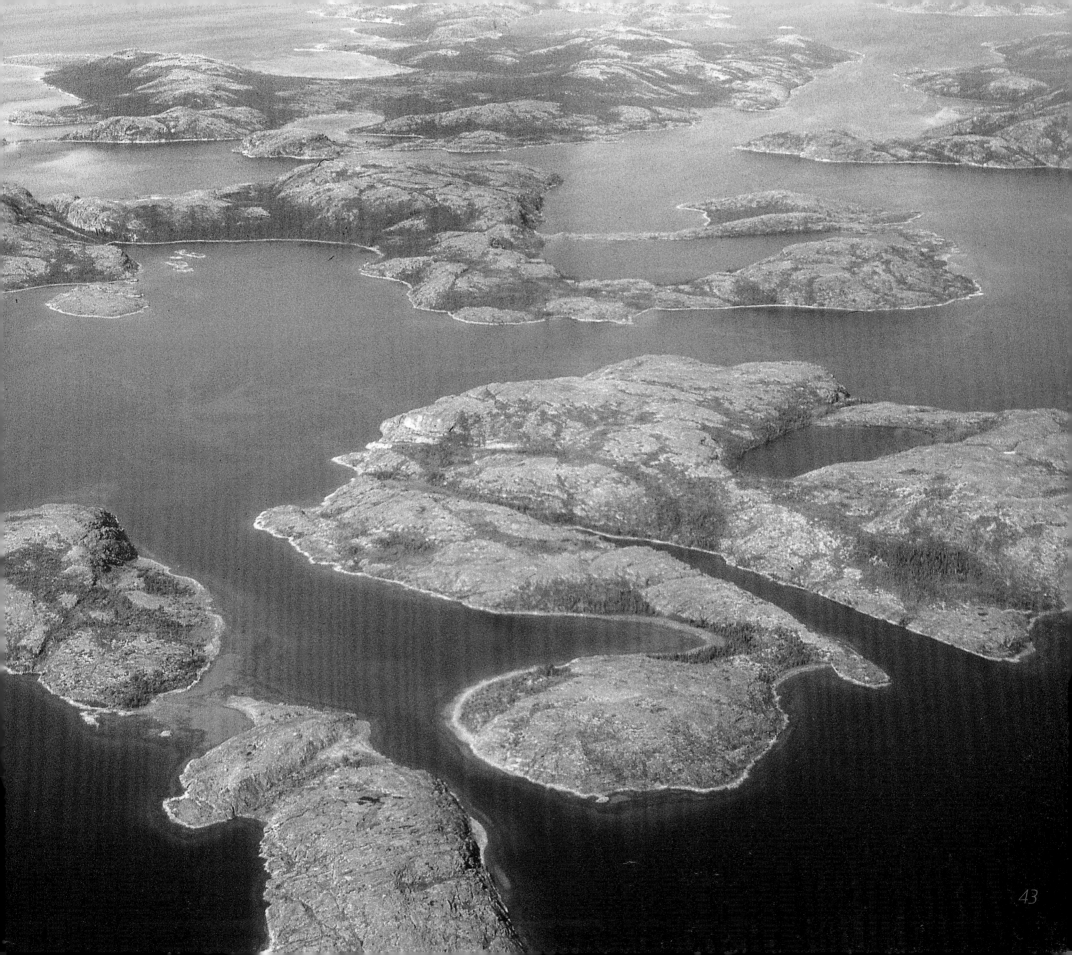

IN SEARCH OF THE BEAVER: THE ARRIVAL OF EUROPEANS

The beaver by its defencelessness, no less than by its value,
was responsible for unrolling the map of Canada.
—Morse, 1968

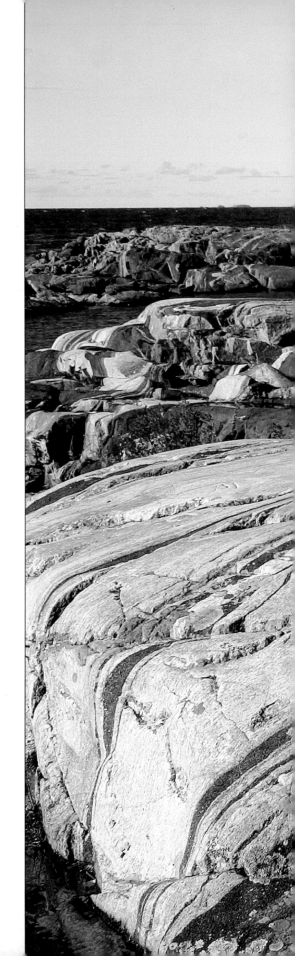

*I*n the seventeenth and eighteenth centuries, the St. Lawrence River was believed the highway to the fabled riches of Asia. Unfortunately, the rugged Shield lay in the way. Great hardships, including the ever-present threat of starvation, were endured by early explorers searching for China, and hunger and want are central themes in their writings. In his journals for 1615, Samuel de Champlain wrote warmly of the Huron near Lake Simcoe, contrasting their rich, "thickly settled" farms with the "disagreeable" region to the north, where his starving men were forced to subsist

The banded surfaces of an outer Georgian Bay island have been polished by glaciers and cleaned by waves and winter ice floes.

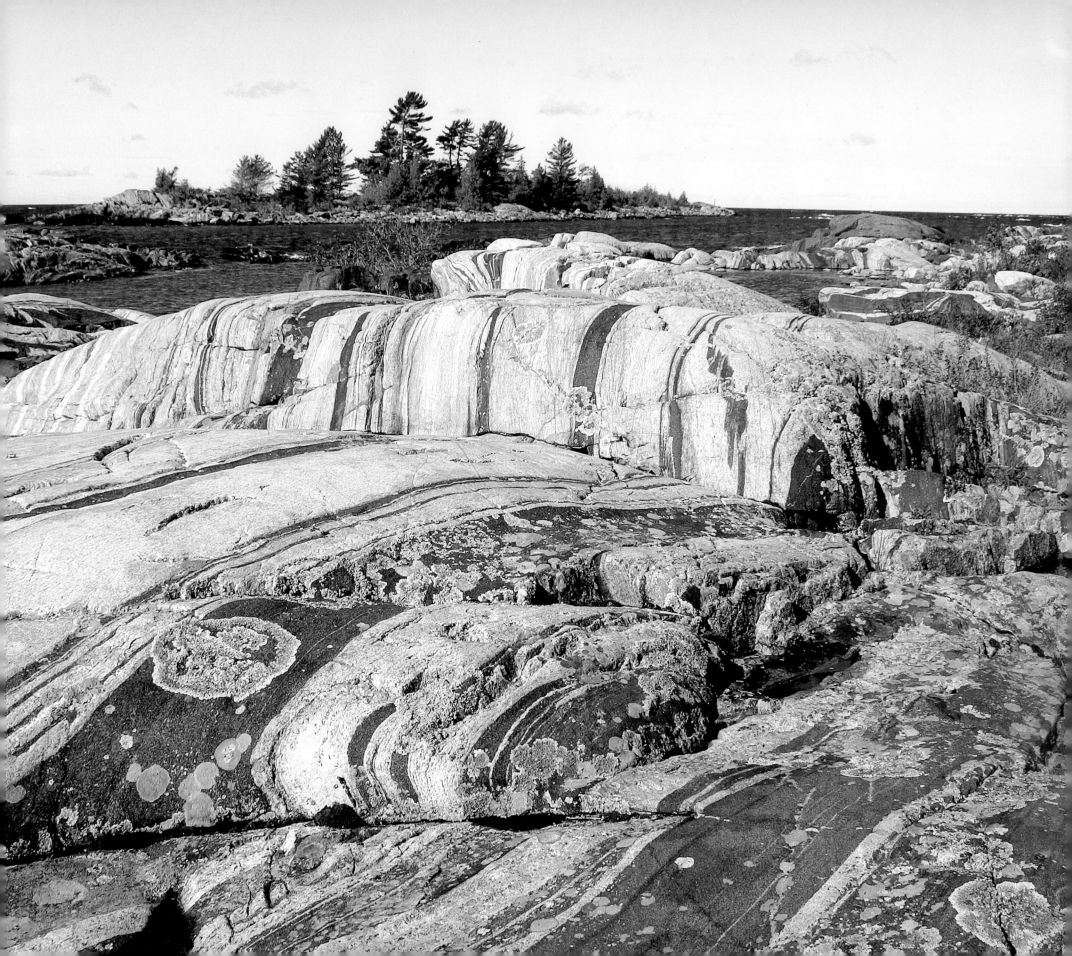

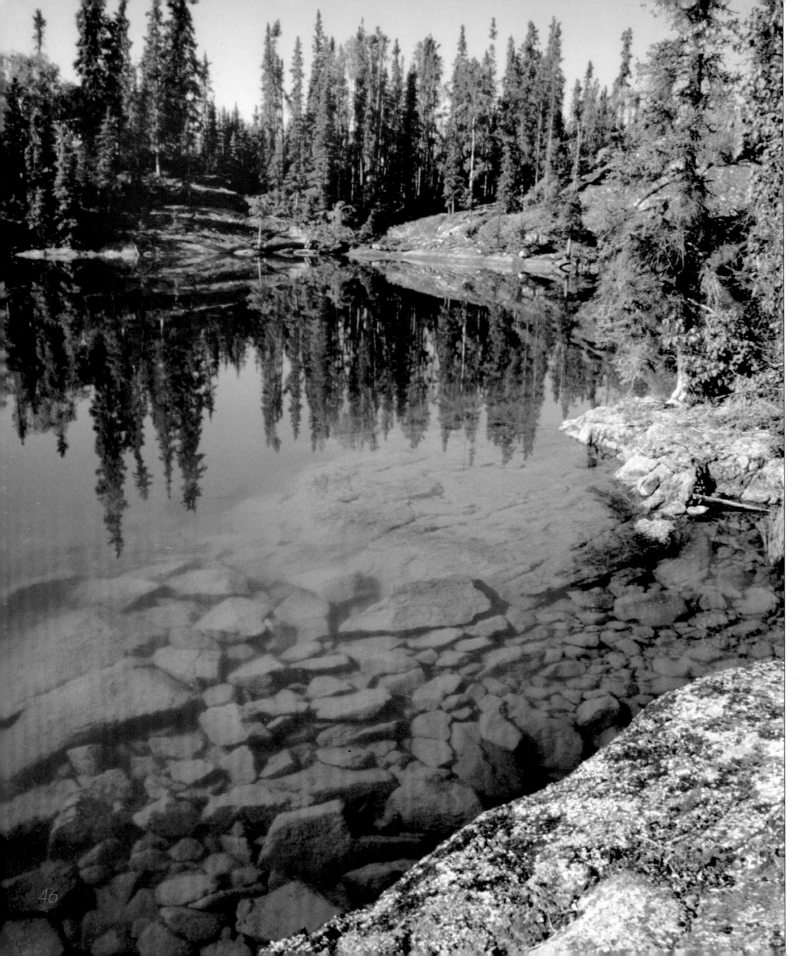

on blueberries. Champlain soon realized, however, that Huron corn, paid for with European trade goods, and then exchanged for Algonkian beaver pelts and other furs from the Shield, could become the commercial foundation of a New France based along the St. Lawrence River.

By 1648–49, the Huron Confederacy had been destroyed by disease and by the aggressive depredations of their Iroquois neighbours. Nonetheless, the demand for European goods among northern Algonkian tribes was still strong—as was the market for furs in Montreal. In 1668, the *Nonsuch* made a successful, London-financed fur-trading voyage to the Rupert River on the eastern shore of Hudson Bay. This resulted in the establishment of the Hudson's Bay Company (HBC) in 1670. The "Company of Adventurers of England Tradeing into Hudson's Bay" were given the mandate to be absolute "Lordes and Proprietors" of nearly the entire Shield (40 per cent of present-day Canada), making an "empire larger than Europe."[4] In effect, a private London club had been placed in charge of more than 10 per cent of the land area of the Northern Hemisphere.

The Shield's terrain was nearly impassable to wheeled vehicles. Peat bogs (or muskeg) were formidable obstacles (and remained so until the invention of dynamite for blasting rock and using the debris as fill). It is significant that the Ojibwa-Cree word for "bog" is *muskeg* and that

A study in azure, sky and water held together by the Shield.

(right) The Thirty Thousand Islands are pine-studded outcroppings of metamorphosed Shield rock. Champlain called Georgian Bay "La Mer Douce" and indeed this "sea" seems vast as the islands stretch for 200 km up the eastern coast and the western shore disappears beyond the horizon.

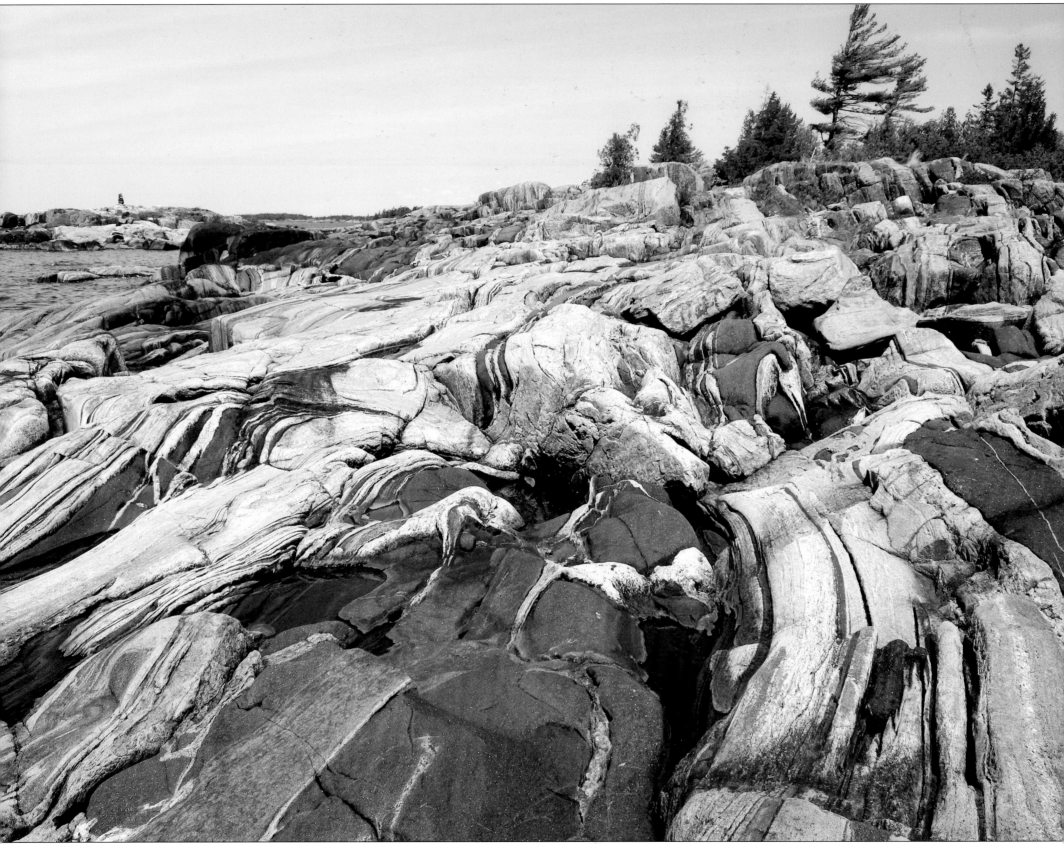

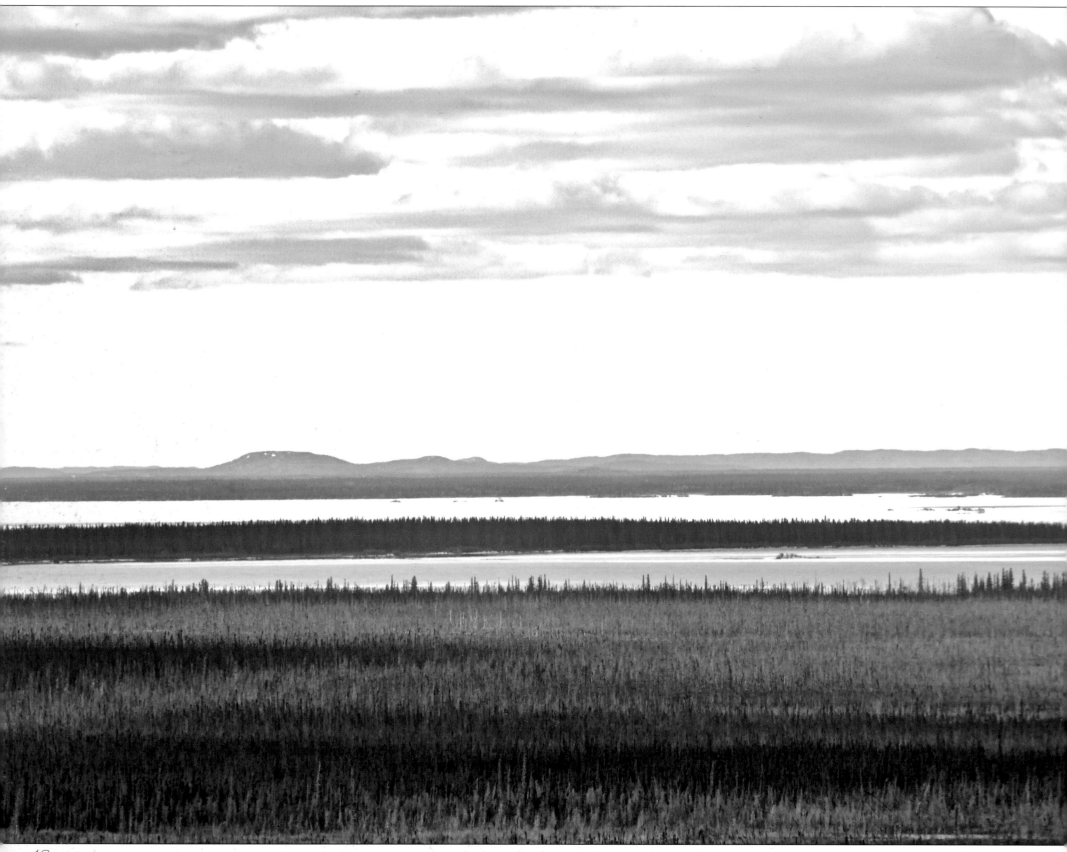

this word is derived, some say, from *muski*, the word for "bad" (hence *mishimanitou*, which means "devil"). But, miraculously, these same bogs were transformed during winter into major highways for travel by toboggan and dogs. French fur traders became the champions of the North, quickly excelling in the use of toboggans, snowshoes and birch bark canoes. Of these, canoes were key because no part of the Shield held a major barrier to river travel, especially with Lakes Athabasca, Winnipeg and Superior acting as hubs. Between the major river and lake systems were short connecting portages, which often followed game trails.

For more than two hundred years, voyageurs were the "water-road truckers" of the Canadian backwoods. In effect, the Ottawa and Mattawa Rivers and Lake Nipissing and French River became "Highway 401" from Montreal to the fur-trading areas. From the mouth of the French River on the northeast coast of Georgian Bay, a short paddle across the bay took the voyageurs to Manitoulin Island, which they crossed via a brief portage to the sheltered waters of the North Channel and from there onto the always dangerous Lake Superior. The Michipicoten River then took them north to the Arctic watershed along the north-flowing rivers that took them to Hudson Bay. Armadas of canoes would set off from Montreal in the spring when the lakes and rivers were finally free of ice. A traverse of 50 miles a day was average for a good river man, but there were important

Overlooking Behchoko, notched in the North Arm of Great Slave Lake, stretches a wide expanse of the interior Platform, the Shield's adjacent geological province.

(right) At first glance the rocks appear bare, like a granite flesh, but more often than not they are clothed in a lace of lichen.

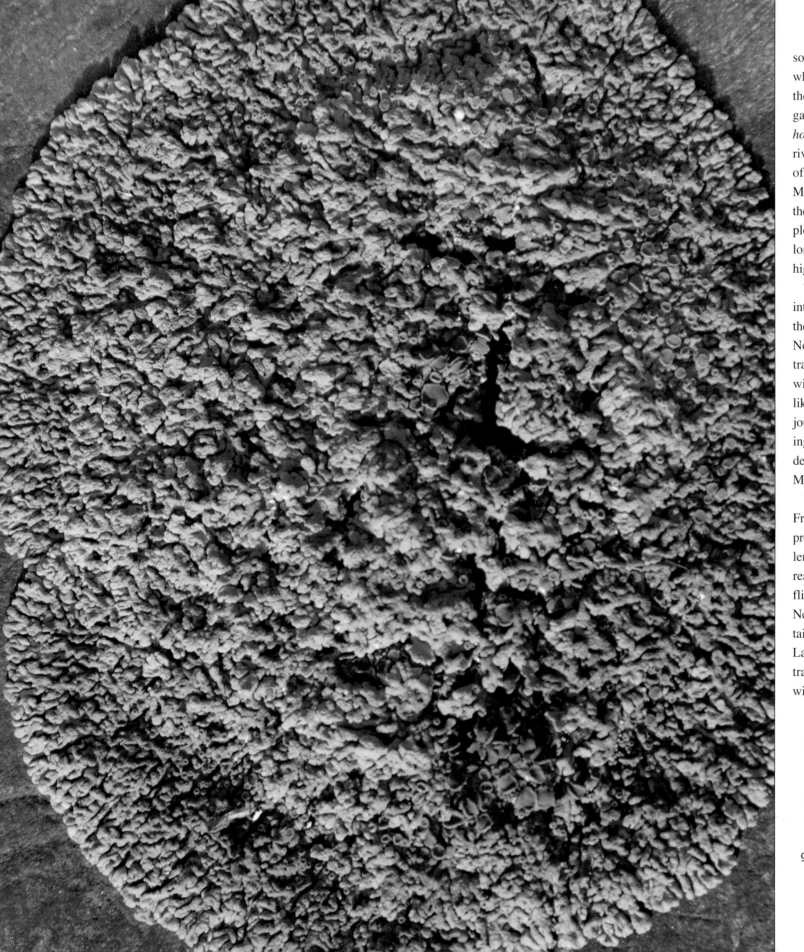

social divisions among the voyageurs. Those who moved the large freight canoes (*canots*) to the western end of Lake Superior were regarded as having an easier time of it than the *hommes du nord*, who paddled the fast-flowing rivers from there to the north and west. Some of these hardy men became ancestors of the Métis people. There are few written records of the watery heroics of the voyageurs; their exploits are quietly commemorated today by lonely plaques off the beaten tracks of major highways and roads.

The HBC slowly established toeholds in the interior in the form of trading posts built across the southern part of the Shield. The Canadian Northwest was then gradually opened up by traffic to and from these locations and by the wider-ranging explorations of HBC employees like Samuel Hearne and Peter Pond, and by the journeys of explorers working for the competing Northwest Company—among them, Pierre de La Vérendrye, David Thompson, Alexander Mackenzie and Simon Fraser.

Before 1759, when Quebec fell and New France came to an end, the inaccessible Shield protected the English fur trade. Its remote, challenging terrain meant that military action never reached the trading areas and the vicious conflicts between the colonies of New France and New England and their Native allies were contained along the St. Lawrence and Lower Great Lakes. In 1821, the HBC's control of the fur trade was tightened further by consolidation with the now nearly bankrupt Northwest Com-

Mimicking the sun, a disc of orange jewel lichen on an island in Great Slave Lake.

(right) On the western edge of the Shield, at the tip of the North Arm of Great Slave Lake, is an intriguing junction of three geological provinces — the Slave, Bear and Interior Platform.

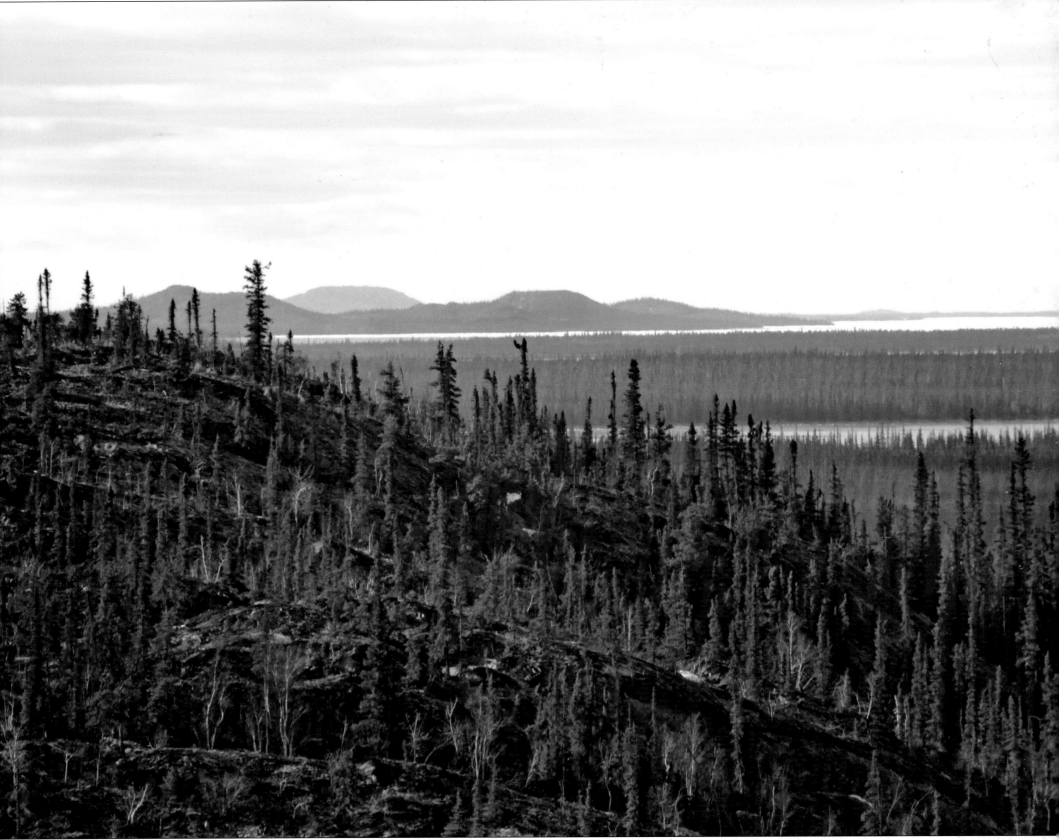

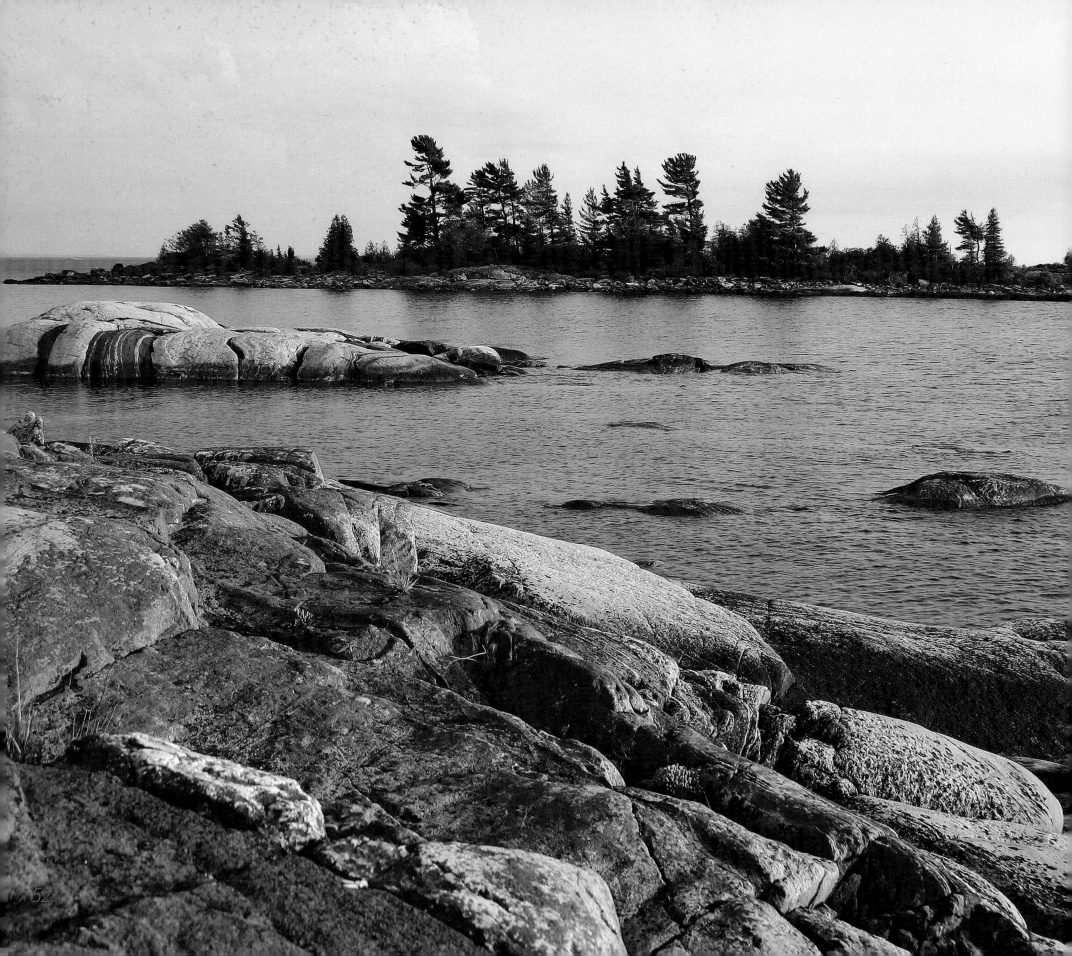

pany, and its domain was extended to the Arctic and Pacific oceans. By 1850, when the HBC's James Douglas became governor of Britain's two westernmost colonies— Vancouver Island and British Columbia—the company had become, in essence, the government of the Far West.

Surprisingly, the Shield was never portrayed as a "last frontier" in the American sense of pioneers pushing westward, facing a threatening natural environment populated by hostile inhabitants who tried to prevent settlement. Instead, it was explored under the auspices of government institutions and companies that set out a relatively orderly framework for the management of resources, principally furs. Settlements only came later. In what became a classic Canadian tradition of "firm government," the law came first to the Shield and the people much later—unlike the situation in the United States. As has been famously stated, "America was settled by men, Canada by corporations."[5] Another major difference from the American experience is that the economic development of the Canadian interior depended for its success on cooperation with Native communities, as the fur trade was entirely dependent on their technology and food. The birch bark canoe, the toboggan, snowshoes, pemmican and corn were foundations of the trade.

Orange lichen on Bartram Island create a dramatic accent to the rock contours.

(right) The North is often thought of as a cold, harsh place but it has its beauty —in the warmth of a fire lit lodge and the wonder of the Northern Lights under the Shield's auroral oval.

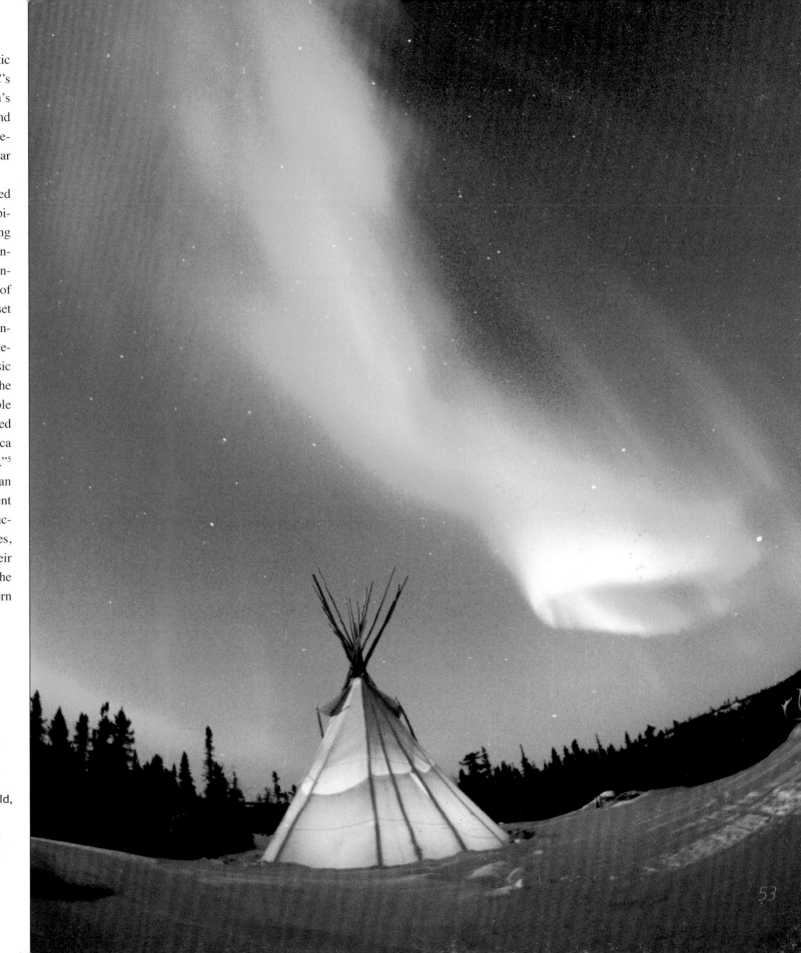

53

CHAPTER 6:
"LAST CHANCE TERRITORY"

B y 1855, Ontario (called *Canada West* at the time) was running out of farmland and economic prospects. New infusions of immigrants were desperately needed. However, the agricultural boom of the mid-nineteenth century, based on wheat and new farming technology, quickly exposed the province's weaknesses: the lack of new farmland for prospective settlers and an emerging shortage of coal for its emerging manufacturing industries. Potential immigrants were being lured elsewhere—to Britain's Pacific colonies, for instance, where gold was discovered in 1858 along the Fraser River.

After hundreds of falls with countless twists and turns, this melt water from an August snowfall finally finds its way home to the sea. In some places further out on the water, you can count over 30 such cascades. With eyes closed one can appreciate the rushing sound and realize that the storm still continues.

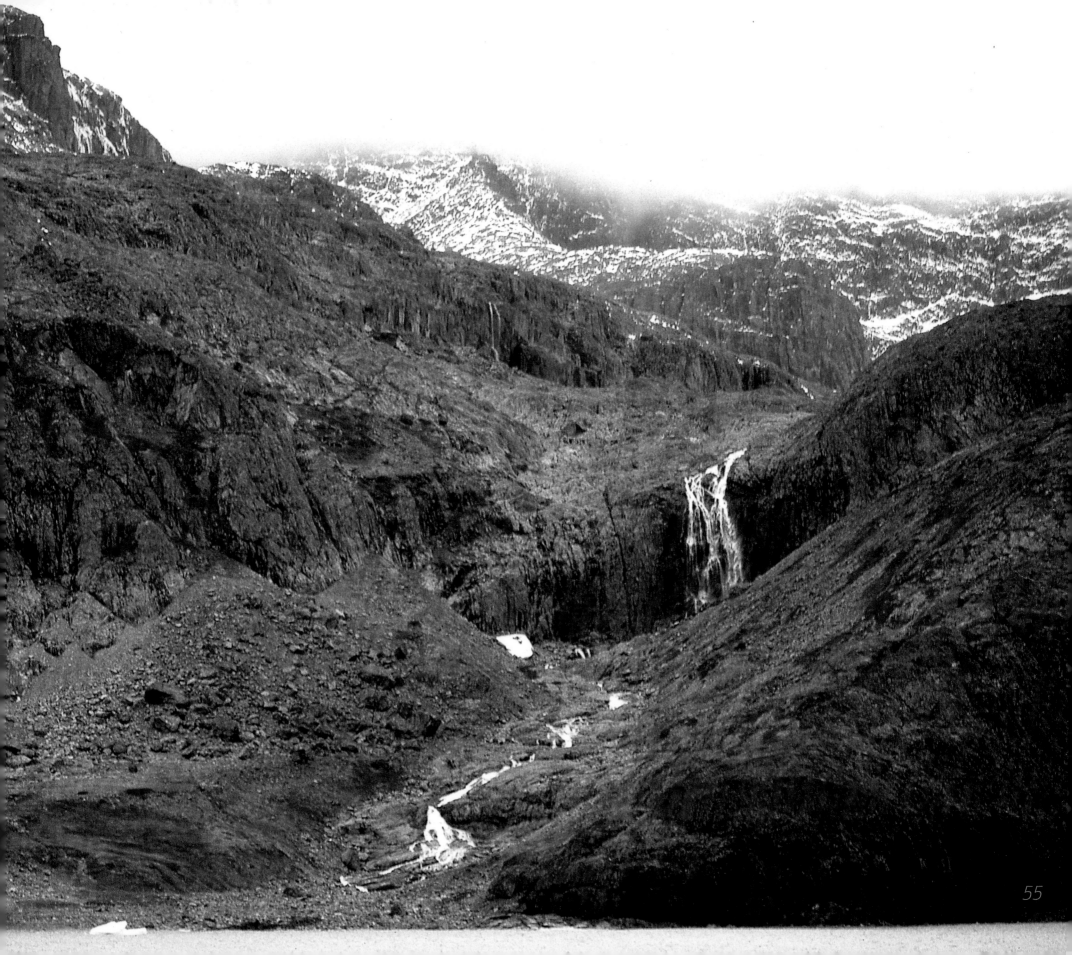

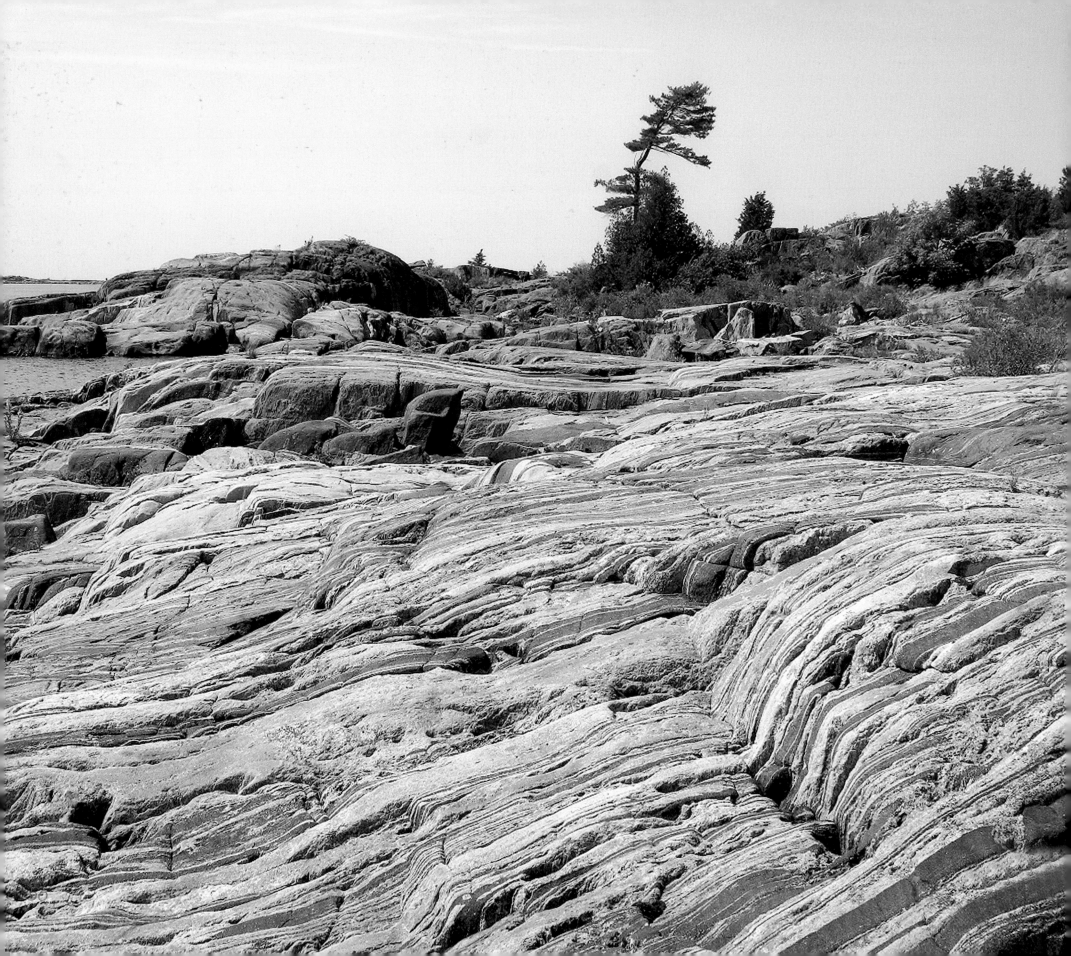

For a time, it was thought that further settlement and economic growth in central Canada could be stimulated by systematic mapping of its geology. The Geological Survey of Canada was set up in 1844 to look for mineral resources—especially coal and oil shale. The latter was successfully mined for a few short years at Craigleith on the southern shore of Georgian Bay until disastrous fires (and cheaper supplies from Petrolia) shut the industry down for good in 1863. There was no coal to be found anywhere in southern Ontario.

The pioneer phase in Ontario was largely over and the province found itself in an economic straightjacket which only the Shield could unlock. In 1869, the province passed the Free Grants Act, offering land "sight unseen" in the Huron Tract between the Ottawa River and Lake Huron. Each settler was given title to 100 acres if he cleared 12 acres in the first year and built an 18 x 20 foot log house. For a while, the Shield became known as "Last Chance Territory"—providing some glimmers of hope of owning a farm for those who had missed out on land farther south. But getting settlers to the North required the construction of up to twenty "colonization roads." Like Roman military roads radiating out from Rome, these started in the limestone plains of the South and extended into the poorly charted and so far unconquered rocky expanses of the North. Even the 1858 decision to locate Canada's capital at Ottawa, where the Shield meets the southern limestone plains, was intended, in part, to aid development of the "untamed" Laurentian country. And the new capital ("Westminster in the wilder-

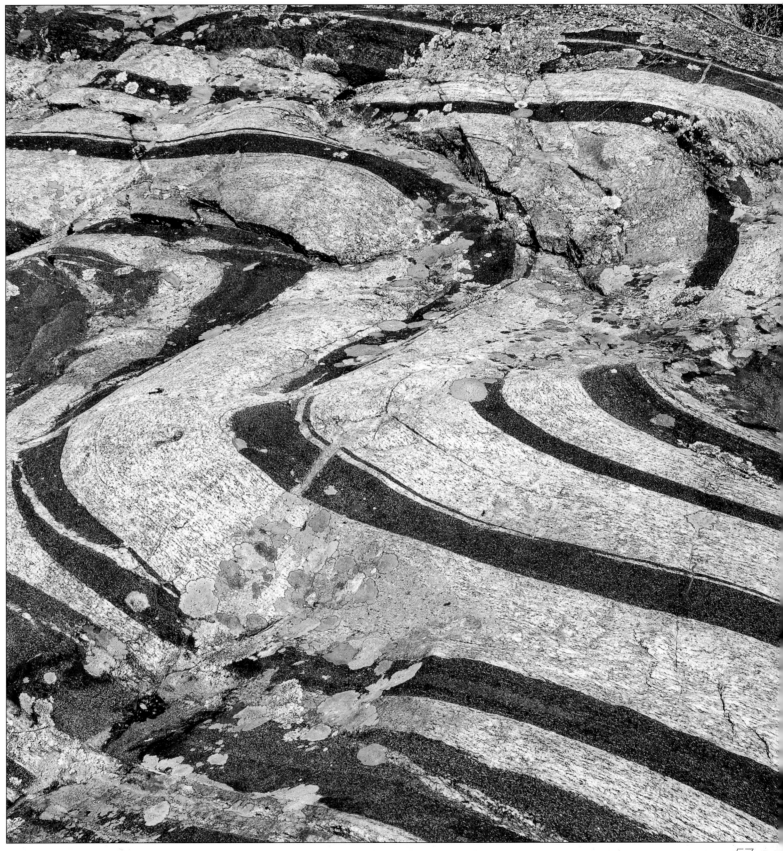

Complex banding on a windswept outer island.

(right) Black and grey lines in banded gneiss create the appearance of dancing arcs.

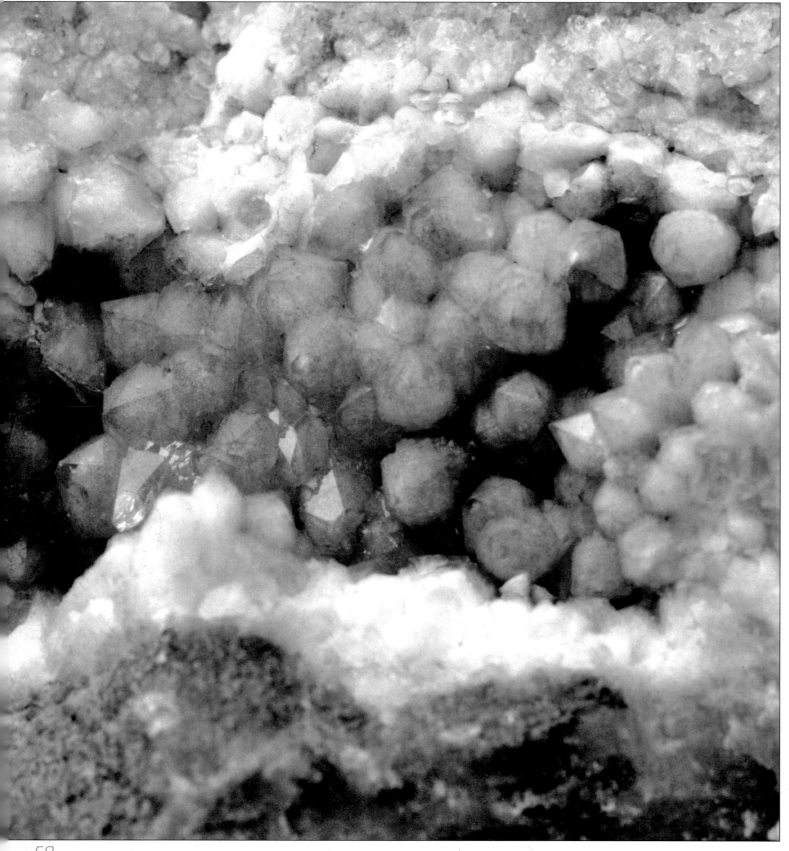

ness") became a gateway between the two regions.

Unfortunately, the Shield remained untamed.

"Away with Canada's Muddy Creeks and Canada's Fields of Pine"

The impossibility of "farming rock" became immediately apparent to newcomers who had been lured to the north along the colonization roads by overly optimistic advertising in Europe. A government report of 1856 had actually predicted that the "natural barriers presented by extensive rugged and comparatively barren tracts were such as to be insurmountable to individual enterprise."[6] This certainly proved to be the case. Letters to the home country wrote of agonizing, jolting journeys over corduroy roads; poor, shallow soils beset with boulders; a short growing season often terminated by early frosts; outbreaks of pests such as grasshoppers; and legions of biting insects. The bad news spread. Place names like Starvation Creek and Disappointment Bay tell their own poignant stories of unsuspecting, often desperate families duped by aggressive land agents extolling the virtues of free farmsteads in central Canada.

Isolated tracts of sediment left behind by glacial lakes supported small dairy and beef farms (and still do today on the Clay Plains around New Liskeard). Crops were often planted in sandy soils among tree stumps and rocks too large to remove. They were productive for a

Semi-precious gems of rose quartz crystal embedded in the rock near Great Slave Lake.

(right) When subjected to great heat and pressure deep below the Grenville Mountains, the Shield rocks oozed and flowed creating the patterns we see today.

58

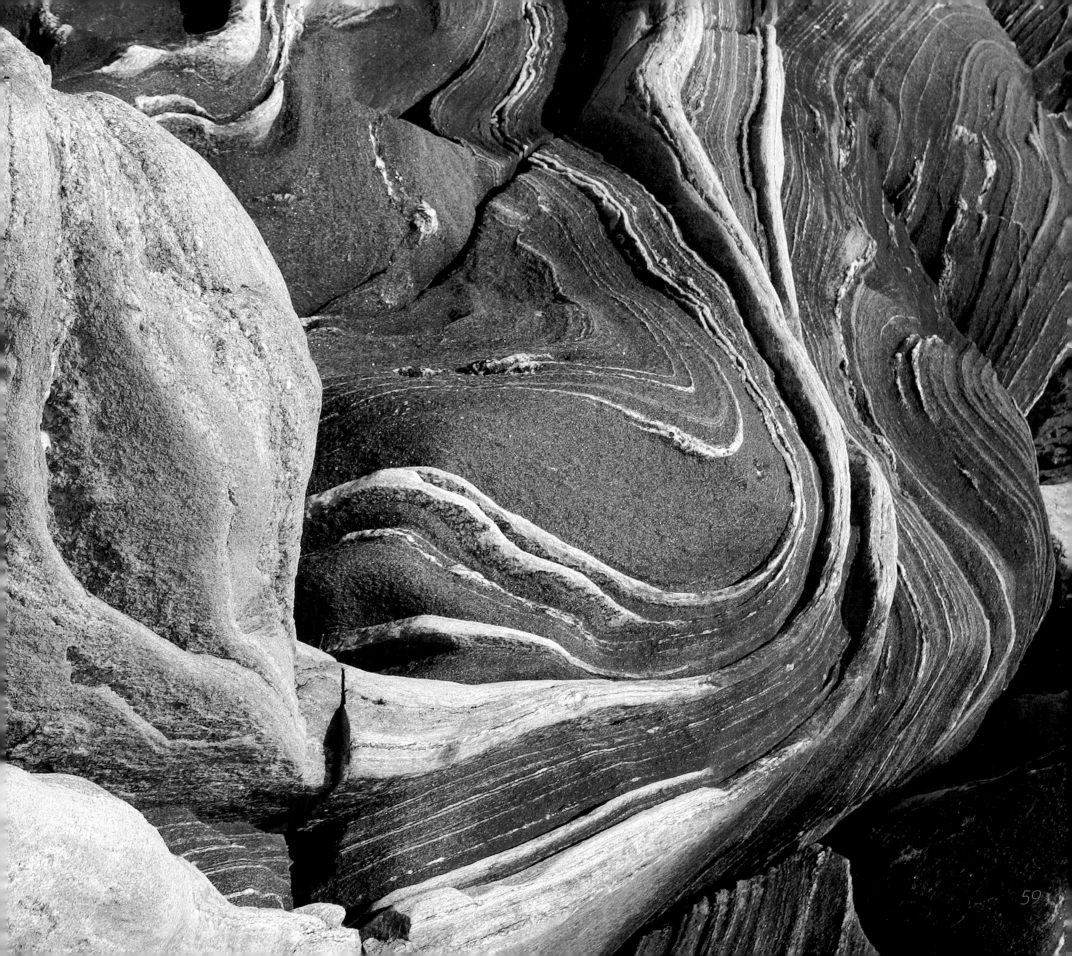

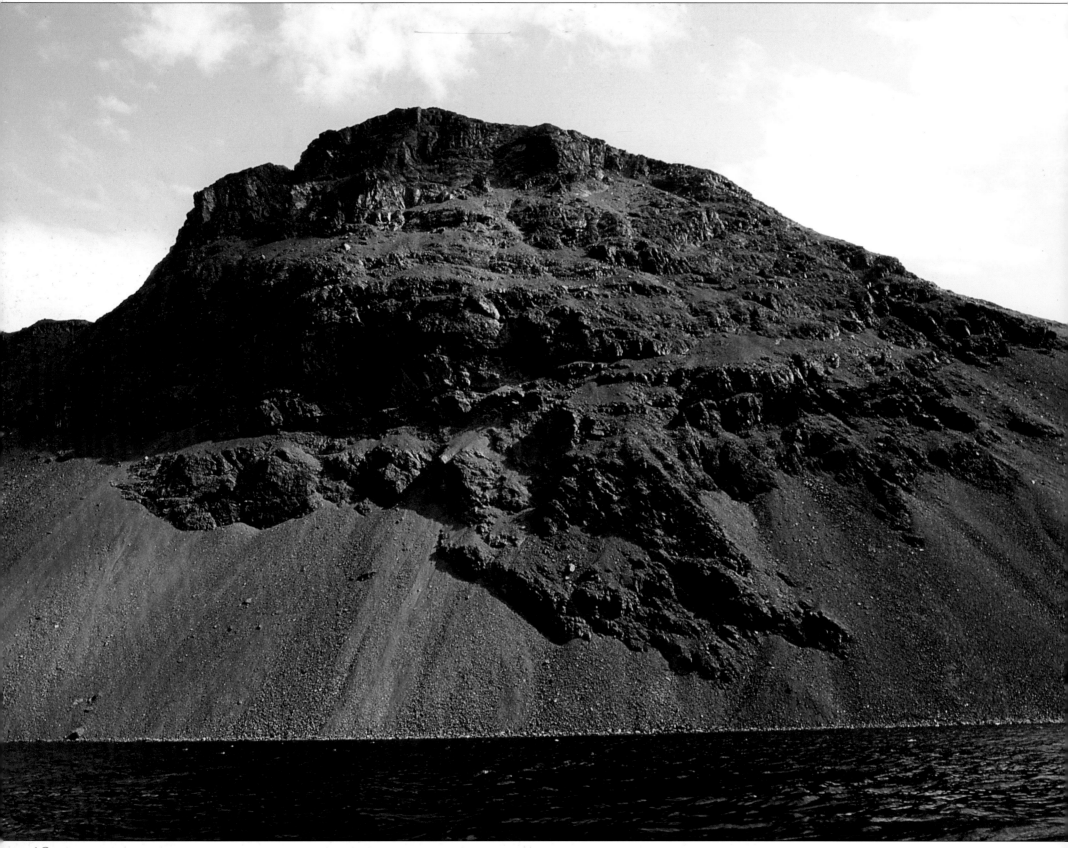

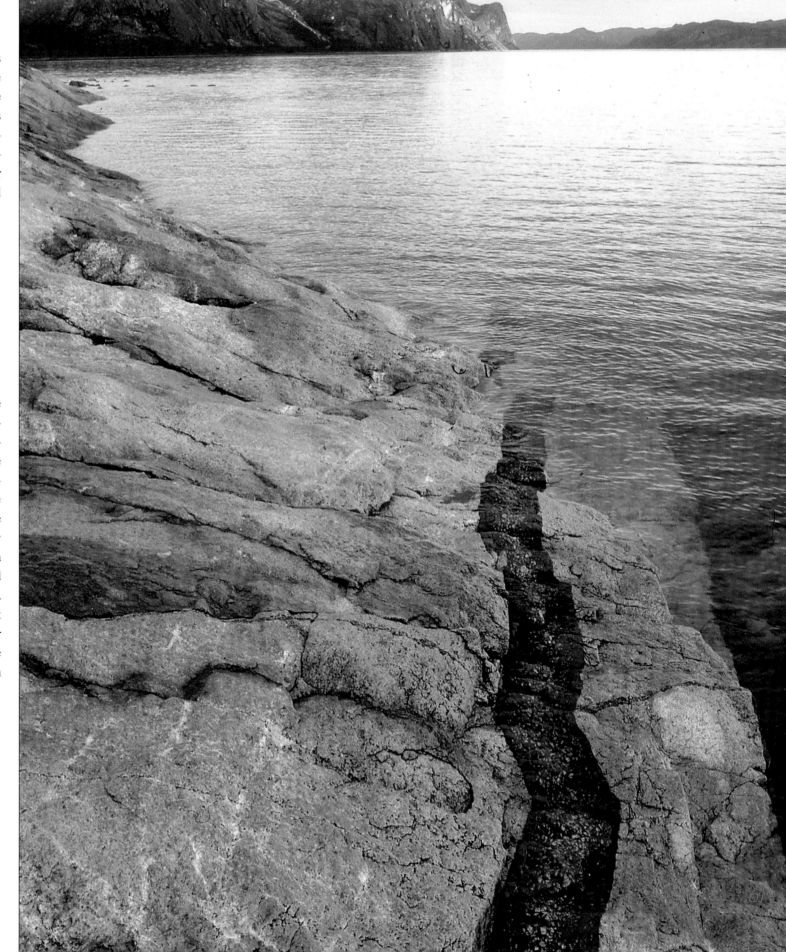

few years, raising bumper crops of turnips, oats and peas, but hopes were soon dashed as the soil's nutrients became exhausted. Marble (widespread within the Shield's rocks) was burnt to lime the cold, acidic soils, but large-scale sustainable farming was out of the question. Settlers began to turn elsewhere. Their sentiments were embodied in this traditional Canadian folk song:

"You may stay there and live,
you may stay there and die,
But as for myself, I'll no
longer remain
Starving to death on a
government claim."

For the pioneers who persevered on the Shield, the local forest provided seasonal lumber. The Shield became "Great Britain's woodyard" and the source of massive, squared pine timbers for its rapidly growing cities. The lumber companies owned all the pine, but other tree species on a settler's property belonged to the landowner. Employment in the lumber industry was part-time at best, since it was essentially a winter and spring activity. Wood was cut and then hauled by sled over roads smoothed by ice. In the early summer, after the snowmelt freshet had passed through the creeks carrying their load of logs, the lumbermen would leave the camps and shanties and return to their farms. In

One can see where this mountain is going. Weather, gravity, and time each do their part to contribute to this mountain's angle of repose.

(right) When thinking of rocks one does not usually think of fluid dynamics, but in this conspicuous dike one clearly sees the black intrusion and placement of rocks frozen within.

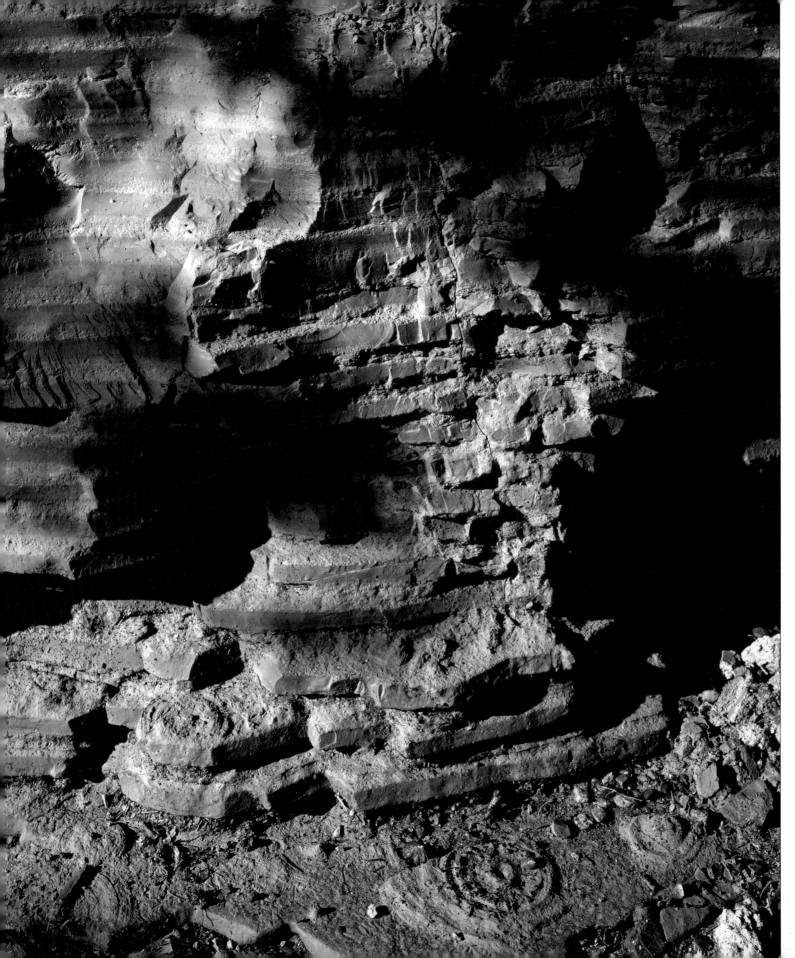

the forest, lives were often cut short by falling timbers, and for the rivermen and drivers charged with delivering thousands of logs to the mills, the threat of cold, tumbling waters and collapsing log jams were ever-present risks. Untimely death, lost love and regret are persistent themes in the lumbermen's songs.

The "slash and dash" mentality of the lumber industry served to cast further light on the harshness of the northern landscape. Huge tracts of Shield were devastated by cutting and were then swept by bush fires; the blackened wastes that remained emphasized, in the words of A.R. M. Lower, the land's "rugged and uncouth appearance." Unlike the case with agriculture, the profits did not go to the local community, leaving no long-term benefit for the people living there. "When the pine is gone the country is not far behind" was a phrase widely quoted at the time.

Newspapers took up the theme of the inherent "cruelty of sending newly arrived immigrants to worthless Free Grants Lands." Land agents ruthlessly dispersed settlers over large tracts of the Shield in order to increase the value of their own holdings. Some communities managed to struggle on until the early twentieth century, and photographs from this time period show open landscapes entirely devoid of any tree cover. Today, ghost towns, now reclaimed by bush, dot the old colonization roads that snake across current backcountry road maps, testament to a failed experiment.

One can easily imagine that with time this mound of clay will dry, harden, and become stone with maybe a few fossils thrown in.

(right) A semi-circular ridge in the landscape denotes the protrusion in the earth's crust where the Acasta Gneiss, the world's oldest rock, slowly rebounds after the retreat of the glacier.

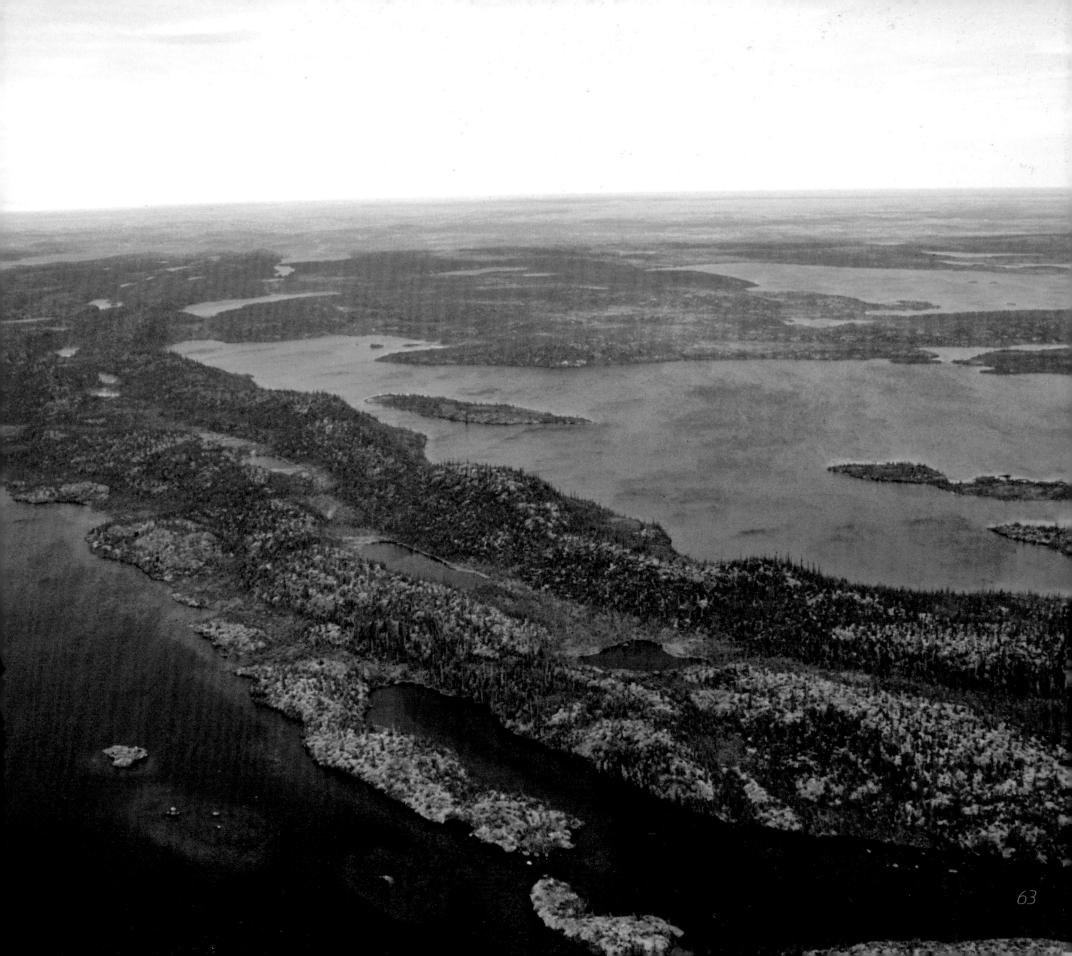

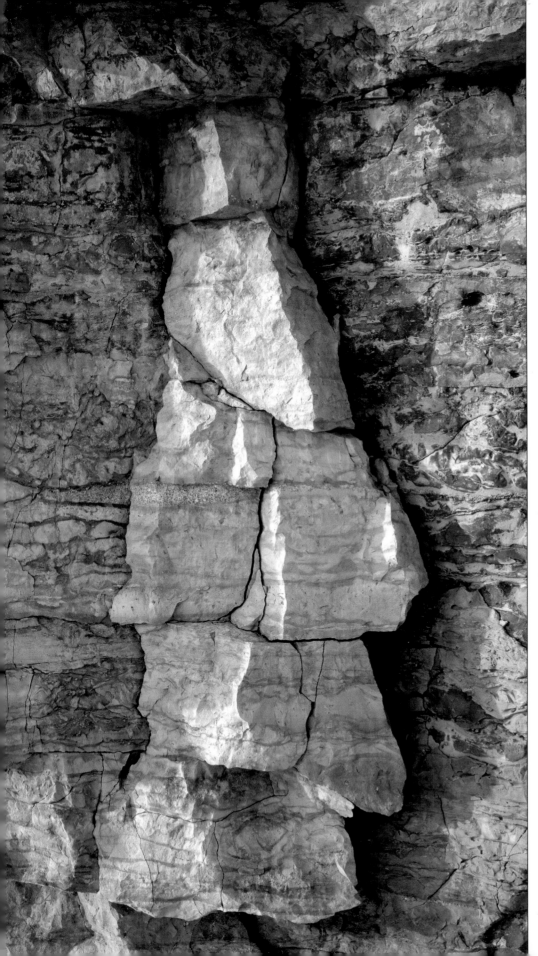

Disenchantment created by the "roads of broken dreams" set in, and "Manitoba Fever" soon took hold. As a consequence, there was a wholesale exodus of Ontario settlers from the Shield to the "Fertile Belt" (named by geologist H.Y. Hind) west of Lake Winnipeg. The journey was not an easy one. The rough terrain of the Shield was a major impediment to settlers in their "breakout to the West" just as the Appalachians had been to westward moving American settlers. In 1864, the Toronto *Globe* described the "rough and barren country which lie between us and the fertile prairies of Northwestern British America" as a roadblock to national prosperity.

"We Recognize Ourselves as Belonging to the Land"
—The Shield Becomes Canadian

The westward migration of settlers out of Ontario into lands controlled by the Hudson's Bay Company had an entirely unforeseen but fortuitous result. It set the province into direct conflict with the "injurious and demoralizing sway" of the HBC's cozy monopoly over the remaining parts of the Shield. After long negotiations, the company finally gave up its claims to a young, newly federated Canada through the Rupert's Land Act of 1869. On December 1st 1869, the huge tract of HBC land became part of Canada.

Ironically, the tight control of the Hudson's Bay Company had kept a large part of North America in the British sphere of influence in the face of repeated American threats. Without the HBC, it is unlikely that there would ever have been a "Canadian" Shield. Indirectly, the fur-trading monopoly sowed the seeds of an emerging national consciousness. In 1897, this description of Canada appeared in the *Nation* newspaper: "Here we are, rooted to the soil, clinging to it by the very fibres of our being. Should we not have, then, a different feeling towards this land from any that we cherish from others? We recognize ourselves as belonging to the land . . . and borrowing from it a name and a position in the world."[7] This was one of the first inklings of a distinct Canadian identity rooted in its own particular northern landscape.

Nonetheless, the Shield still remained large and unloved, its wild and rocky expanse viewed despairingly by those who saw prosperity only in fields of waving wheat. In the United States, the Appalachian barrier to the West had finally been broken by the construction of the Erie Canal, which ran from the Hudson River to Buffalo on the shore of Lake Erie. The Canadian roadblock represented by the Shield was to be eventually overcome, not by water, but by steel. A transcontinental railroad would move immigrants west and transport their produce back to central Canada and the Atlantic seaboard.

Lake Temiskaming shore is a warehouse of fossils, remains of ancient creatures that once lived on an ocean bottom. Stone such as this can be easily broken and scratched, revealing the fossils within.

(right) The banded gneiss has eroded to create a sculpted surface covered with orange lichen. One can walk for miles on ribbons of outer shoals west of Sandy Island.

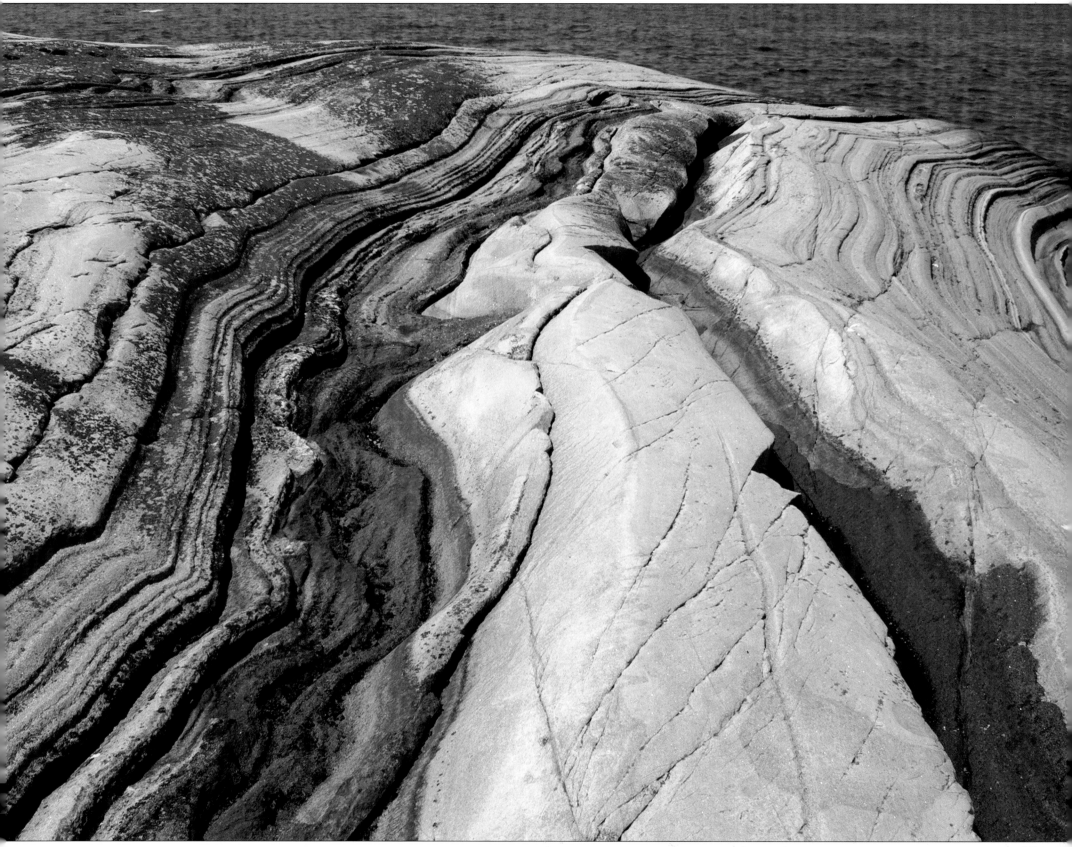

CROSSED BY STEEL, MADE OF GOLD

And they built the mines, the mills and the factories
for the good of us all.
—Gordon Lightfoot, "Canadian Railroad Trilogy"

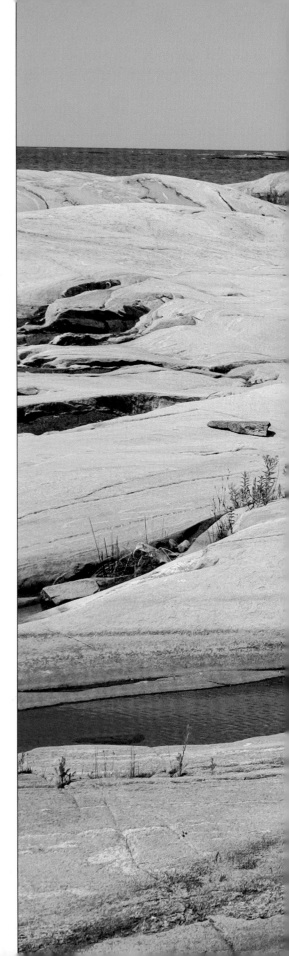

The completion of the Canadian Pacific Railway across the Shield in 1885 finally broke the physical and psychological barriers represented by the northern wilderness. The herculean task of construction, its tragedies and hardships, have been described in many other tomes, but one surveyor's description symbolizes this epic feat of engineering and back-breaking, sometimes life-threatening work. The Canadian Pacific surveyor J.H. Rowan wrote: "The greater part of the country explored was of the most barren and rugged descrip-

Near the outer entrance to Parry Sound, numerous long fingers of treeless rock stretch into the Bay. Their surfaces reveal the complex patterns and colours of highly metamorphosed rocks.

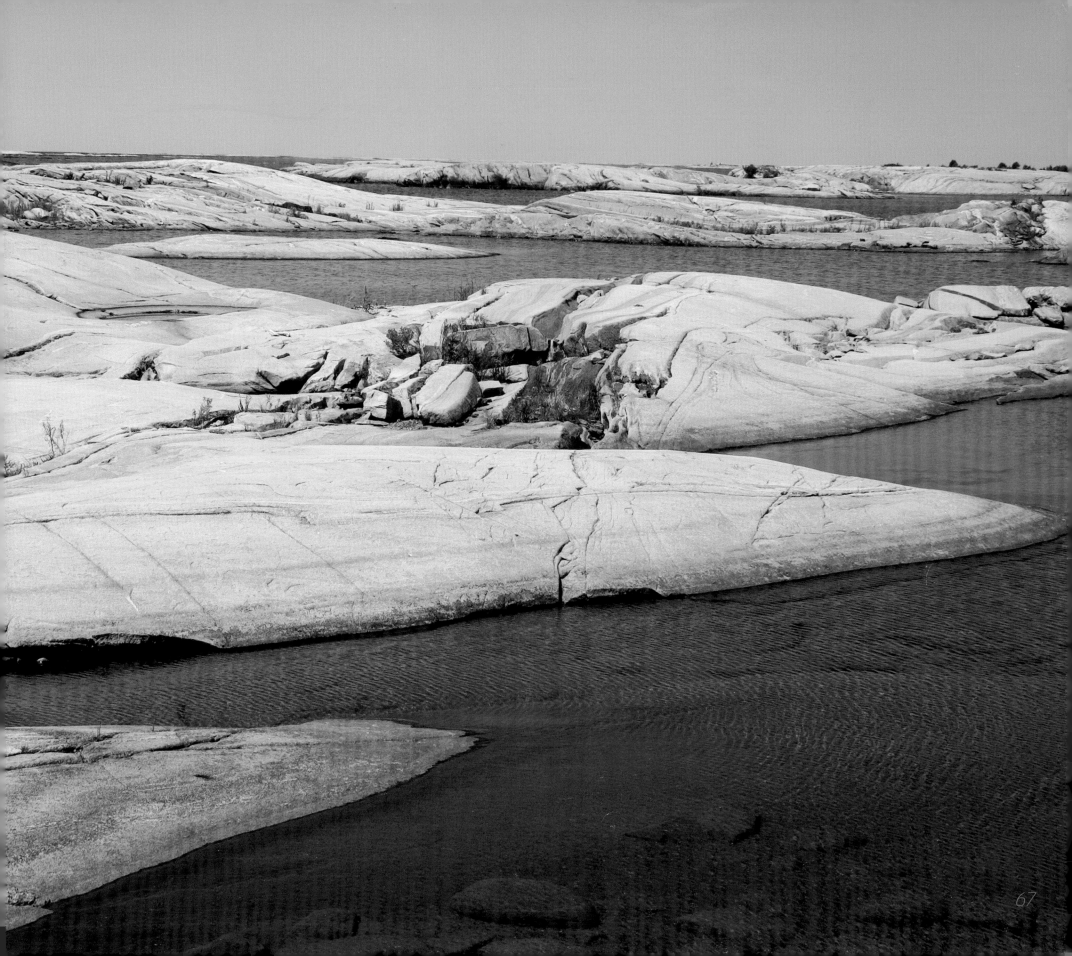

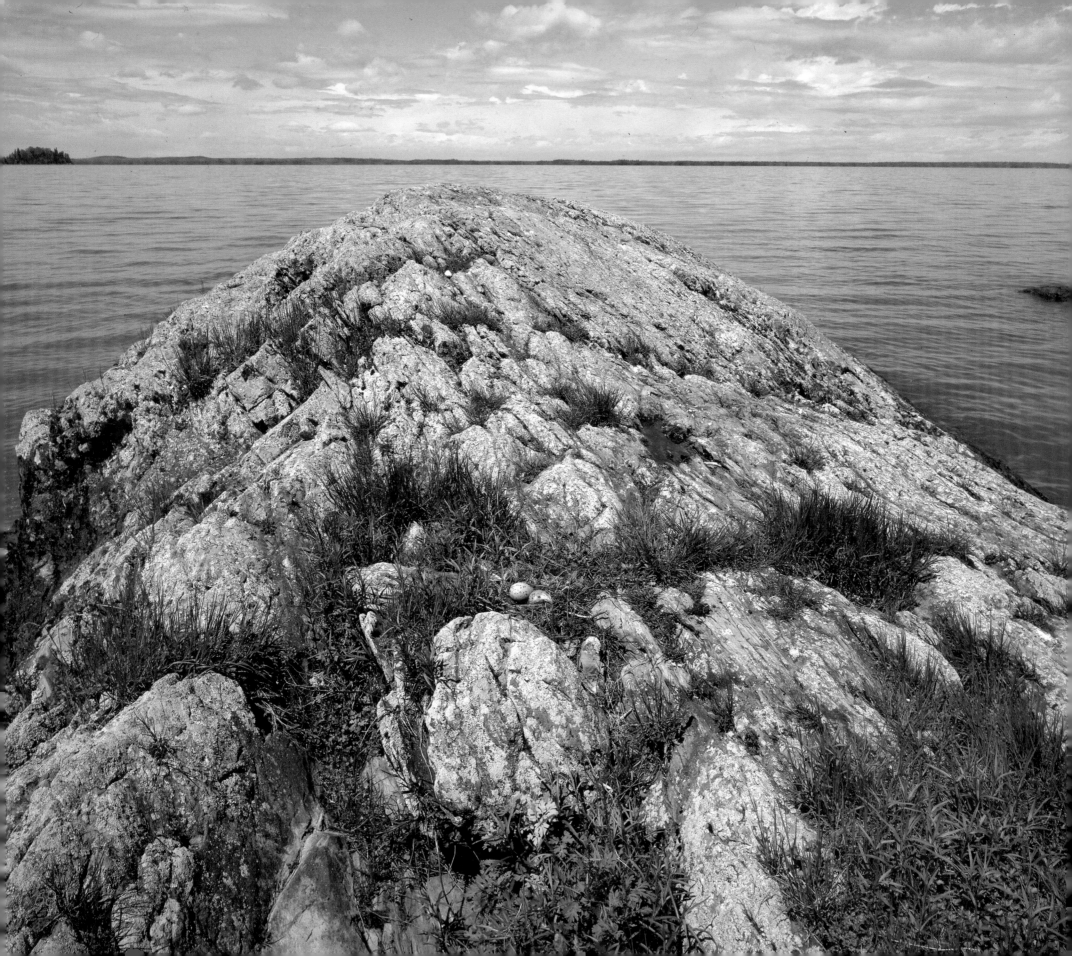

tion, traversed by high ranges of hills of primitive rock from which every vestige of vegetation had been removed by fire." During the actual building, rock cuts were made by blasting, and the shattered rock was used to fill muskeg that swallowed up entire locomotives. One mile in particular was said to have cost $700,000. Unfortunately, having been built at vast expense to connect west and east, the Shield brought in no commercial gain for the CPR. But this situation changed rapidly in the early years of the twentieth century as the geology along the route and its potential mineral wealth became more widely known. These developments grew out of several key events that had occurred about half a century earlier.

In 1844, the Geological Survey of Canada was formed under the directorship of Sir William Logan. Born in Montreal, Logan had worked in Britain as a self-styled "practical coal miner of education." He was charged with finding new mineral deposits, especially coal in Ontario. In 1847, the Montreal Mining Company was formed, an ambitious, vigorously led enterprise, which aimed to explore the mineral deposits on the north shore of Lake Superior. These were known to include copper, which was then being eagerly sought by an expanding telegraph industry. It wasn't the first mining venture on the Shield, but it represented the leading edge of a movement to drive out the HBC and prompted talk of a railway to the Pacific and a canal at Sault Ste. Marie.

Then, in the spring of 1851, an extensive collection of Canadian minerals was put on display for the entire world to see in the Great Exhibition in London, England. Canada's exhibit was on the main floor and garnered rave reviews at home and abroad. In 1855, the *Times* of London (the authoritative voice of the Empire) saw evidence of the "first stages of progress" of an infant country hewing out "wealth and independence . . . from primeval wilds."[8] Confidence was raised, and foreign investment flowed into Canada.

For a brief spell, the Shield enjoyed world fame as preserving the first spark of animal life on Earth. In 1858, from rocks thought to be entirely crystalline and devoid of life, the Geological Survey of Canada and Sir John Dawson reported the discovery of a fossil in Precambrian rocks near Ottawa. This was interpreted as the remains of a primitive, single-celled organism (called a *foraminifera*), which they named *Eozoon Canadense* (the "dawn animal of Canada"). This discovery was eagerly described by Dawson in many scientific papers during his subsequent career and even promoted by Charles Darwin in later editions of his *Origin of Species* as proof of life's great antiquity. Alas, it was a false dawn. The specimens turned out to be a curiously formed example of the common metamorphic mineral serpentinite. Regardless, Canada and its Shield had been showcased to a world audience. Ironically, about a hundred years later, well-preserved specimens of early bacteria some 1.8 billion years old (then the world's oldest known bacteria) were found in the Gunflint Formation in northern Ontario. Today, fossil bacteria as ancient as 3.5 billion years old can be found in Western Australia.

Lake Abitibi, with nearly 1,000 square kilometres of water, has 989 islands. Many are outcrops, such as this, a nesting site for terns, gulls, herons, and cormorants.

(right) With Hudson Strait in the distance, the form and barreness of the land gives us a feeling that nothing has happened since the glaciers melted.

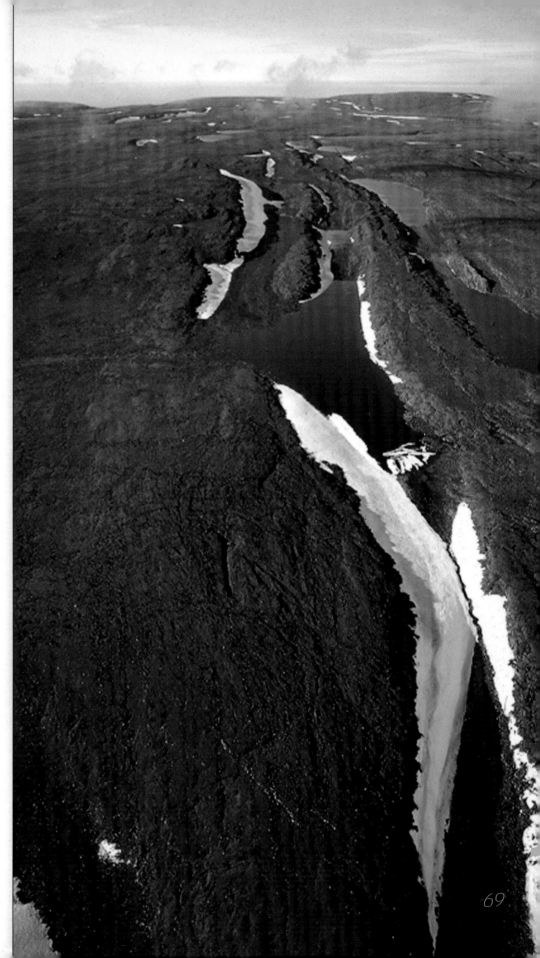

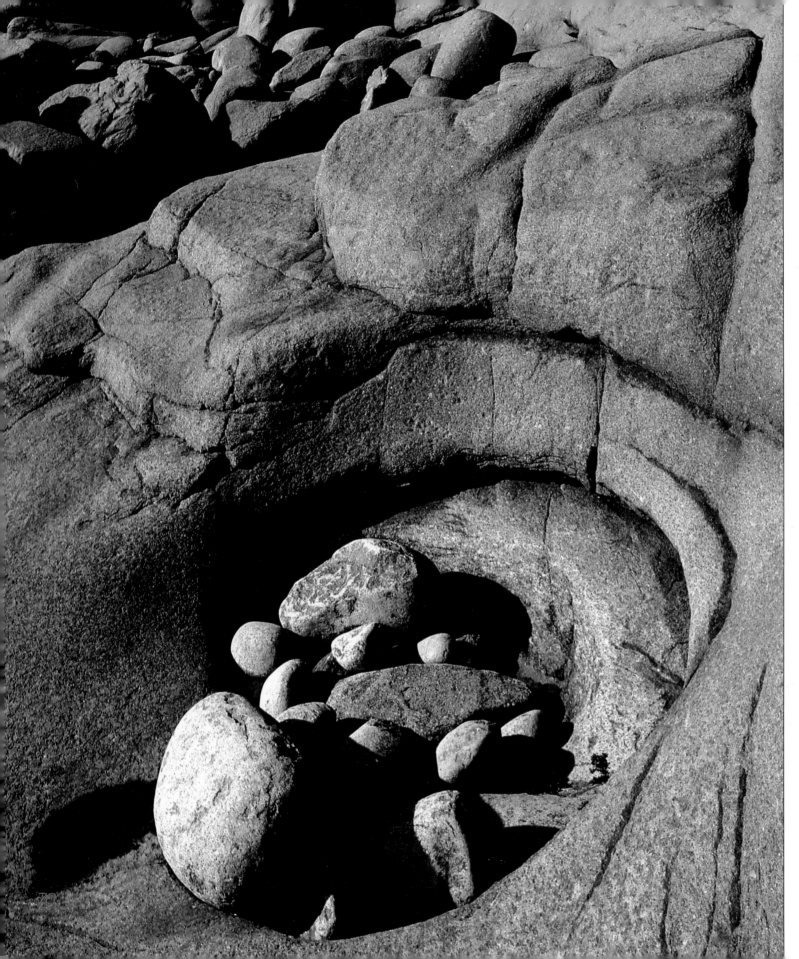

Inadvertently, the first geological survey of the Shield was completed by railway workers. As the transcontinental railway was being built, rich mineral deposits were revealed in excavations along its route. In contrast, the Geological Survey's mapping was a detailed and painstakingly slow process: geologists were few, the country was large and much of it unknown, the summers were short, the rocks varied and the terrain rough. In fact, Canada was not entirely mapped until the 1970s, when helicopters were used to help finish the job. The most famous deposit found during the construction of the CPR was a collection of rich, copper-nickel ores discovered at Sudbury in 1883. First regarded as an impurity, nickel was later used to harden the steel skins of battleships and in munitions during the buildup to the First World War.

Other major railroad discoveries soon followed. In 1903, when the Timiskaming and Northern Ontario Railway (now Ontario Northland) was being built to access the agricultural "Little Clay Plain" around New Liskeard, silver deposits were found in veins as thick as wood planks at Cobalt. The railway reached Cochrane in 1908 and Moosonee in 1932, and meanwhile, Cobalt became the silver capital of the world, creating a cadre of mining professionals and attracting investment for further ventures.

During the early years of the twentieth century, mineral exploration across the Shield became a professional, scientific endeavour, supported by university geology departments and newly created provincial geological sur-

Swirling rocks and water give this bedrock what present-day Inuit call a toilet bowl effect.

(right) The red to pink granite of the Killarney Pluton contrasts with white quartzite of the La Cloche Mountains across Killarney Bay.

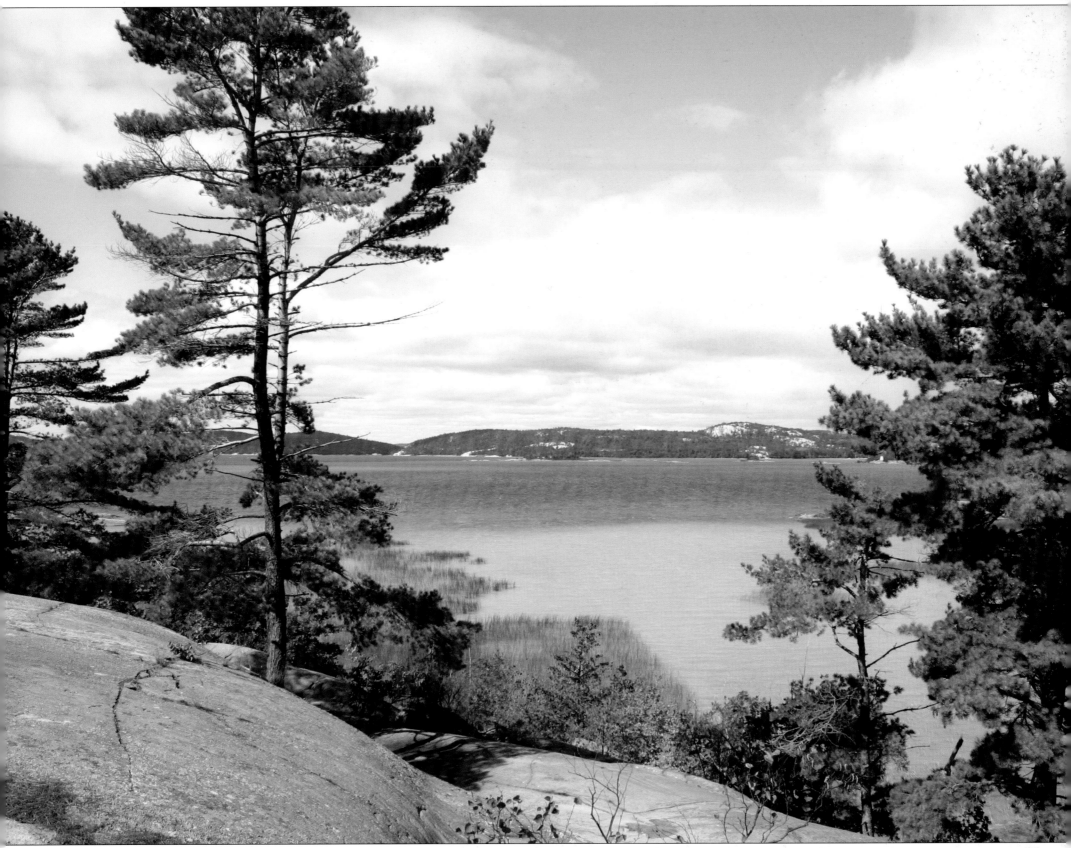

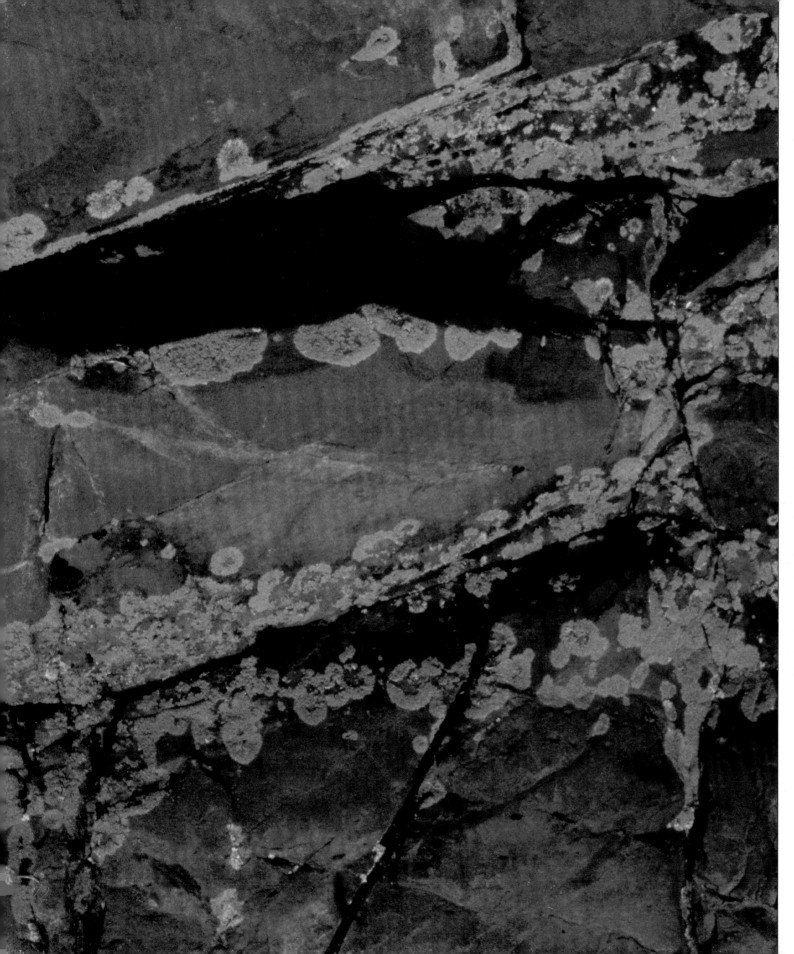

veys. Enormous gold deposits were found successively at Kirkland Lake and Timmins, and by 1904, the Shield had become the biggest mineral producer in the country, overtaking British Columbia. National mineral output multiplied an astonishing 160 times between 1886 and 1912. The Porcupine gold camp at Timmins was Ontario's leading producer. Production peaked there in 1941, and by 1969, its total yield was second only to the Witwatersrand mines of South Africa. One mine, the Hollinger (1909–1968), staked by Benny Hollinger in 1909, is still regarded as one of the most prolific producers in North America. During the first two decades of the twentieth century, Canada attracted 5 million immigrants. Government policy gave preference to farm workers to settle the still empty West, but many were drawn to lucrative jobs in northern railway camps and mines.

But not everything was rosy. As had happened in the 1870s, immigrants were enticed north on false pretexts by a government still afraid of running out of farmland (and thus settlers). In the early years of the twentieth century, the government of Ontario aggressively promoted the availability of new farms in the clay belts of the North. These were the old floors of the enormous glacial lakes that had formed during the melt of the last ice sheet. The "Little Clay Plain," north of Lake Timiskaming near New Liskeard, was the floor of glacial Lake Barlow. The "Great Clay Plain" to the north and west in the Cochrane District near

Bright orange jewel lichen explodes across dark greenstone, a reminder of its volcanic origins perhaps, but more likely due to the high nitrogen content of the whitewash of perching birds.

(right) Anchored in Nain Bay, Labrador is a rock appropriately called Pikaluyak, meaning ... you guessed it ... nipple.

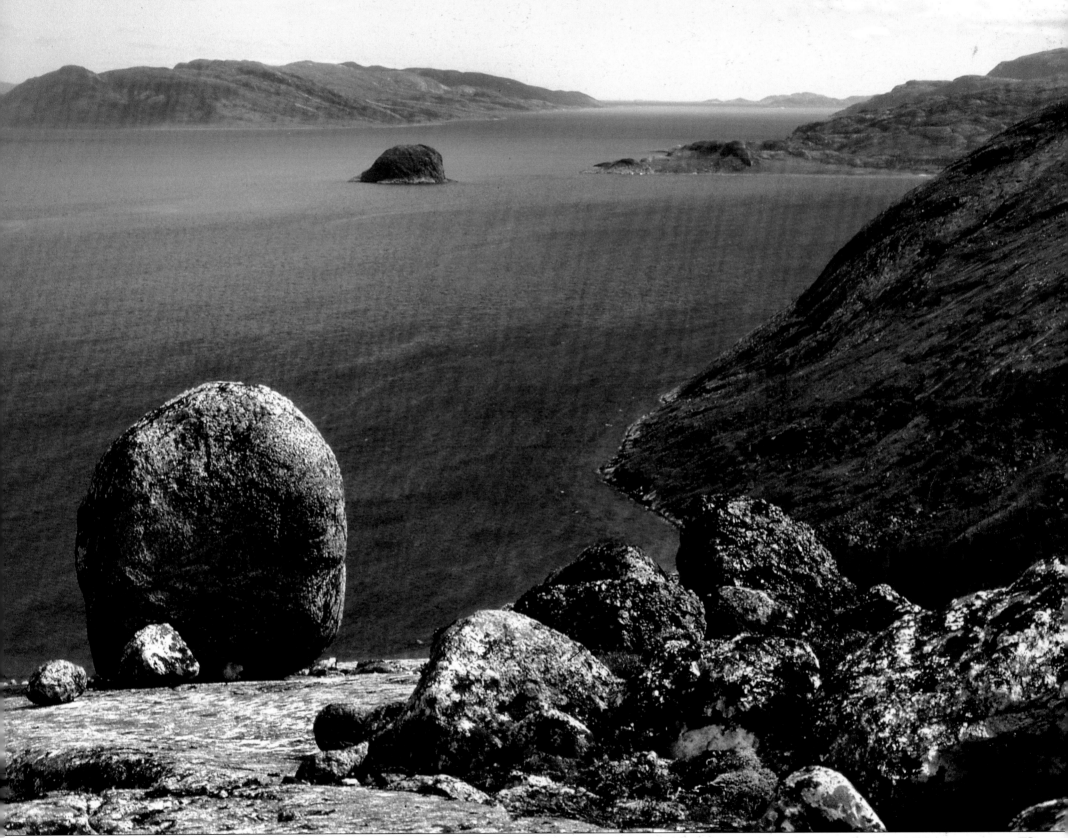

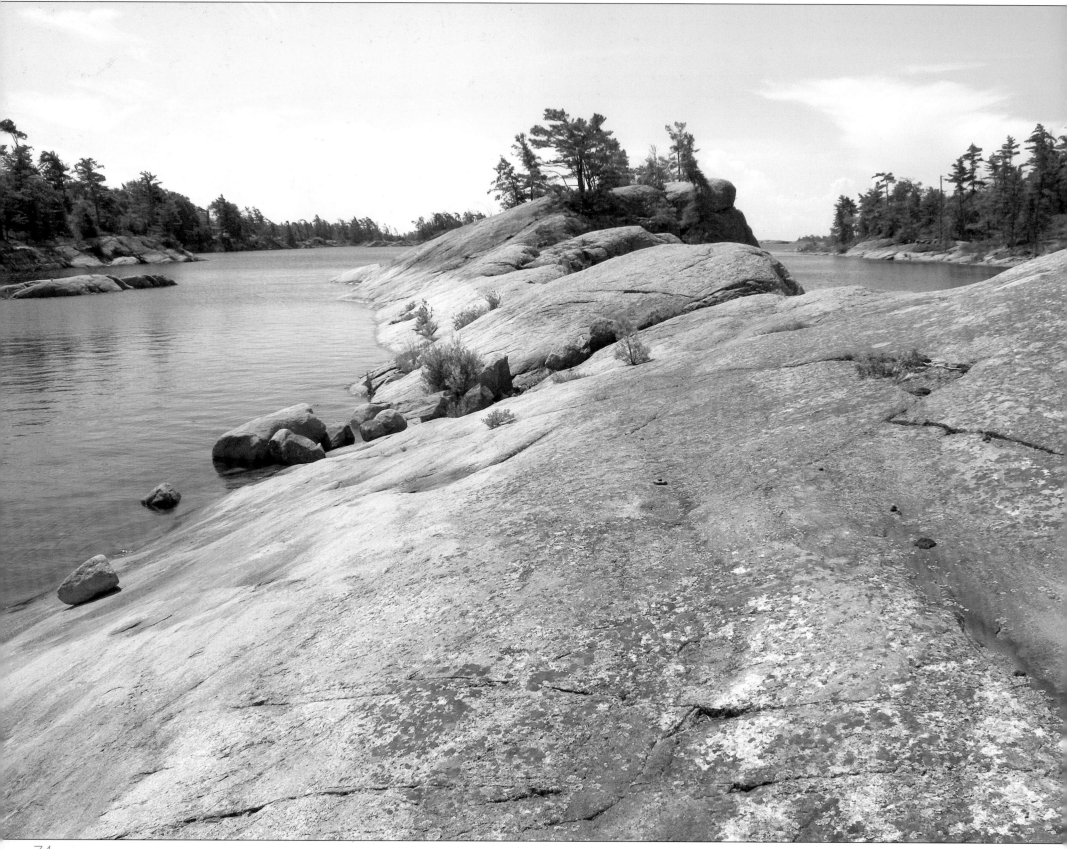

Kapuskasing was left behind by Lake Agassiz. The soils were cold and wet, and many settlers stayed barely a single generation before moving on. The real wealth of the region did indeed lie in the ground but it was in the rock far below, not in the soil. Ironically, the Timiskaming and Northern Ontario Railway, built primarily to service agriculture in the Little Clay Plain, ended up triggering a mineral prospecting boom.

By 1910, the population of the North was rapidly increasing as new mines opened and the economic value of the Shield had become evident. The authorative voice of the *Encyclopaedia Britannica* reported in 1911 that "there is now in process of development a 'New Ontario' stretching for hundreds of miles to the north and north-west . . . chiefly made up of Laurentian and Huronian rocks. The rocky hills of the tableland to the north long repelled settlement, the region being looked on by the thrifty farmers of the south as a wilderness useless except for its forests and its furs; and unfortunate settlers who ventured into it usually failed and went west or south in search of better land." Railway construction and the mining discoveries that followed close behind were the driving forces behind this "New Ontario."

Between 1867 and 1912, the Province of Ontario formally acquired a massive piece of the Shield by pushing its northern limit to Hudson Bay tripling the province's area in the process. A new atmosphere of economic and scientific optimism prevailed and was reflected in part in the choice of Toronto to host the International Geological Congress in 1913. This coincided with a peak immigration year, when four hundred thousand people made Canada their new home. A series of geological guide books were produced for the congress and participants from around the world were shuffled across Canada and the Shield by private rail car. A piece of the Canadian Shield, pink, nepheline-rich gneiss from Combermere just west of the Ottawa Valley, was named "congressite" in honour of the meeting.

But the Shield was not just about mining, farming and logging. At the time of the congress, the dramatic landform was also attracting the interest of artists, who saw beauty in the barren ground and rock.

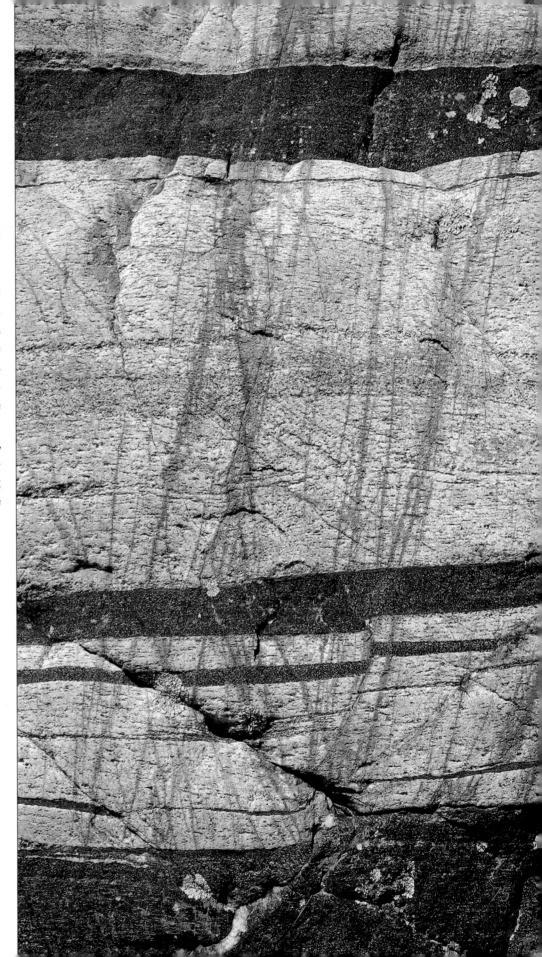

Massive intrusions of pink granite underlie the smooth, massive surfaces of many of the Thirty Thousand Islands.

(right) The geometric abstract structures found on the Shield surface of Bartram Island are the inspiration for the paintings, prints, and photographs created by Ed Bartram over the past forty years. Ed finds abstract in the most concrete Shield rock.

A NEW IMAGE: PAINTING AND WRITING THE GROUP OF SEVEN

With bold impressionism they brought the Precambrian north into the Canadian consciousness and by their paintings made of its barren solitude an imagery of beauty and strength.
—W.L. Morton

In 1913, an art exhibition of Finnish work held in Buffalo, New York, changed public perceptions of the Canadian Shield forever. At that time (until 1918), Finland was a vassal of Russia, but a new art movement devoted to depicting the rocky landscapes of the Scandinavian Shield helped galvanize a growing Finnish sense of place and national pride. Images of northern rock, snow, water and ghostly birch trees, viewed until then as the face of an unloved wilderness, inspired Canadian artists to paint their own North from a similar perspective. In the early

A golden sun rises gallantly over a royal purple Shield at Snare Lake.

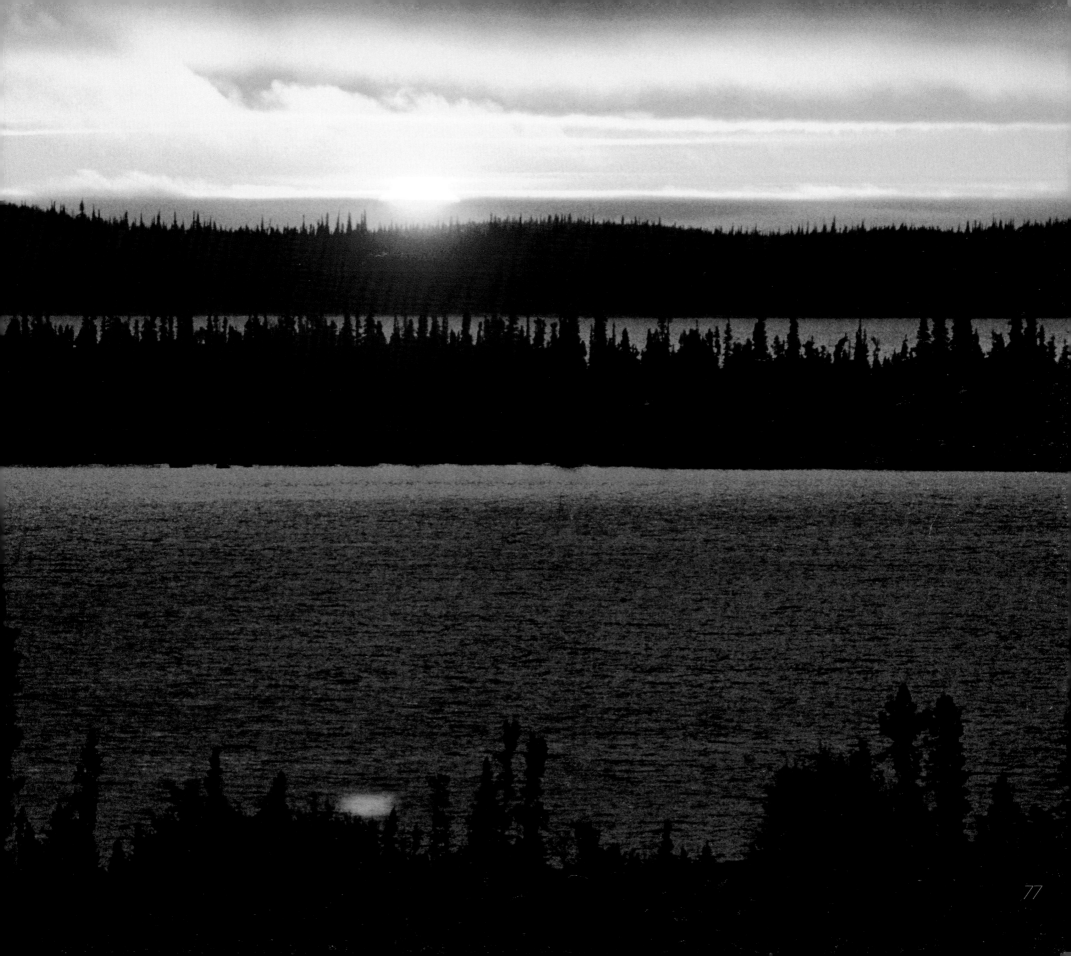

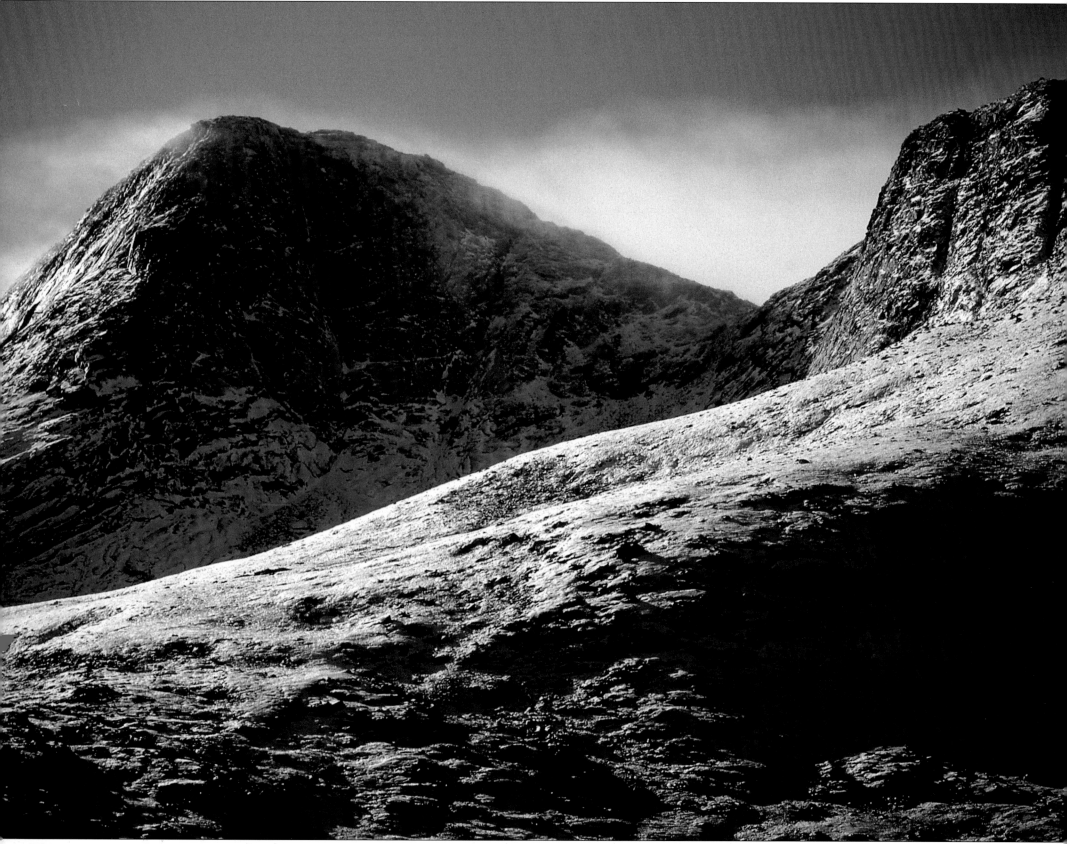

1920s, using a style borrowed heavily from the Finns, the Group of Seven went on to forge a new visual language for the Canadian Shield. No more would the landform be viewed as a barren wasteland as compared to the familiar pastoral scenes of Europe.

The Group of Seven started as a casual meeting of like-minded commercial artists from the Toronto area. Many were interested in the quiet solitude of the North as a contrast to the noisy commercial and industrial world in which they lived and worked. Franklin Carmichael's images of rocks, rounded hills and expansive vistas of the Shield—such as *Bay of Islands* (the La Cloche Ranges near Killarney)—convey the immensity of the landscape and the insignificance of humans within it. The group pointedly ignored the Native inhabitants of the region, and their work was also criticized in some quarters for presenting an unattractive image of Canada to European immigrants seeking farmland and rich soils. The group carefully fostered the myth that they had been the first to explore many areas of the North, although most of their expeditions had actually taken them to parts of northern Ontario already accessible by railroad. Nonetheless, they created the "trademark brand" of the Shield that persists to this day.

True to their commercial origins, the Group wanted their work to be accessible to all. They sponsored travelling exhibitions and promoted their works as institutional art forms to be displayed prominently in libraries, town halls and every school in Canada. Postcards were made and widely circulated to offices and homes. In

The early snows on Okak Island give one a feeling of lifeless abandonment. However, on the opposite side till the early nineteen hundreds lived a thriving Inuit community. Now only graves remain.

(right) On Manitoulin Island is a rare example of a pitted shore.

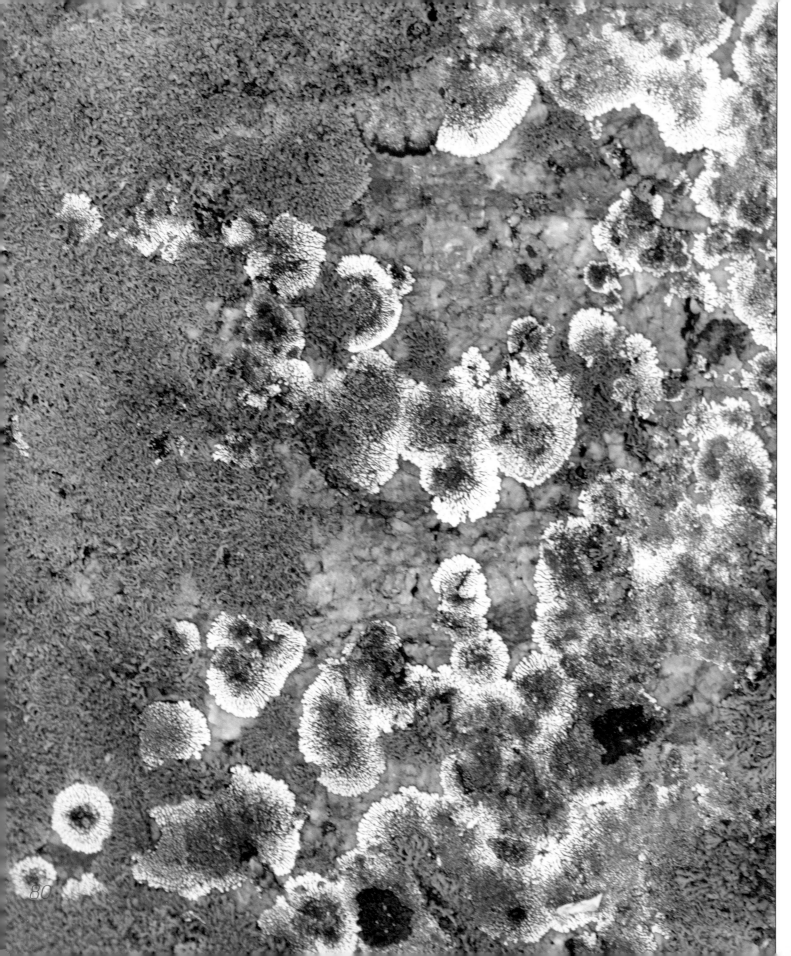

this way, a national image was built at a time before widespread popular photography and television. And that image has survived to this day. The Group of Seven opened up the North for wider recreation by urban dwellers and encouraged the beginnings of cottage culture in the 1930s.

Writing about the Shield

This alternate penetration of the wilderness and return to civilization is the basic rhythm of Canadian life, and forms the basic elements of the Canadian character.
— W.L. Morton

In the realm of the written word, Canada's northlands reached an appreciative international audience through the work of Wa-Sha-Quon-Asin (He-Who-Flies-By-Night)—or Grey Owl as he was more widely known. Posing as a full-blooded Native, Grey Owl was indeed something of a "fly-by-night," for he had, in fact, been born as Archie Belaney at Hastings, a coastal town in southern England. No matter, for he was a skilled storyteller, and in *Men of the Last Frontier*, published in 1931, he brought the Far North to life for a global urban audience as the Group of Seven had done with their art. Grey Owl's biographer, Lovat Dickson, wrote: "I could think of no other writer in Canada who had caught so truly the essential boom note of this huge, rocky, monolithic land." Unlike the Group of Seven, however, the

A cosmic collage of saffron and chartreuse splattered across a rosy granite canvas.

(right) Mont Chaudron sits on the Quebec — Ontario border and was an important meeting ground for Aboriginal people that lived to the north and south. Many people still meet there today.

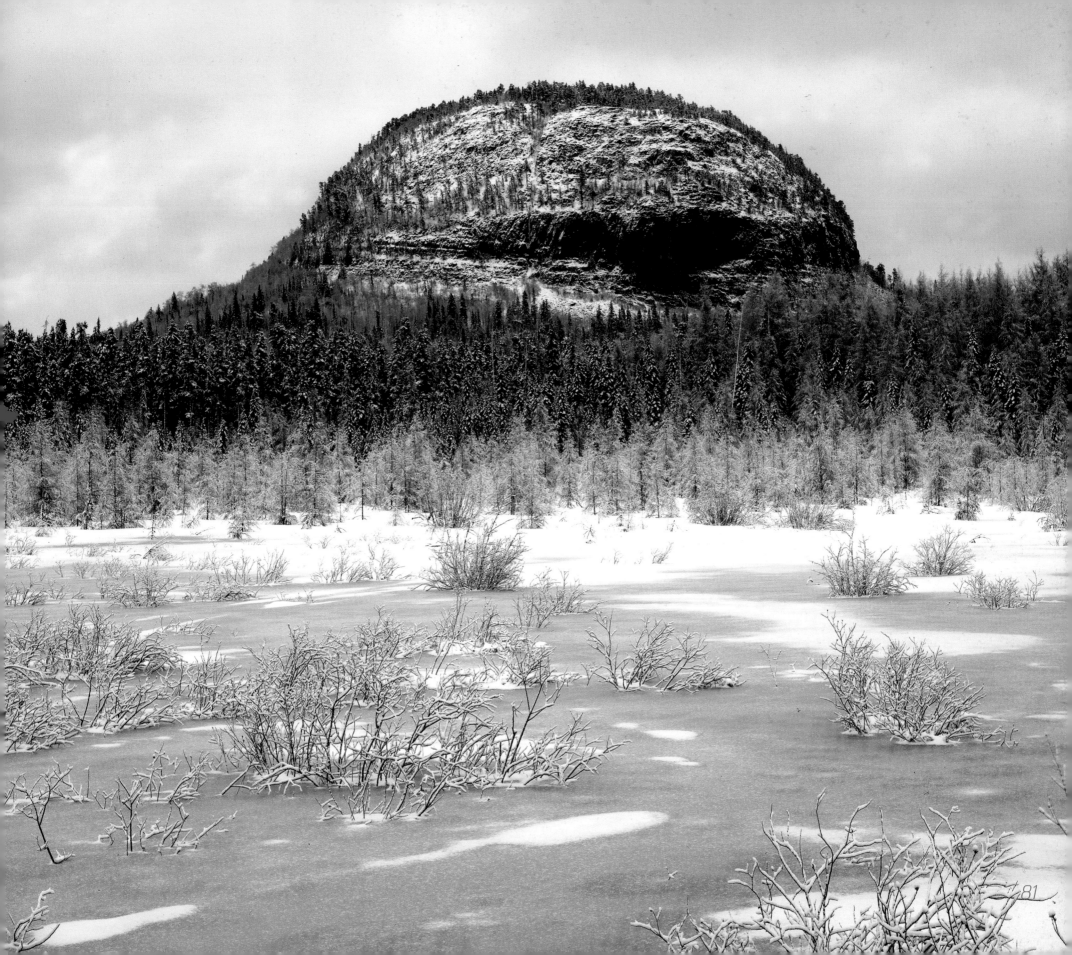

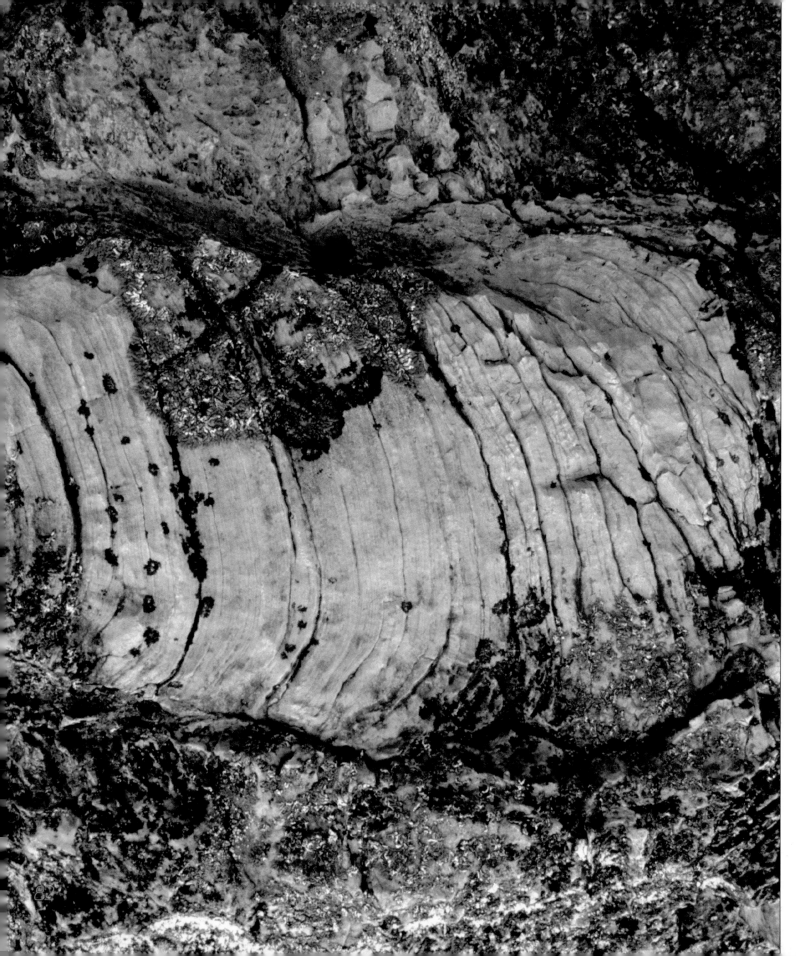

original inhabitants of the North, its Indigenous peoples and animals, were at centre stage in Grey Owl's writings. The spiritual nature of his wilderness descriptions and those of his main characters served as a refreshing antidote for Europeans in the 1930s, who were rightly nervous about the future of their own "superior" civilization. His work also communicated a stark warning about the fragility of our boreal ecosystems in the face of rapacious forestry and mining operations; his was an early voice of the conservation movement and environmental protection.

In *The Canadian Shield*, Barbara Moon has described Canadians as "a shield race . . . they live with this permanent reminder of elemental process. They live with bedrock and bush and a million hidden lakes always at their backs. They live with a greedy secret of riches."

Margaret Atwood wrote in a similar vein in *True North*: "When we face south, as we often do, our conscious mind may be directed down there, towards crowds, bright lights, some Hollywood version of fame and fortune, but the north is at the back of our minds, always."

Found near Great Slave Lake, a stromatolite fossil consisting of micro-laminated sedimentary structures and dating back more than 3 billion years, is evidence of blue-green algae—the earliest life form on earth.

(right) At a diamond mine near Exeter Lake, a spring freshet floods the waterways. It is these very waters that may be the Precambrian gems of Canada's future.

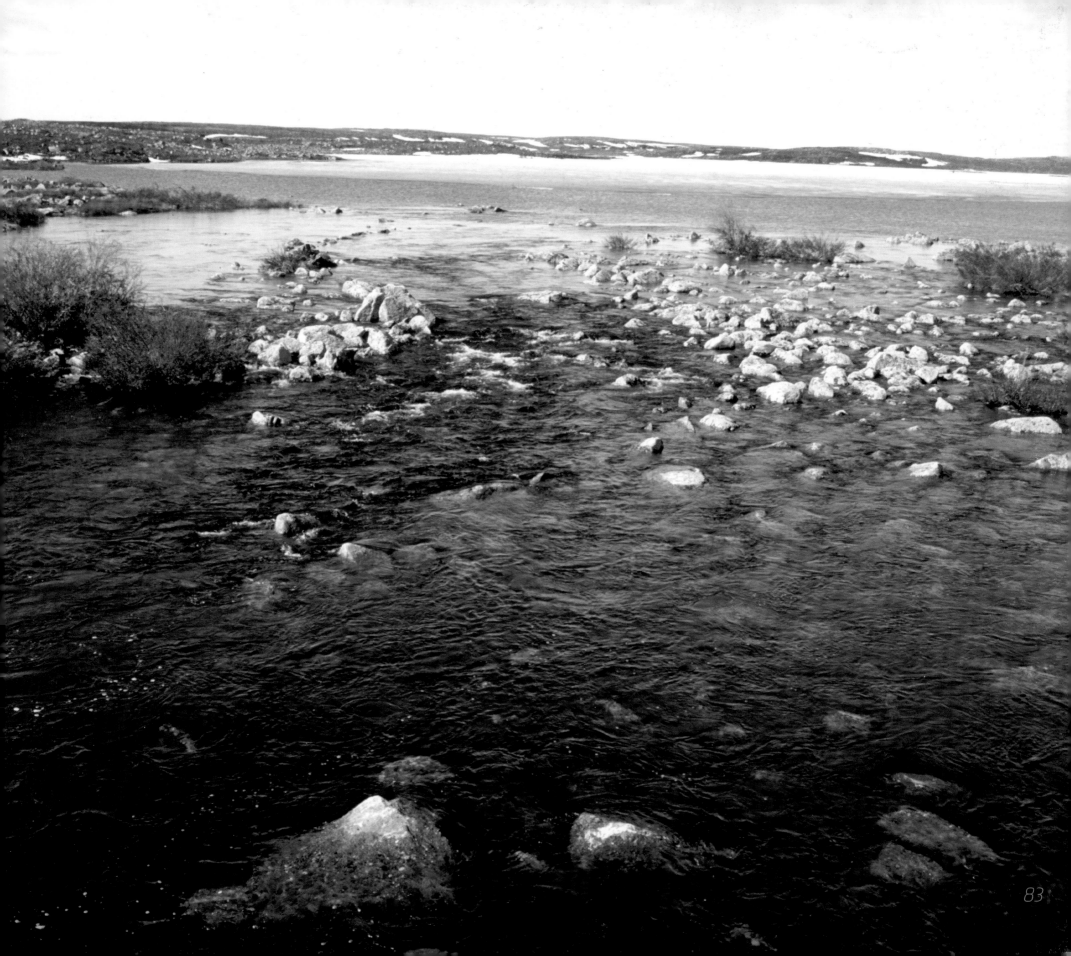

A BRIEF HISTORY OF ROCKS

This anomalous land, this sprawling waste of timber and rock and water . . . this empty tract of primordial silences and winds and erosions and shifting colours.
—Hugh MacLennan

W hile the arts created a new international image of Canada's North, geologists came to dramatic conclusions about the evolution of the world's continents and oceans from their explorations of the Shield's rocks.

The Canadian Geological Mosaic

The Canadian Shield is an immense mosaic made up of large pieces of crust, hundreds and sometimes thousands of square kilometres in extent, that have travelled long distances over the surface of the planet. They were brought together over the

While looking out across the ranges and into seemingly lifeless valleys, one stares and wonders how the Inuit survived here. Yet they did. Their footprints are everywhere.

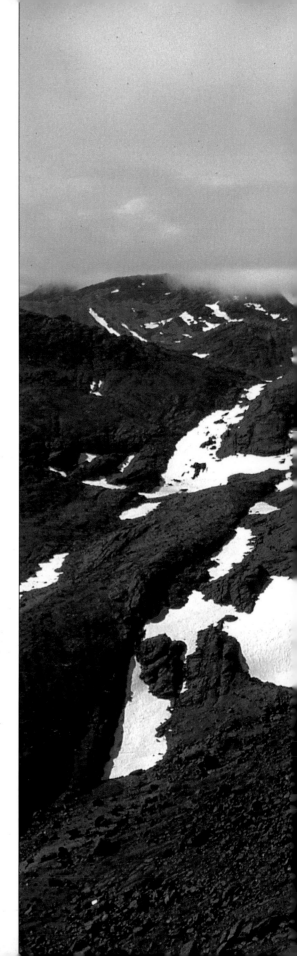

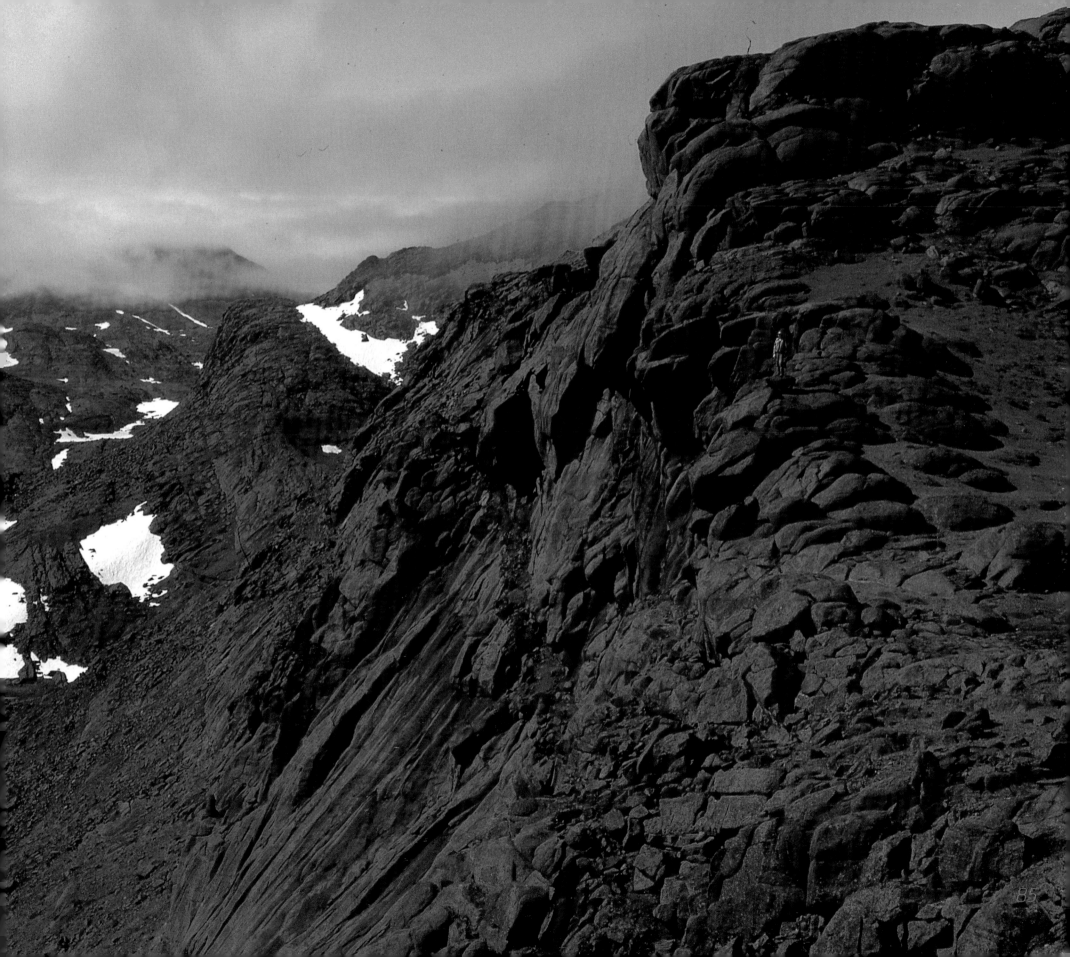

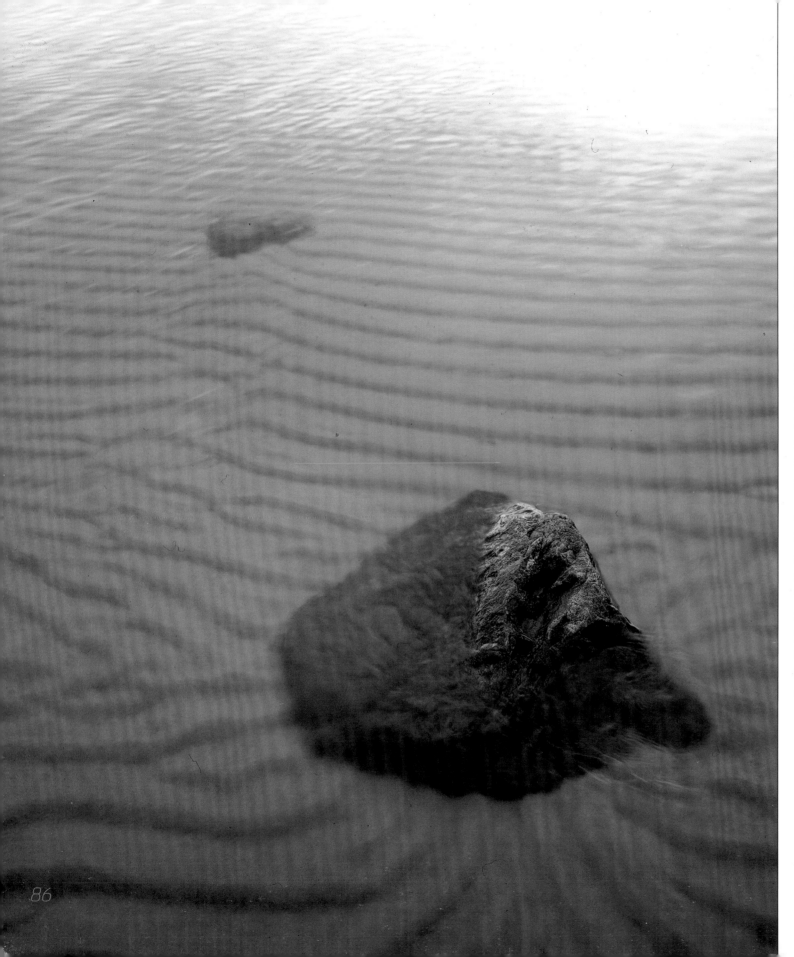

eons of geological time by plate tectonics and welded into a larger continental mass. As such, the geologic history of the Shield fits with present-day multicultural Canada and its Indigenous and immigrant peoples, all of whom have come at different times and landed on the country's shores from far-off places. Other continents have similar histories, and the Canadian Shield shares many characteristics with those of Western Australia, South America and Africa—but it is distinguished by being the planet's most extensive. And possibly its oldest. The Shield is made of crystalline rocks more than 1 billion years old representing the old hard core of the North America craton that records its earliest beginnings. The oldest rocks in the world occur at Acasta in the Northwest Territories (ca. 4 billion years) and at Nuvvuagittuq in northern Quebec (ca. 4.2 billion years). The building process finished about a billion years ago. Younger rocks have been added around its margins recording the later growth and expansion of North America.

It has taken geologists about 150 years to write the history of the Shield. Many mysteries had to be solved along the way. If early settlers stayed away from the Canadian Shield, so did many geologists. And they had good reasons. While mining opened up the area's resource potential, understanding the origins of its rocks posed a formidable challenge. In 1905, Shield expert F.D. Adams wrote this about Canada's northern geology: "We . . . are obliged to descend into the deeper parts of the Earth where

On a shore in Lake Superior two rocks interfere in an otherwise uniform and consistent pattern.

(right) The base of this weak rock has been undermined by the sea. At low tide one can walk into such a sea cave. A spooky place with blowing wind and the rising sea at the doorstep.

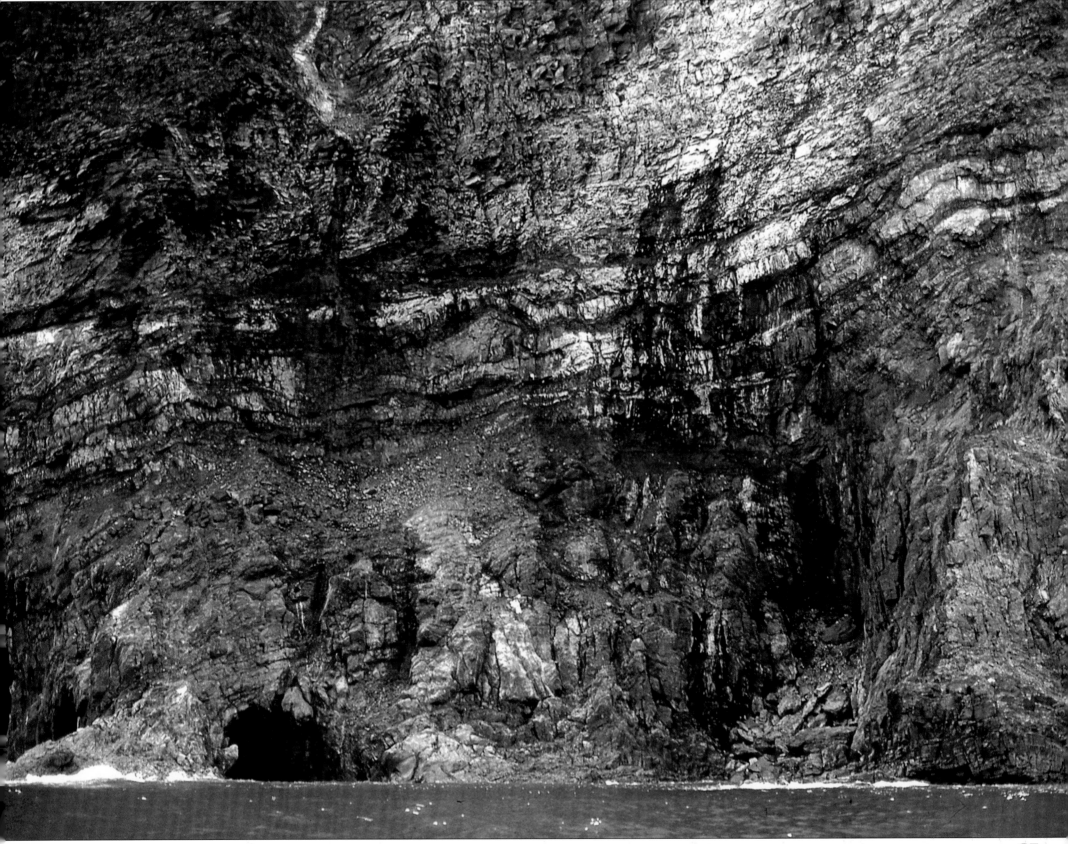

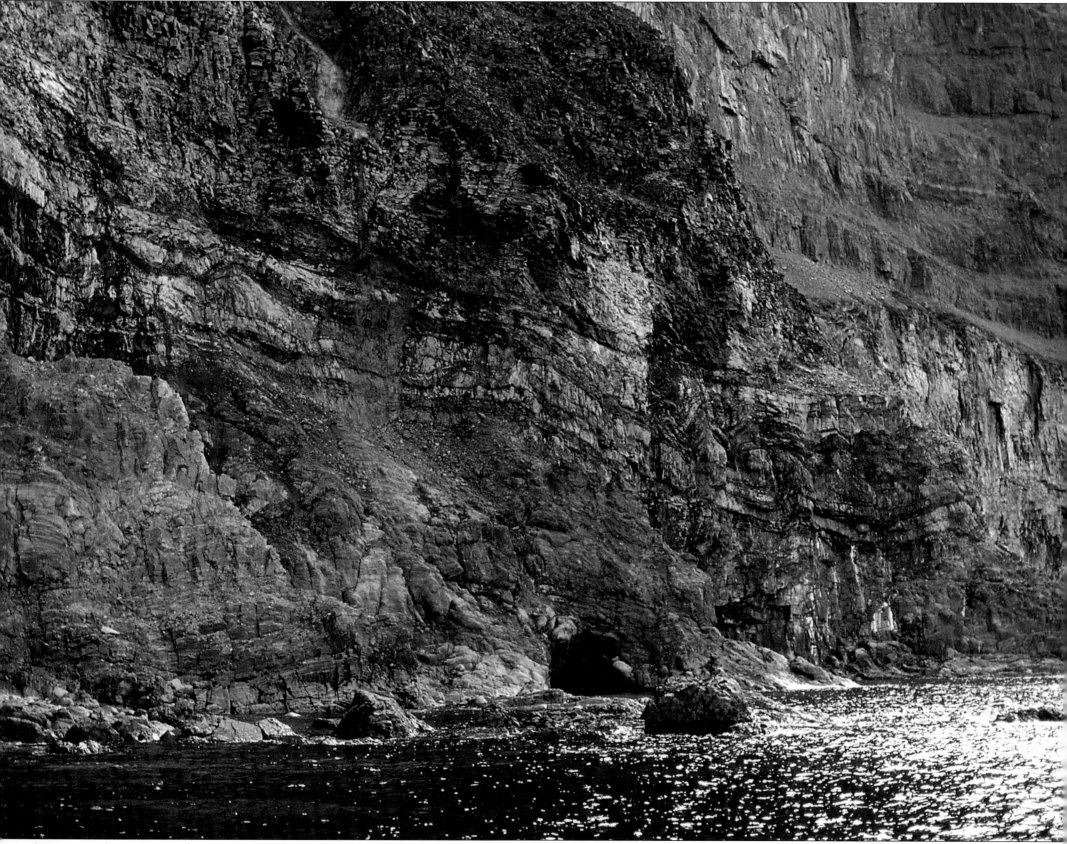

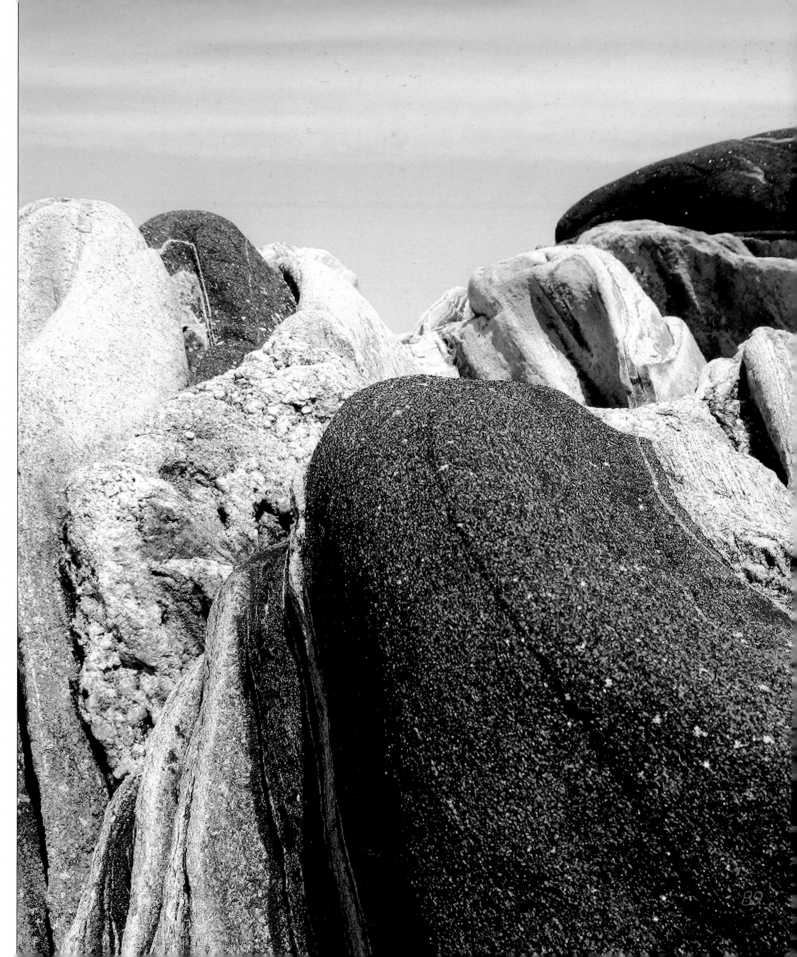

the light begins to fail and when once we pass through that last grim portal into the drear pre-Cambrian world, we enter in what . . . earlier geologists regarded as a hopeless chaos." The area was large and physically taxing to cross, and the complex rocks lacked the fossils that were used for matching (correlating) outcrops of younger rocks from different areas. The ancient Shield landscape looks from the air like an ocean. Islands of higher ground stand above green swaths of forest, bog and shimmering water. Its rolling topography of crystalline, primitive rock resembles the swells of the open sea. To geologists, the Canadian Shield had "too much geography *and* too much history"— to paraphrase the statement made famous by William Lyon Mackenzie King.

Dr. John Richardson provided the first coherent view of the Shield when he produced the first full geological map of British North America in 1851. The next year, W.E. Logan, the head of the Geological Survey of Canada, distinguished "primary gneisses" of the Shield (the Laurentian Series) from the "secondary" fossil-bearing Paleozoic rocks that overlaid them. Other subdivisions were later identified across the Shield including the Huronian Series of stratified Precambrian rocks that are well exposed along the north shore of Lake Huron.

Logan began his work by looking at rocks exposed halfway between Montreal and Ottawa on the north shore of the Ottawa Valley. Here the Laurentian Mountains overlook the limestone plains to the south. Logan recognized that many so-called "primary" rocks making up the

Here you can sense the ages and feel that if you stayed long enough a dinosaur would raise its head.

(right) The scouring action of waves has created this Precambrian sculpture.

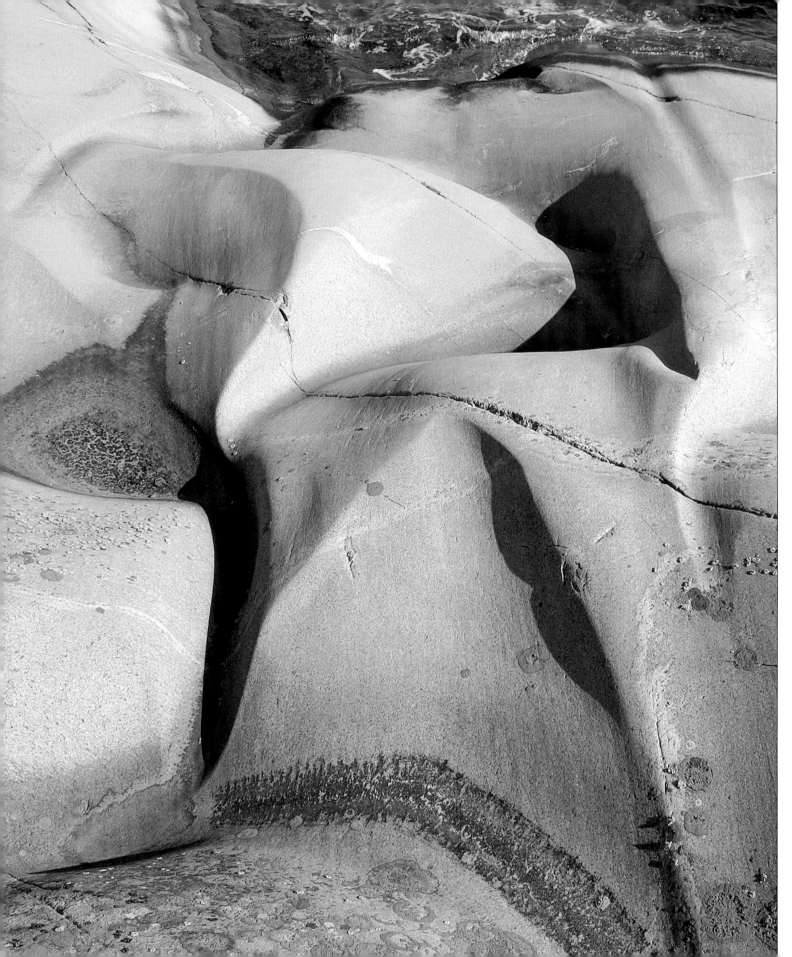

Laurentians showed evidence of having once been sedimentary rocks substantially changed by metamorphism. For instance, he identified marble (metamorphosed limestone), which is a common rock type in some parts of the Shield, especially in eastern Ontario and around Montreal. This was a key observation because it contradicted the long-held notion that the "fundamental" rocks were igneous in origin having cooled from the Earth's originally molten crust. Logan soon established that large bodies of igneous rock did exist but that these had formed much later. By 1863, the term *Grenville Series* was being used to refer to the varied metamorphic and igneous rocks of the Shield. The name comes from outcrops studied by Logan along the Rouge River and the small community of Grenville in Argenteuil County, Quebec—on the Ottawa River between Gatineau and Montreal.

"The mystery of the Grenville"
—W.G. Robinson 1957

Geological understanding of the rest of the Shield proceeded at a painstakingly slow rate. Mapping in rough terrain where no topographic maps existed was completed haltingly and in great detail (one inch to the mile) generating a fog of local minutiae. One map often didn't agree with that of an adjacent map; geologists had their own opinions about what they saw with no widely agreed model for the origin of the rocks. The mountain of detail was simply too high to climb.

The Fox Islands in northern Georgian Bay are high domes of granitic rock.

(right) This land once nurtured a prosperous Inuit community. Just below the mountains in the distance is Shuldham Island. Here many related artifacts are found.

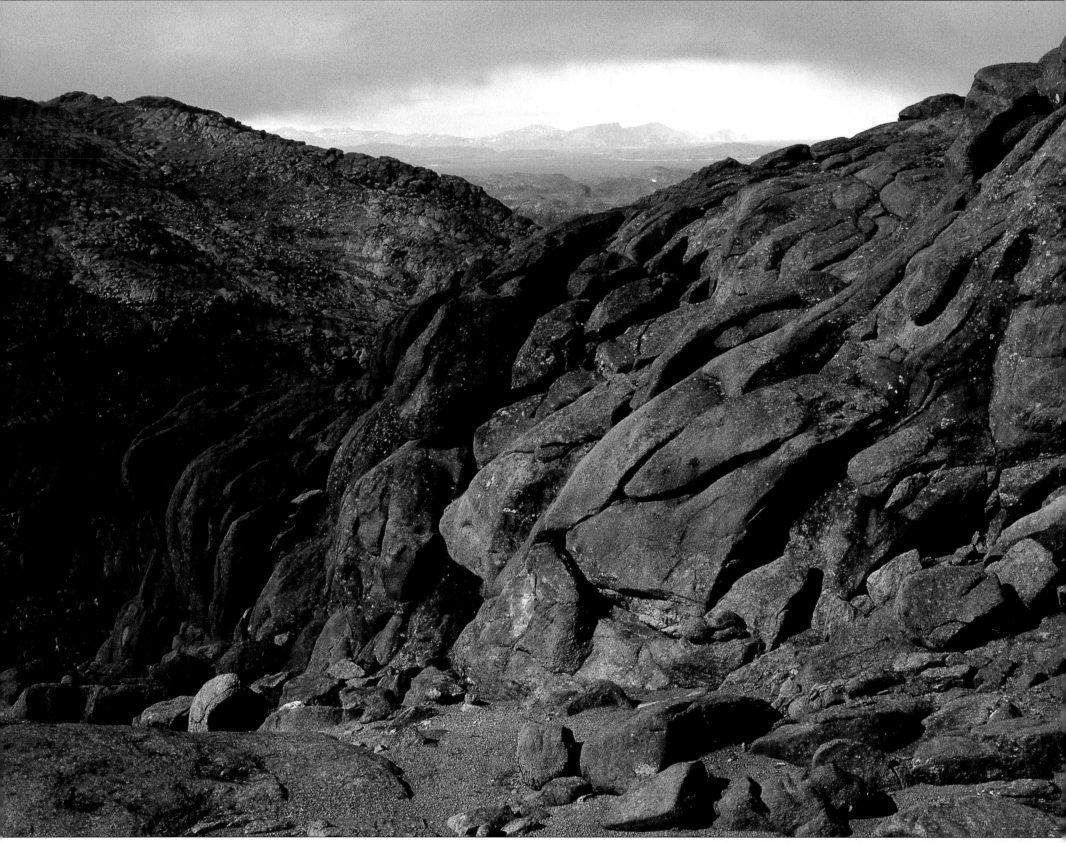

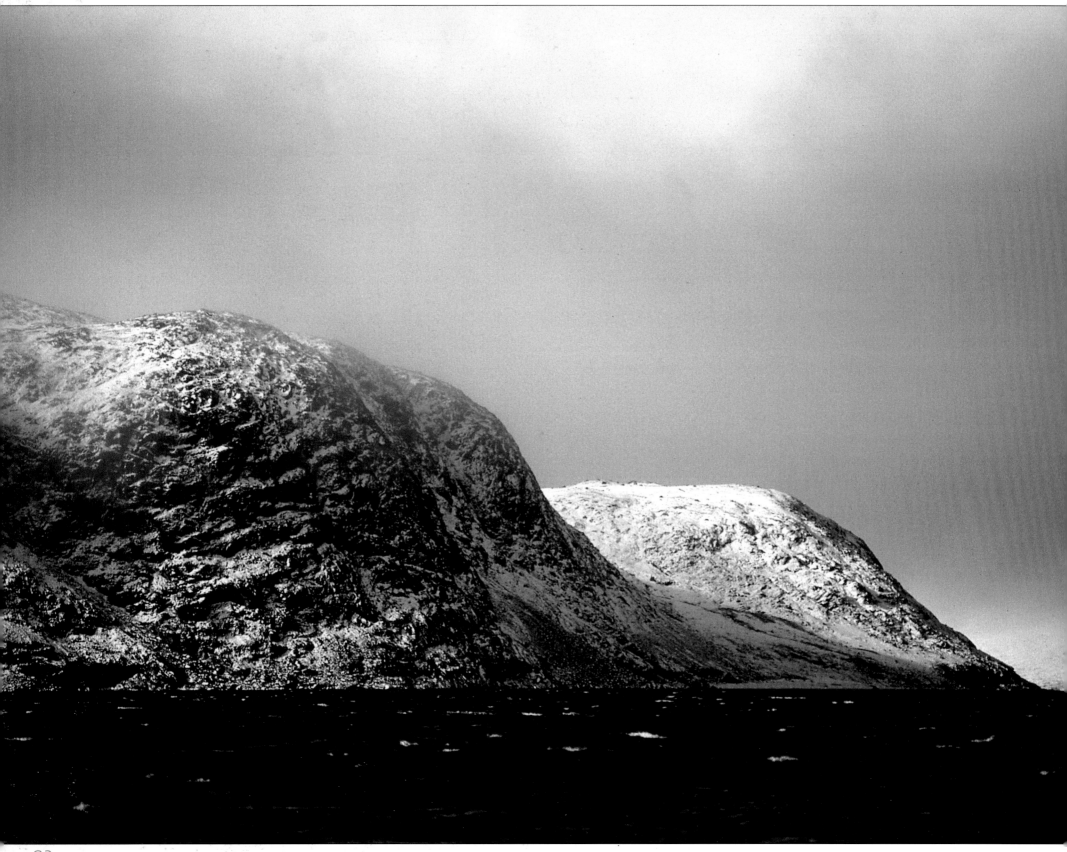

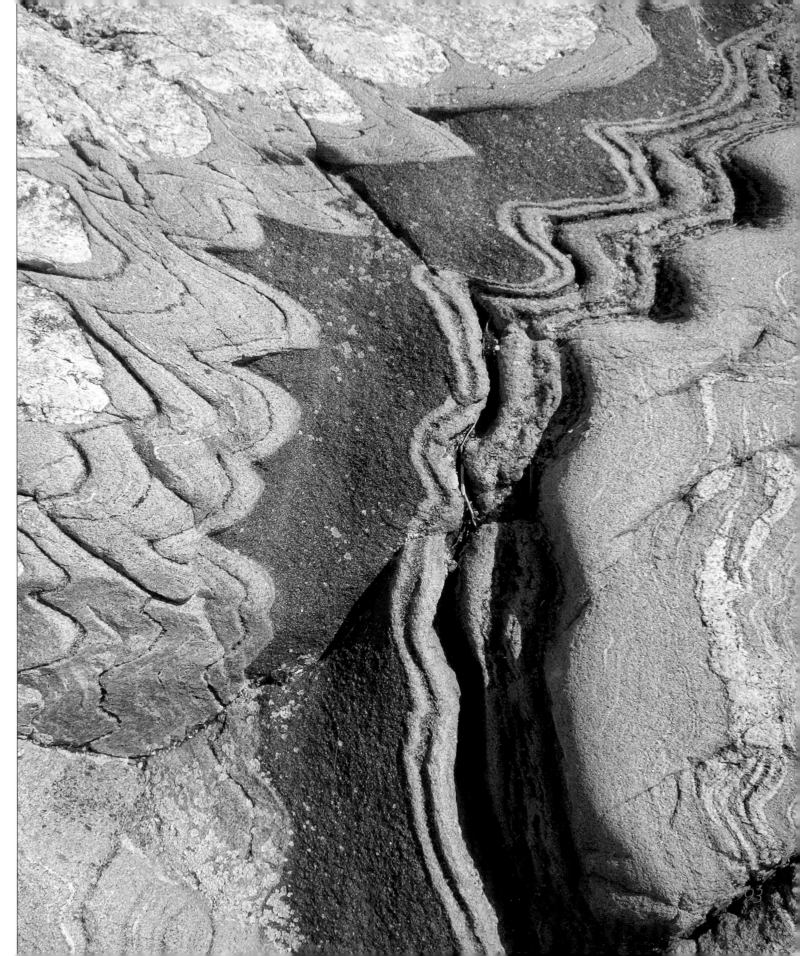

A wider perspective appeared when geologists came to realize that Logan's Grenville Series stretched as a broad belt of rock all the way from Ontario to Labrador (and southwest into the United States) in what was to become known as the "Grenville Province." In 1885, geologist A.C. Lawson had shown that the geology of the Keewatin District northwest of Lake Superior revealed the presence of giant granite intrusions of enormous extent. Through the painstaking fieldwork of Lawson and F.D. Adams and others, the Shield became to be viewed as an enormous continental-scale mosaic of geological "provinces" such as the huge Superior, Slave and Nain provinces. How had they been juxtaposed? In the 1920s, H.V. Ellsworth made a key observation when he demonstrated that the innermost provinces in the central parts of the Shield were actually much older than those located nearer its margins, but why was this? This question was to be answered only in the early 1970s, during the "plate tectonic revolution." The leading revolutionary was a Canadian geophysicist, Jack Tuzo Wilson, and he was to change the way we see the Shield – and the planet – forever.

Putting the Pieces Together: From Ship to Shield

In the late 1960s, a handful of ship-based geophysicists found the clue to understanding the complexity that had baffled legions of geologists working on land. Ocean-based research,

Still one of the world's wildest places, the Labrador coast offers few places of refuge.

(right) A vivid indicator of the plastic flow of hot rock many kilometres below the earth's surface. The skeletal appearance makes one think of the origins of continents.

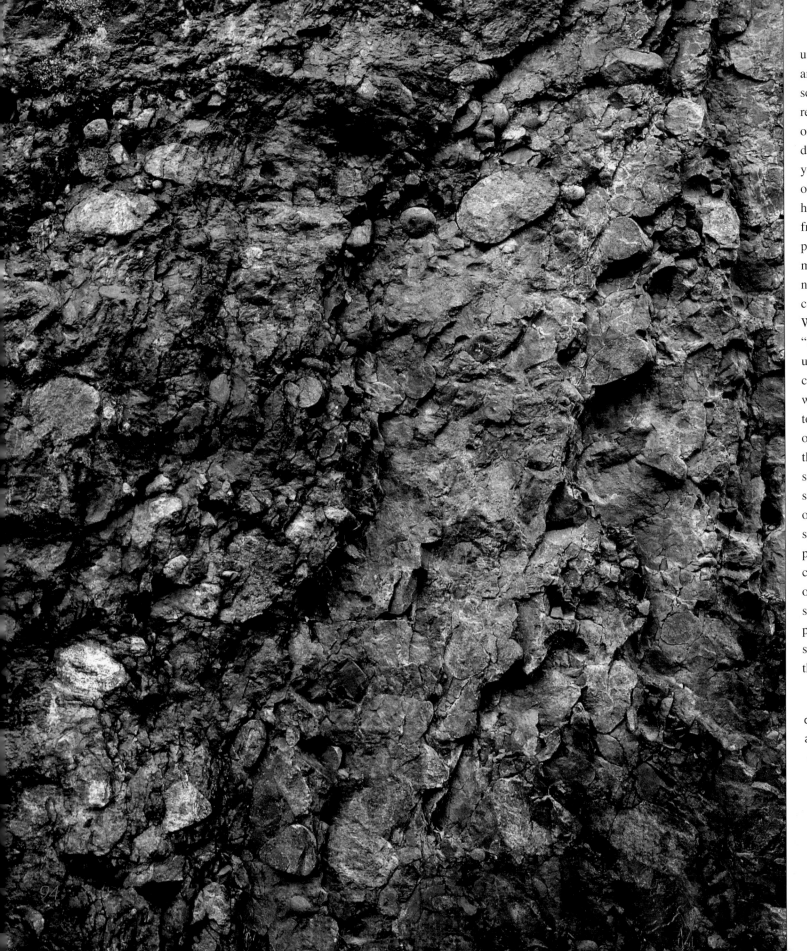

using drill ships that range across the oceans and recover rock samples deep under the seafloor, confirmed that the Earth's surface was relentlessly on the move. By drilling into rocks on the ocean floor, it was learned that present-day oceans are all younger than 180 million years because they are the result of the breakup of a large supercontinent called *Pangea*. They have widened from cracks (called "rifts") that fragmented that large supercontinent into the present-day continents. Moreover, oceans are marked by prominent chains of seafloor volcanoes that run down what is more or less the centre of the ocean floor; mid-ocean ridges. When these volcanoes erupt, they create "oceanic crust" (or "ocean floor crust") made up of an igneous rock called *basalt*. It was discovered that the basalts near mid-ocean ridges were brand new but became progressively older toward the margins of the oceans. Harry Hess of Princeton University advanced the notion that volcanic rocks forming along the ridges simply pushed older ocean floor crust aside, slowly widening the ocean basin, in a continuous ongoing process he termed "seafloor spreading." As a consequence, continents are pushed around. J. Tuzo Wilson took these conclusions one step farther by developing the theory of "plate tectonics"— that the Earth's surface was broken into about two dozen large plates of crust that were pushed around by seafloor spreading. The mid-ocean ridge along the centre line of the North Atlantic Ocean di-

Not having time to melt and seemingly caught unaware by a landslide, these pebbles and boulders reveal their tortured history. No doubt if left alone they could tell their story for millions of years to come.

(right) Cape Uivak at the entrance to Saglek Bay has a weathered history. In Inuktitut uivak means cape, so really Cape Uivak means Cape Cape.

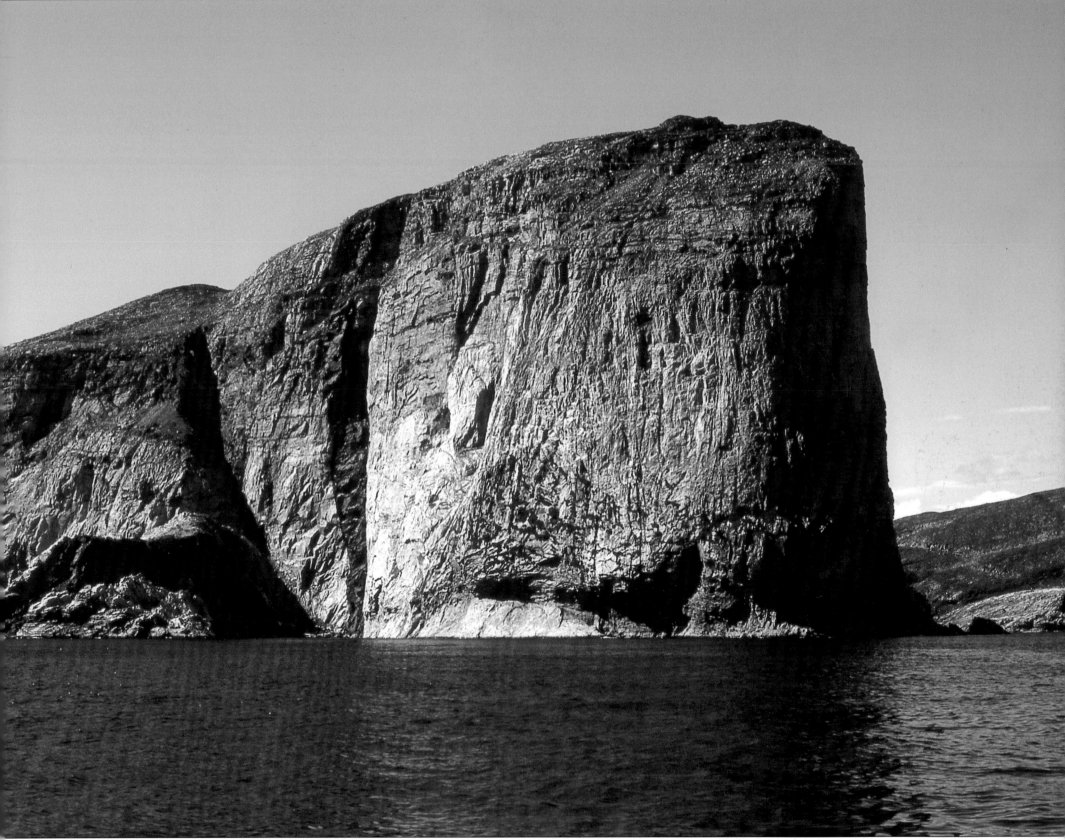

vides the North American from the European plate. He also recognized that plate tectonic activity had occurred during most of the Earth's history: it was essentially the way in which the Earth's surface constantly reshaped itself whereby oceans were first formed, widened and then as he so convincingly showed, ultimately *closed*. Wilson showed that the proof of modern plate tectonics can be found in the Pacific Ocean. The islands of the Hawaiian chain are the record of a mobile Pacific plate slowly migrating across a plume of hot magma (a "hot spot") deep within the Earth's mantle. As the plate moved across the hot spot, successive volcanoes formed only to become extinct as the plate carried them bodily away from the source of magma below. This has produced the Hawaiian "hot spot chain."

The island of Newfoundland provided further compelling evidence for the operation of plate tectonics in the ancient past. Much of the eastern half of the island is composed of rocks that were formerly part of Africa. Some 350 million years ago North America, Africa and Europe were locked together within the supercontinent Pangea. As Pangea broke apart, narrow rifts widened into oceans (the North and South Atlantic). In the process, some "African" rocks remained stranded on the eastern coast of Newfoundland. Other parts of Newfoundland are made up of older oceanic crust that once formed the floor of the Iapetus Ocean which had been squeezed shut when North America, Africa and Europe collided during the formation of Pangea.

Near Yellowknife, a relief on the rock surface is an example of weathering and erosion by the elements in response to different minerals within the bedrock.

(right) Here many rabbits find food, nudging rocks aside to get at the small sheltered plants.

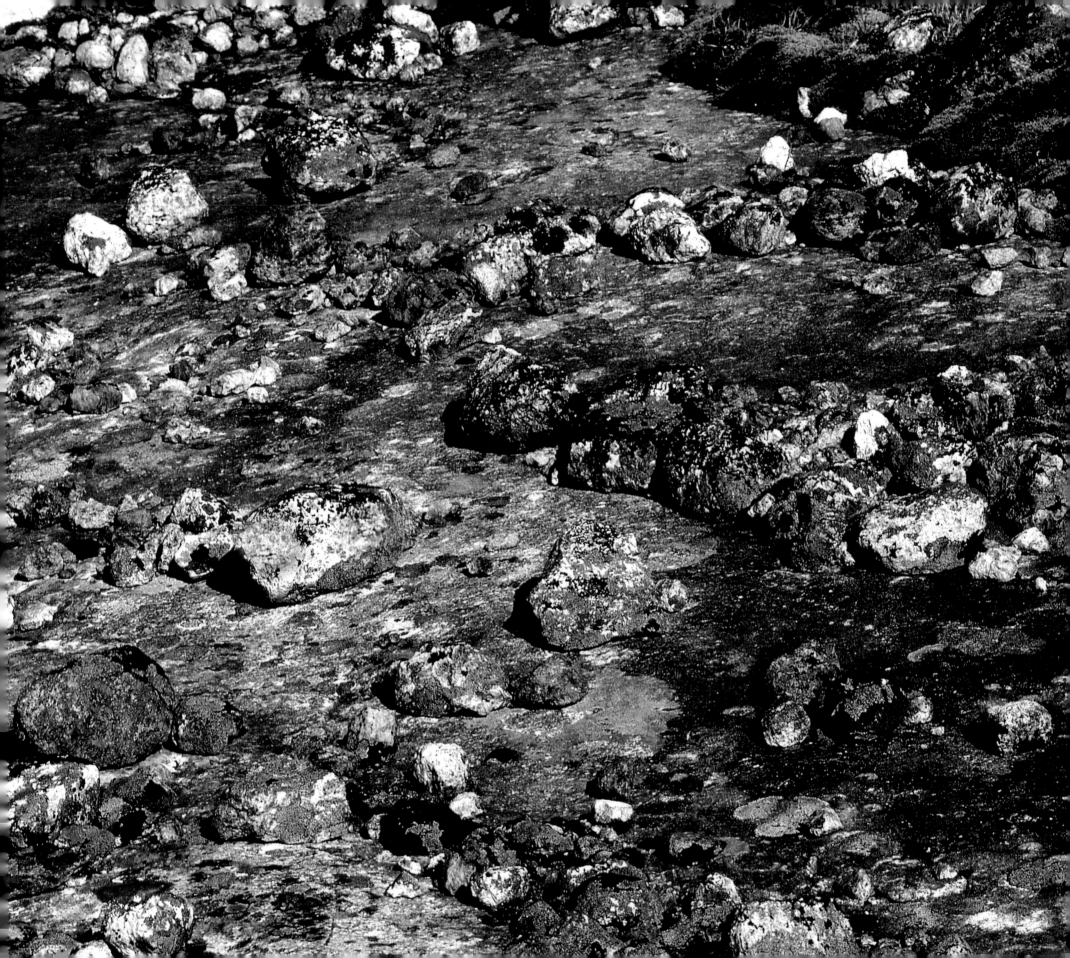

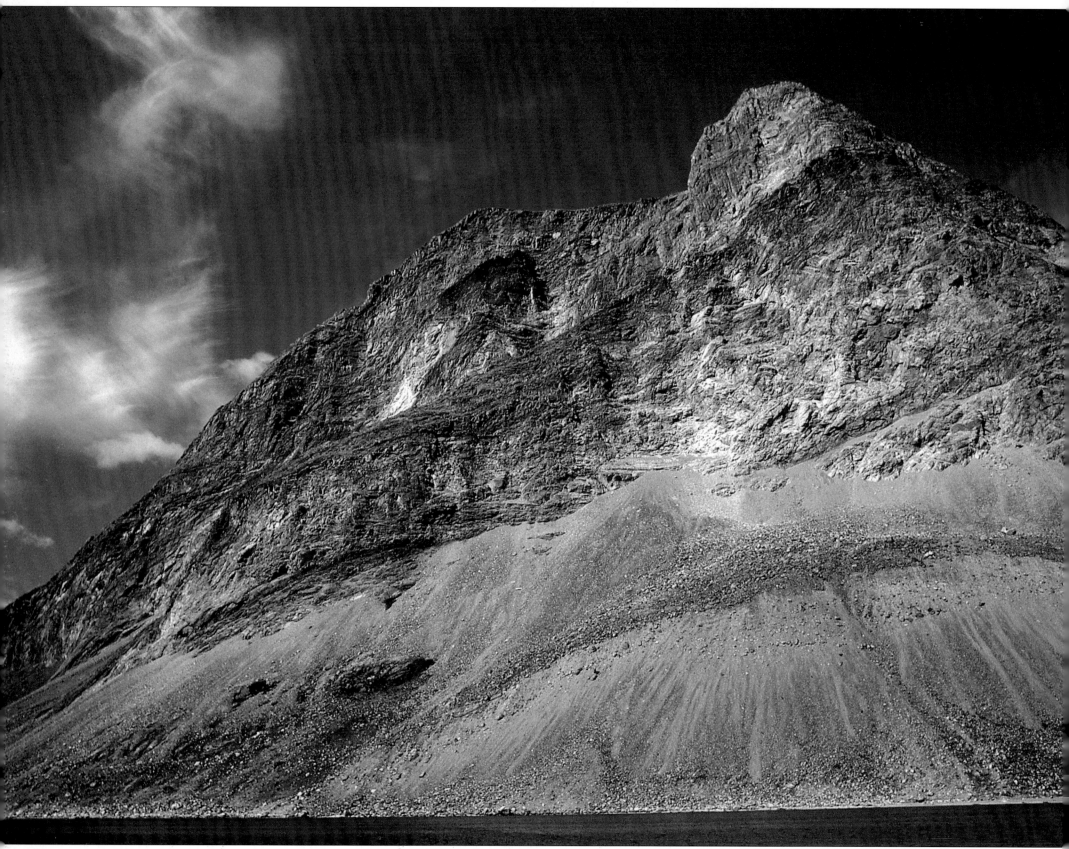

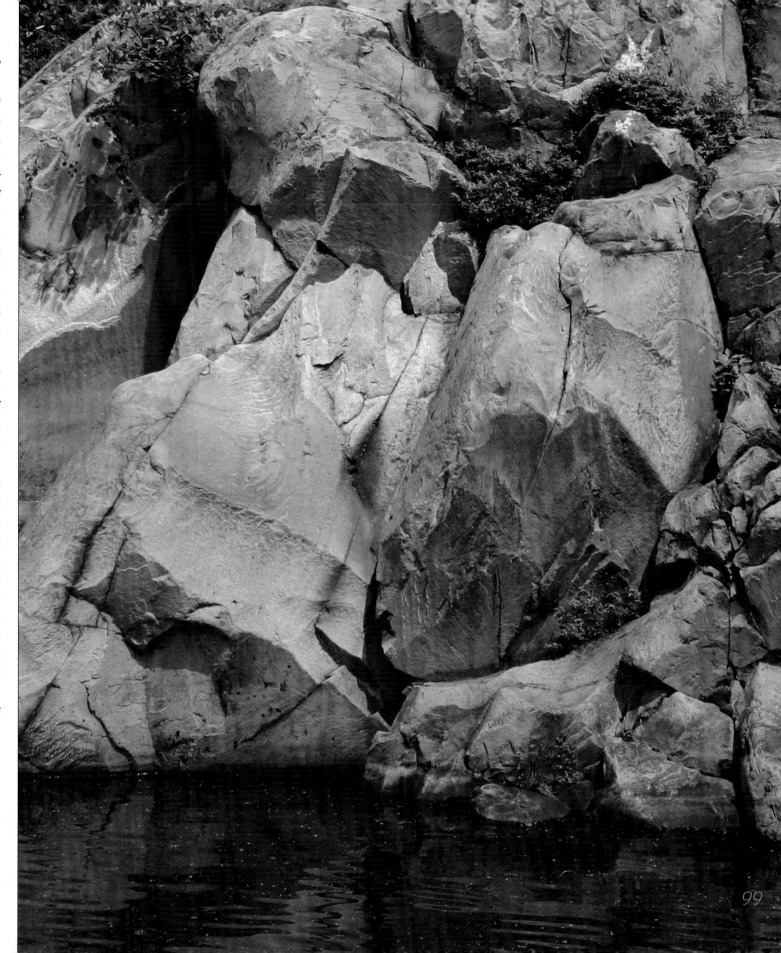

Parts of its ocean floor were thrust up onto North America where they remain today.

Here at last was a model to explain how the various pieces (or provinces) of the Canadian Shield had been moved and brought together. Its component pieces had been assembled by plate tectonics. Today, knowledge of the deeper structure of the Shield is increasing because of *Lithoprobe*—a massive, decade-long investigation of the Canadian crust by universities, government and industry. This project used reflected seismic waves that echoed their way deep underground to identify deeply buried geological structures. These explorations revealed a history of massive tectonic collisions between crustal pieces.

We now know that the Shield grew from a very small nucleus called the *Slave Craton,* which is found in the far northwest region of the Shield. It contains some of the oldest known rocks in the world (4 billion years old) discovered along the Acasta River northeast of Yellowknife. By at least 3 billion years ago, the Slave had given up its solitary life and collided with and stuck to the Rae-Hearne Province, in turn, colliding with the Superior Province along the line of the Trans-Hudson Orogen (a younger belt of extremely deformed rocks) 1.8 billion years ago. Labrador and much of Quebec and also Greenland were added at this time. This created a much larger ancestral continent called *Nena*. And by 1.5 billion years ago, an even larger supercontinent called *Columbia* had come into existence.

Squeezed into narrow belts between each of

It is in high places far above our mortal path that the spirits live. The Torngats!

(right) George Lake in Killarney Provincial Park dramatically sits between the red granite cliffs on the south and the white quartzite mountains on the north.

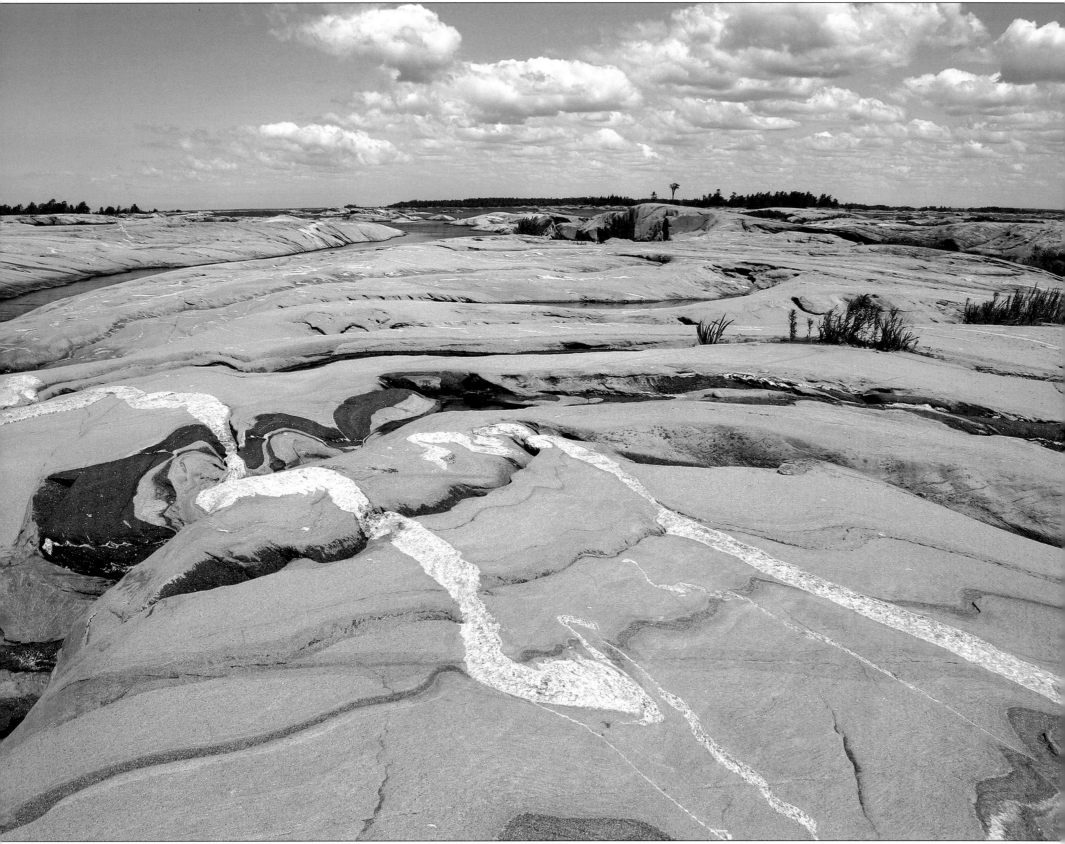

the provinces are "greenstone belts" composed of large expanses of often highly deformed marine sedimentary and igneous rocks. The latter contain great accumulations of bulbous "pillow" lavas—indisputable evidence that magma had erupted on the ocean floor. These rocks are now preserved high and dry in the middle of the continent, testament to the closure of ancient ocean basins and the preservation of their crusts between the crushing, vise-like grips of colliding cratons.

The final stage in the creation of the jigsaw puzzle that is the Canadian Shield occurred when South America collided with eastern Columbia about a billion years ago. This event left the highly deformed and metamorphosed rocks of the Grenville Orogen and marked the formation of the large supercontinent Rodinia, thereby solving the "mystery of the Grenville."

In 1957, Wilson wrote of the growth process that had assembled the Canadian Shield: "Continents have not been permanent. They have grown from nothing." In 1989, Canadian geologist Paul F. Hoffman echoed this when he coined the phrase "United Plates of America" to describe the broad scale mosaic of the Canadian Shield that has been brought together by plate tectonics — a unique "made in Canada" idea that has informed understanding of the history of shields and continents elsewhere on the planet.

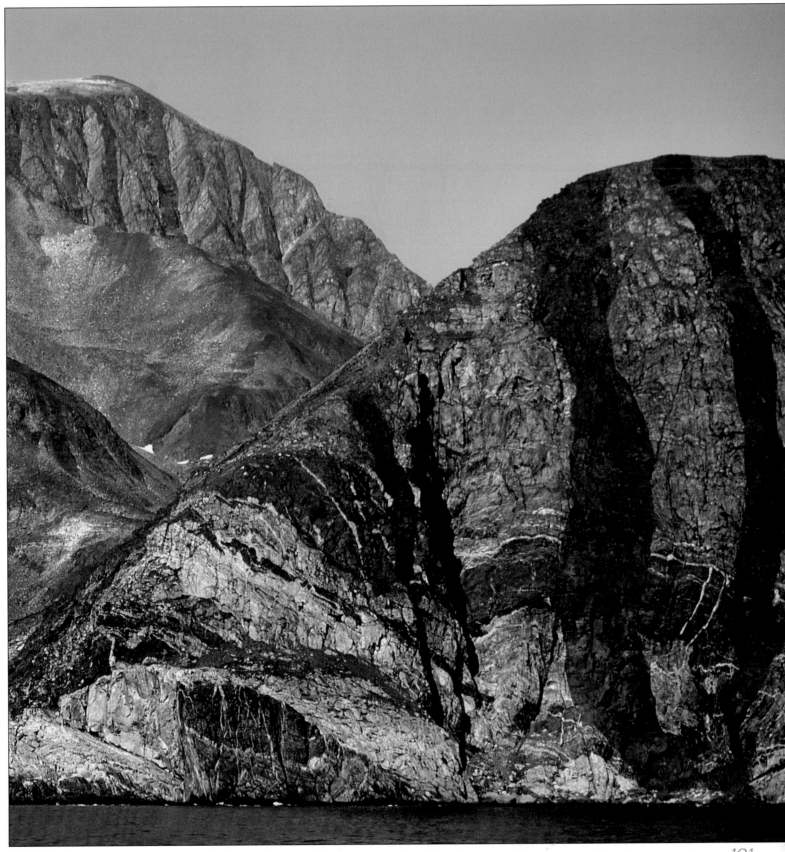

Banded gneiss is cut by a later intrusion of quartz and pegmatite.

(right) Over a billion years ago, hidden deep in the earth, lava found its way through cracks then cooled and froze. Today, after much time and weathering, these dark intrusions speak loudly of the past.

"ROLLING BOULDERS": INSIGHTS INTO THE HISTORY OF GLOBAL CLIMATE

In Canada, the glaciers, foreseeing the rising world power on their southern edges gave them the soil and presented the northern Cinderella with the rocks.
—A.R.M. Lower, 1973

Huge numbers of large boulders are scattered across the Shield. Many lie across the limestone plains to the south. The presence of red-coloured granite boulders from the Shield, showing deep scratches and resting on the straw-coloured limestones that surround the Shield, was very conspicuous. J.J. Bigsby drew a key conclusion in 1823, when

As big as a small truck, this glacial erratic took its place among the thousands that lined the mountain tops. From many miles away these rounded and oddly shaped boulders are visible as stark silhouettes against an evening sky.

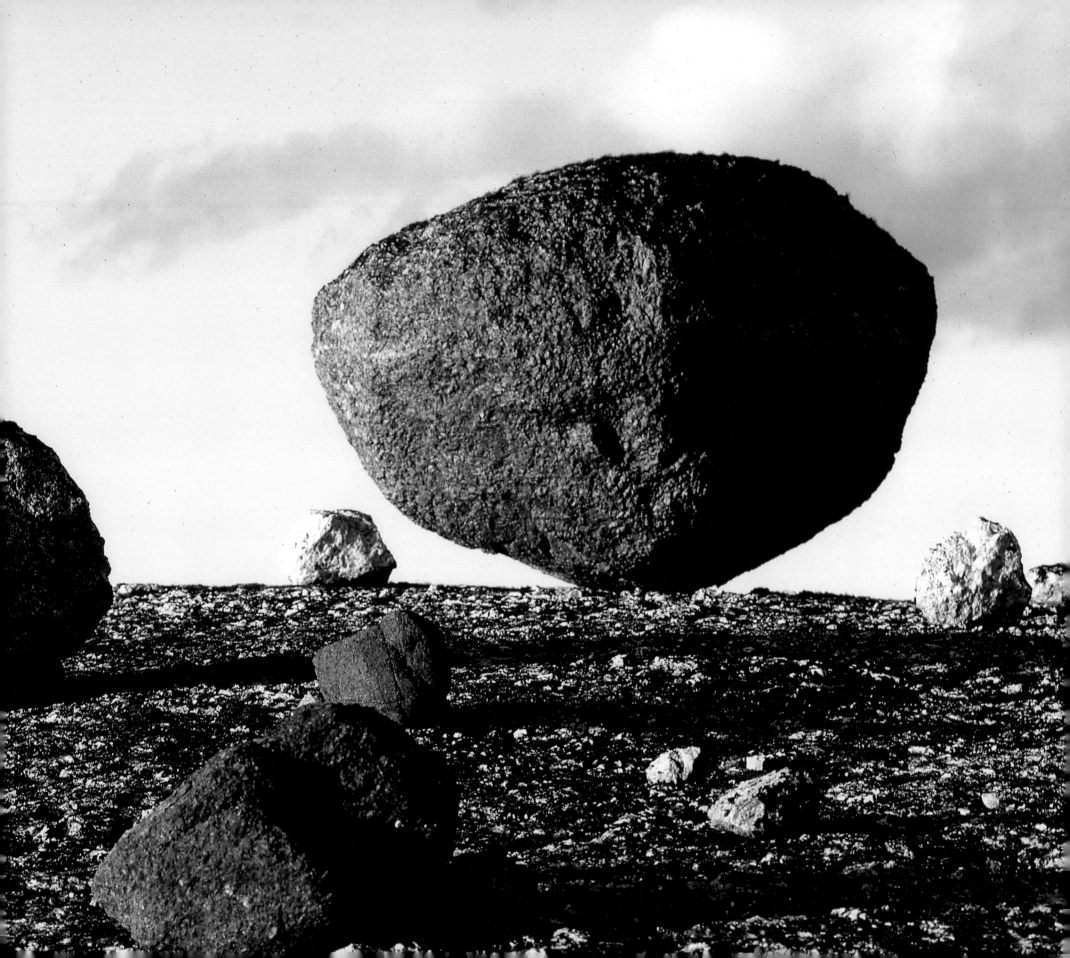

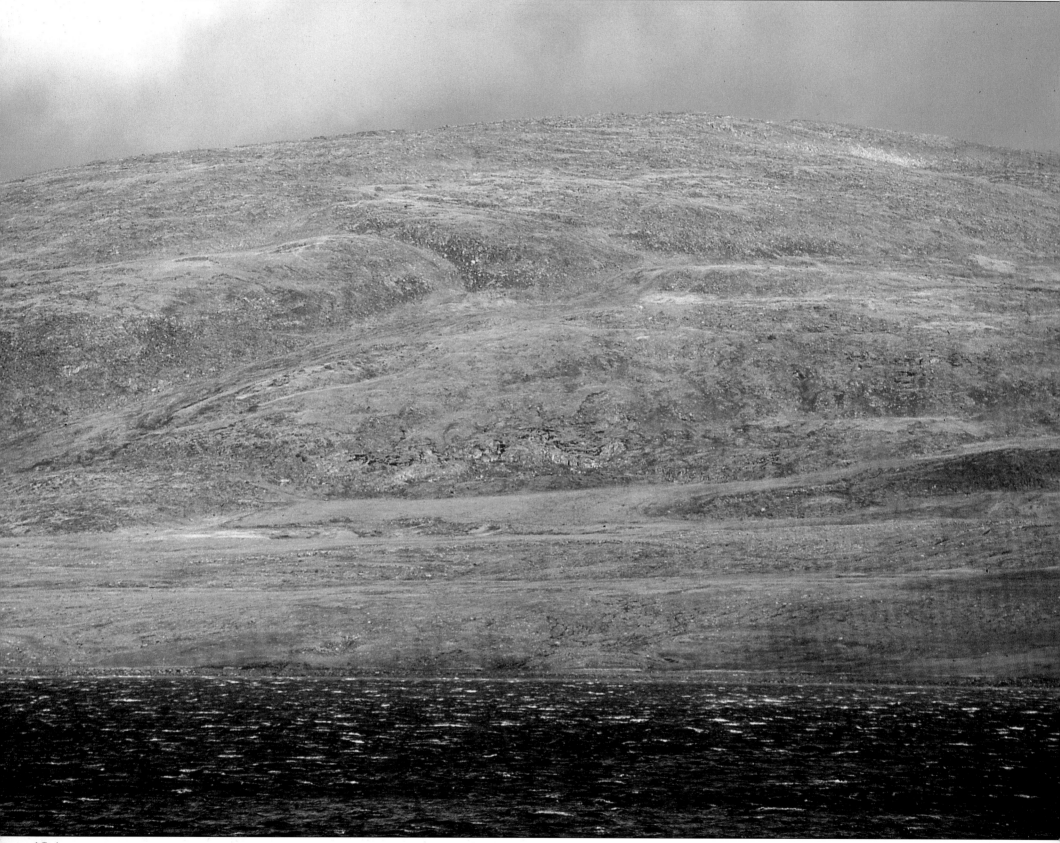

he recognized that these rocks were "travelled blocks," with composition totally unlike that of the others in their surrounding areas. These were a puzzle; while it was clear that they had moved long distances from their sources, how had they moved?

In 1837, glaciologist Louis Agassiz had introduced his famous "glacial theory," which suggested that rocks like these had been ripped up by ice sheets and had been pushed around for many kilometres (often hundreds). Following this line of thinking, the boulders were called *erratics* (from the Latin "to wander"). But not everyone agreed. G.M. Dawson argued (incorrectly) that the boulders had been left stranded far from their places of origin by icebergs floating in cold Arctic seas that had flooded the Shield.

In the late nineteenth century, Robert Bell explored much of the country between Lake Superior and Hudson Bay and recognized in 1873 that some distinctive erratic "bowlders" had been carried from James Bay all the way to North Dakota—about 1,500 kilometres. These erratics included strange-looking *omars* — the name given to light-grey-coloured sedimentary rocks with distinctive rounded carbonate inclusions that resembled "eyes." The term *omar* is derived from the name of the rocks' original home in the Omarolluk Formation on the Belcher Islands in eastern Hudson Bay. The concretions are relatively soft, often weathering back to leave boulders that look like bowling balls with finger holes. The Belcher Islands lie near the centre of large ice sheets that formed

across the Shield, and their rocks were dispersed far afield by radial ice flow. Bell's masterful 1890 summary of ice age landforms in Canada confirmed, beyond any doubt, that erratics had been moved by glaciers.

J.B. Tyrrell (who discovered coal and dinosaur bones in southern Alberta) helped solve the glacial puzzle during two strenuous expeditions between 1893 and 1894 across the Barren Lands. There he found incontrovertible evidence that an enormous ice sheet—later named the Laurentide Ice Sheet—had covered the Shield in the recent past. One of its outflow centres (which Tyrrell called the *Keewatin Centre*) had been located north of Manitoba and west of Hudson Bay. Tyrrell also confirmed that there was an eastern ice centre in eastern Hudson Bay and adjacent Quebec and Labrador, which had been identified by A.P. Low in his explorations of Labrador in 1895. Ice streams from these two centres had coalesced, sandpapering the Shield and moving erratics and sediment southward to create the Fertile Belt of the Prairies. And the same ice had dug numerous deep lake basins into the Shield, creating holding tanks for Canada's immense wealth of fresh water.

Later studies of the Shield solved one more ice age puzzle. It was assumed by many in the late nineteenth century that planet Earth had originated as a molten mass that had simply cooled thereafter. The geologically recent Pleistocene glaciations of the last 2 or 3 million years that had shuffled all the large erratic boulders around on the Shield seemed to confirm this belief — or so it seemed. Imagine the sur-

Like the katabatic wind of the Antarctic, it swoops down thousands of feet unimpeded and mostly unexpected to the bay below. You hear it coming long before you feel its impact.

(right) A by-product of the glaciers, these stones have been moving as if they had been in a ball mill for years. On this beach the smaller rocks and sand have been washed away. Different beaches have different sizes.

prise when, in 1905, A.P. Coleman discovered extremely old glacial rocks within the Shield at Gowganda in northern Ontario. These ancient rocks demonstrated that the Earth had experienced cold climates very early in its history, now known to have been 2.4 billion years ago. The planet is, of course, cooling internally as the crust and mantle slowly run out of radioactive minerals, but its surface has experienced (and will experience) great changes in climate as continents shift and ocean basins come and go. The science of paleoclimatology (the study of ancient climates) was born with Coleman's report. Today, it is recognized that about six different major glaciations have occurred in the last 3 billion years. Some lasted many tens of millions of years.

Constantly struck by waves, the pebbles on this Lake Huron shore are rubbed and pounded into sand.

(right) With a little imagination, one might see in a shallow cave under a mammoth granite dinosaur, a lone ovid rock perched in a nest of moss on the primordial Shield.

GIFTS FROM ANCIENT OCEANS (AND THE SKY)

It takes up half the country on the map, and a special place in the consciousness of Canadians. Rugged and unconquerable, the Shield is a challenge—a good challenge for a people to have in their midst . . .

Royal Bank, Corporate Responsibility Letter 1981

*T*he colour green is universally associated with money. So it is appropriate that of the many varied rocks within the Shield, those in the so-called "greenstone belts" are the most valuable. The basalt rocks found in these belts once sat on an ancient ocean floor and were gently cooked from below by superheated water moving huge volumes of dissolved metal. These metals were left behind as veins and also within massive sulphide deposits rich in silver, zinc and

Alpenglow in the Kaumajet mountains of Labrador.

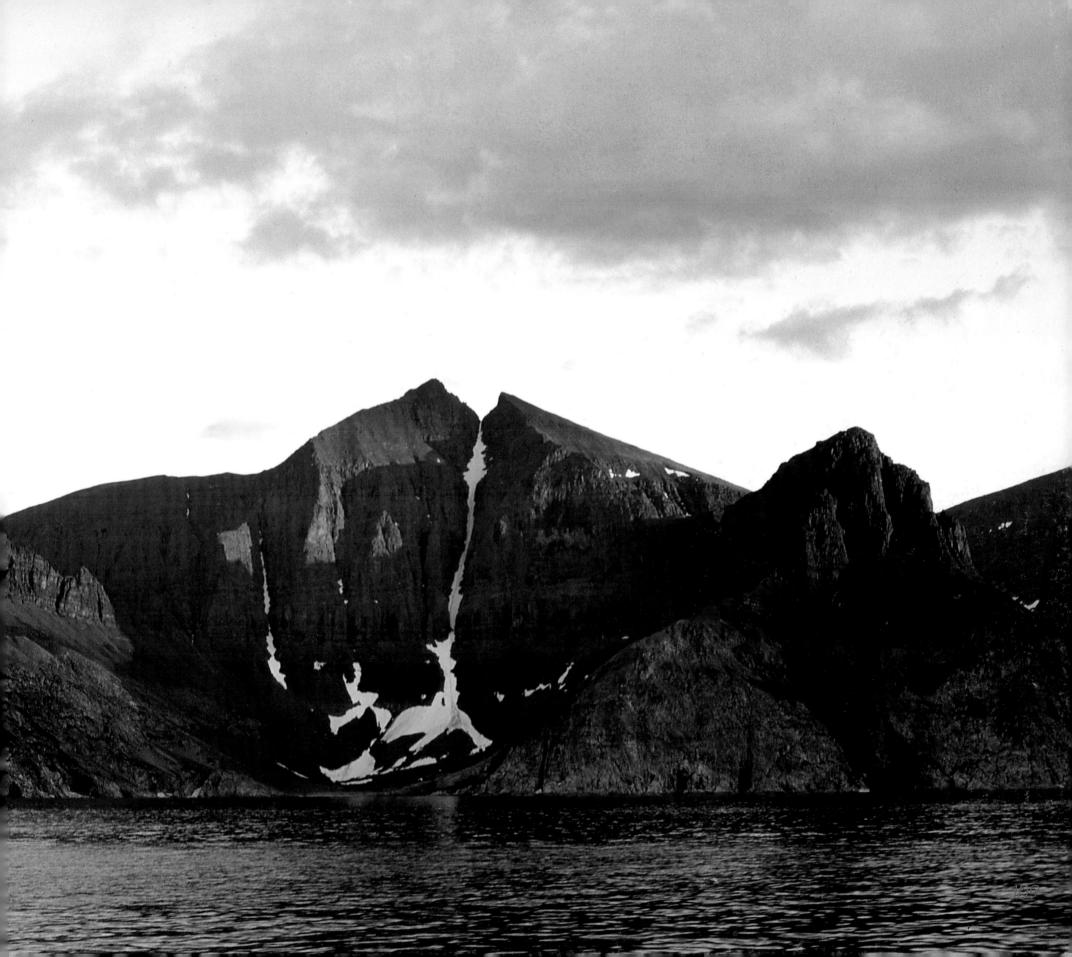

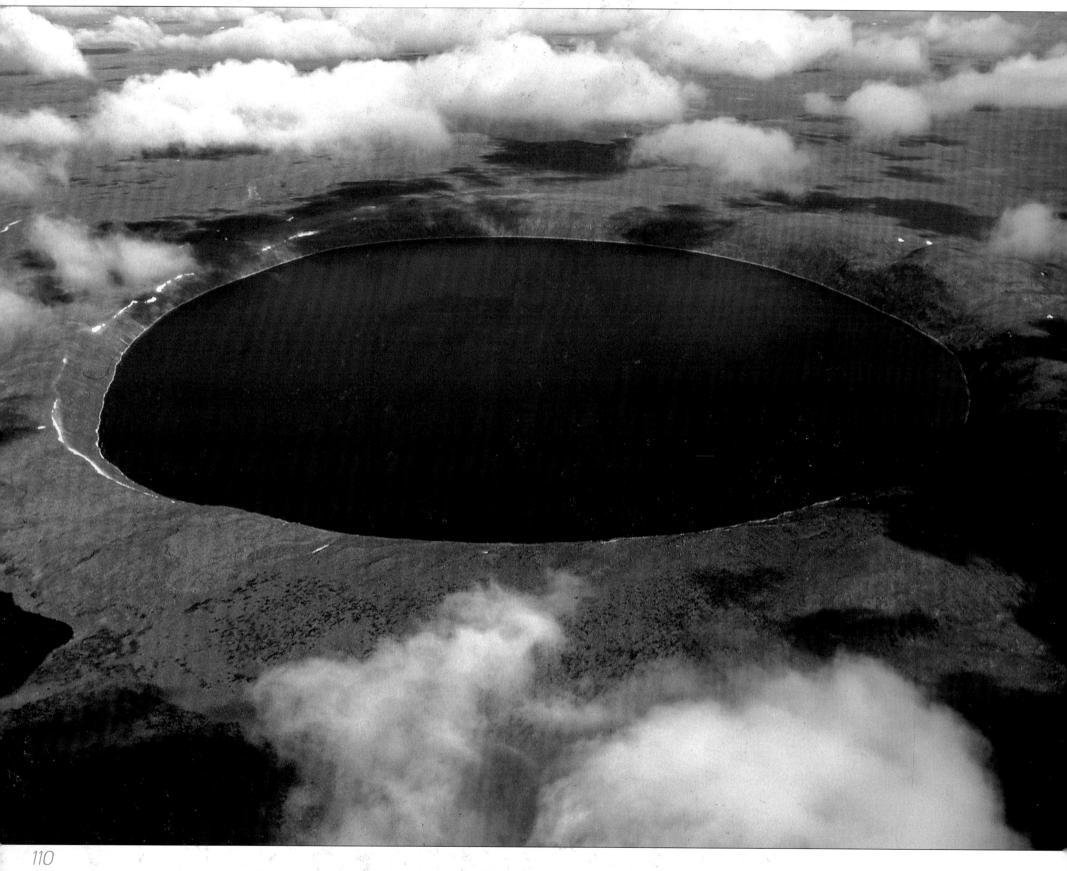

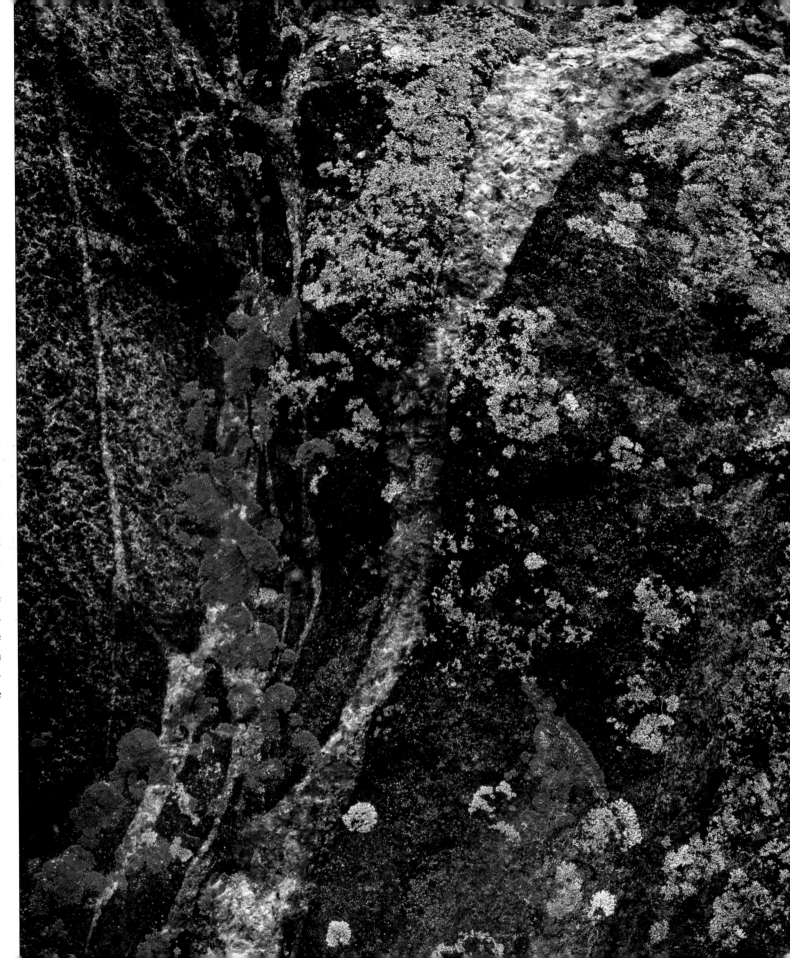

gold. Over the years, Ontario has produced huge amounts of gold (mostly from greenstones of the Superior Province). As of 2005, the output is 166 million ounces—worth $72 billion in today's prices. More than 71 tonnes of the metal (2,313,495 ounces) are produced each year from four main mining camps. All this from ocean crust trapped in the interior of the Canadian Shield when ancient landmasses collided.

Plate tectonics has been kind to Canadians, but in fact, much of the metallic wealth of the Shield was a gift from above. The Shield has had its share of hard knocks, having been occasionally assaulted and severely bruised by extraterrestrial bodies falling from the sky. About half a dozen meteorite impact craters can be found in different locations across the Shield, the most notable being the one at Sudbury which records the impact of a large meteorite that struck here 1.8 billion years ago. It was some 10 kilometres in diameter and travelled at a speed of 40 kilometres per second. So great was the impact that a hole was punched right through the Earth's crust, melting mantle rock below that welled up into the crater.

The Sudbury Basin has been likened to a giant bathtub about 30 kilometres wide and 70 kilometres long. Because of its crater-like appearance, it was assumed, for a long time, to be volcanic, but it is now recognized as the world's second-largest meteorite impact crater (the largest is in South Africa). Pulverized rocks in the form of distinctive "shatter cones" and intensely broken rock called breccia surround the

A meteor slamming into the earth 1.3 million years ago left a hole 3,000 m across and 240 m deep. Nearly perfectly round Nouveau Quebec crater, previously known as Chubb crater, is one of the finest examples of an impact crater on the planet

(right) Lichens love minerals they can exude from the rock.

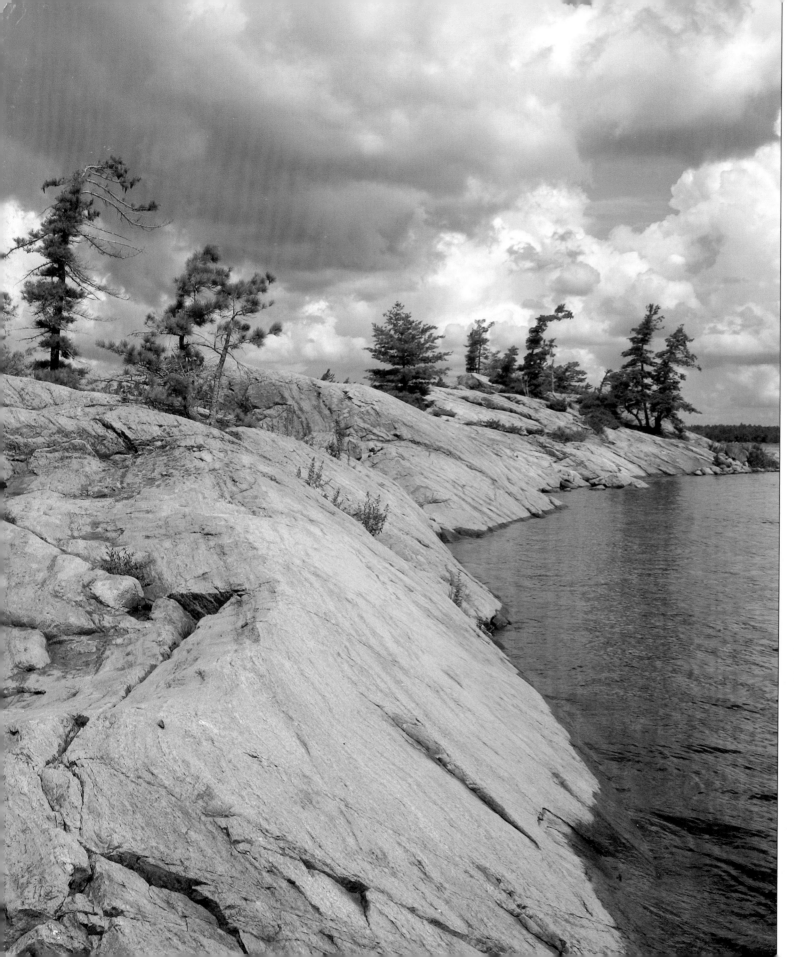

crater like a halo, while nickel-rich rock melted by the impact lines its base. Much of the fill in the bathtub is made up of great thicknesses of "fall back" breccia—broken rock thrown up by the force of the impact, which fell back to the Earth in a rocky rain. The most recent chapter in the history of the basin occurred some 800 million years later, when it was squeezed into an oval shape as eastern North America collided with Amazonia during the Grenville Orogeny.

Today, Sudbury brings new meaning to the term "striking it rich". Deep mines clustered around the rim of the crater gnaw away at the metal-rich rocks below, producing more than 40 per cent of Ontario's minerals, which is equivalent to 15 per cent of our entire national output of minerals.

Sudbury's copper and nickel were discovered entirely by chance, when railway workers spotted the metal-rich rocks during construction of the Canadian Pacific Railway in 1883. Since then, mineral discoveries on the Shield have often been the result of deliberate, sophisticated prospecting, and at present, a diamond exploration boom is taking centre stage. Diamonds occur in narrow pipes intruded from the mantle below. These are made of a dark-coloured igneous rock called *kimberlite*—after Kimberley, its place of discovery in South Africa. The pipes are small (think the length of a football field). They are also very difficult to find, being hidden below lakes or glacial sediments. Seven years after the discovery of the first pipe on the Shield, Canada's first diamond mine opened in 1998 at Ekati in the Northwest Territories.

The Georgian Bay islands are a dramatic watery landscape regardless of weather or season.

(right) It took brave men to ply with skin covered kayaks the frigid waters of a sheltered fjord. It took braver men still to round the headland and face an open ocean.

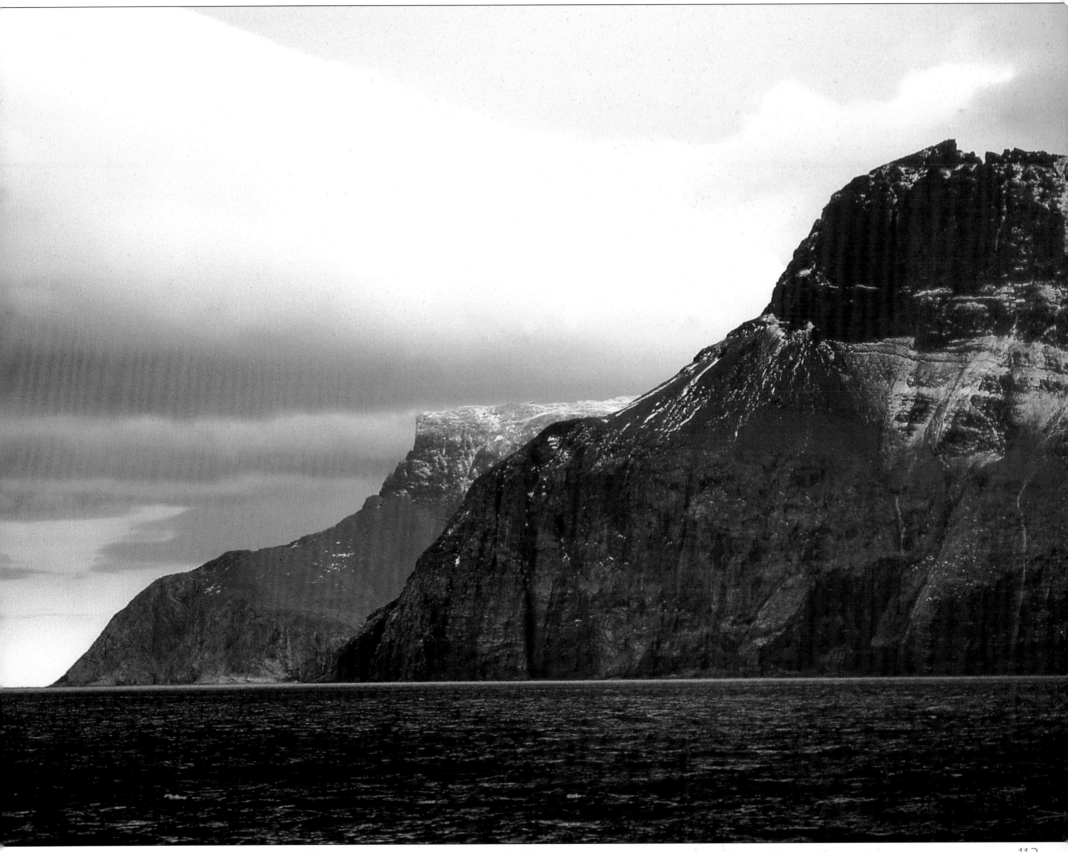

THE FUTURE

The lords of the lakes and forest have passed away but their work will endure in the boundaries of the Dominion of Canada. The place of the beaver in Canadian life has been fittingly noted in the coat of arms. We have given to the maple a prominence, which was due to the birch. We have not yet realized that the Indian and his culture were fundamental to the growth of Canadian institutions. We are only beginning to realize the central position of the Canadian Shield.

—Harold Innis

I t is true to say that without the Shield there would be no Canada. The Shield has been the key to our survival as a nation. For hundreds of years, it has been unloved, perceived as infertile and something to be avoided. The Hudson's Bay Company's two-hundred-year monopoly gave them *de facto* governing power over a huge piece of North America. Without the HBC, much of this land would have passed into American hands and there would have been no "Canadian" Shield and no Canadian nation. This is our debt to hard rock. If it had been more accessible, seen to be

A seemingly benign landscape, Nachvak Fjord can very quickly turn into a force that must be dealt with in order to survive. Here, the unprepared and inexperienced have paid with their lives.

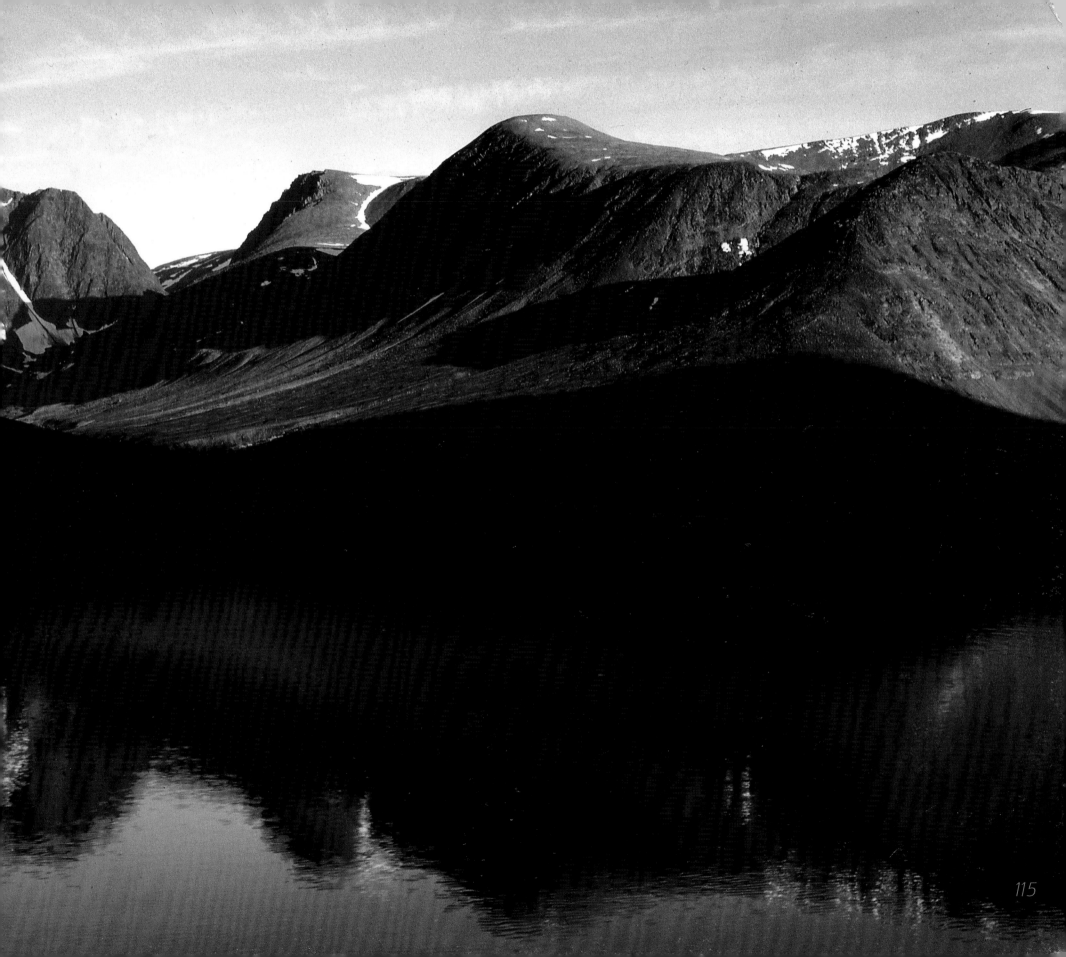

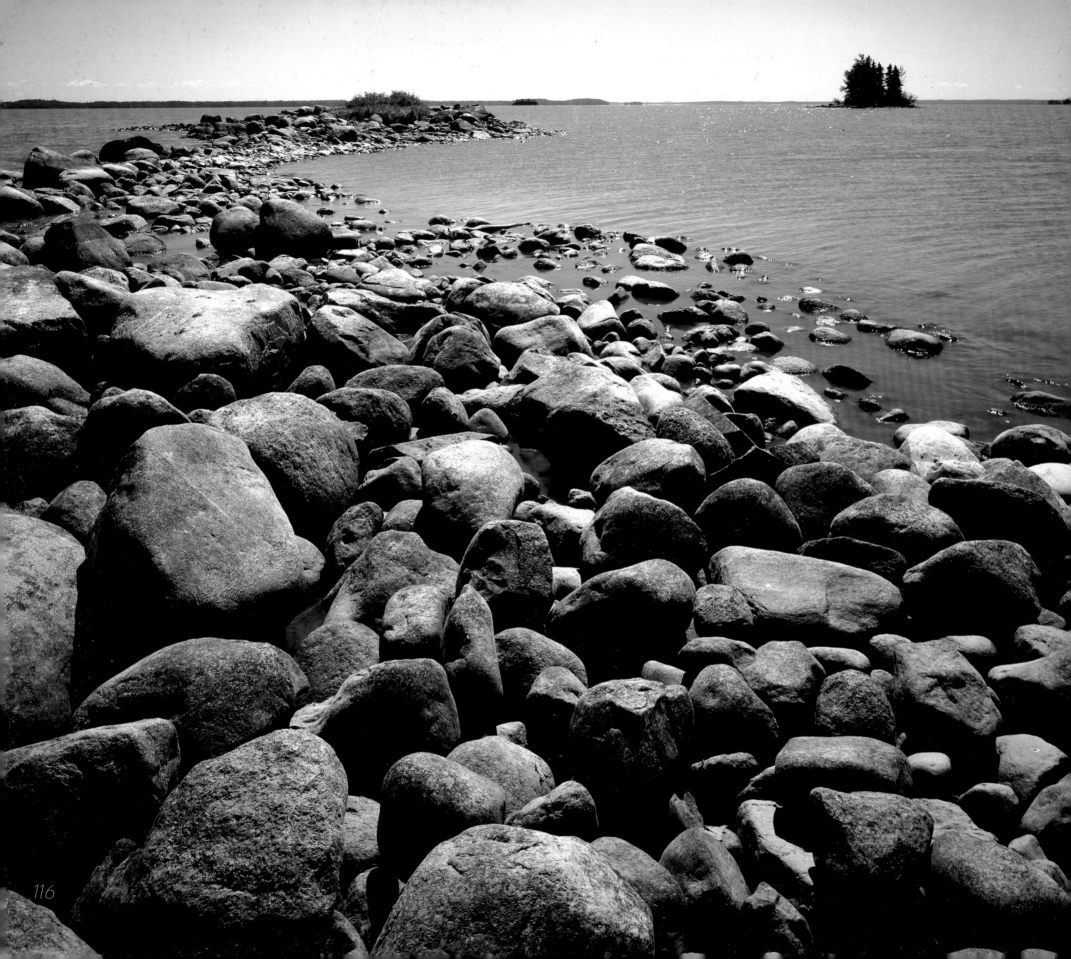

more useful, there would likely have been a unitary, transcontinental United States, the links to the founding French or British long since forgotten.

Ironically few Canadians are aware of our debt to this magnificent landform. Still deeply buried in early Canadian culture is the image of Nature as a monster or a hostile environment in which early settlers barely eked out an existence. In her 1972 book *Survival,* Margaret Atwood demonstrated that the theme of staying alive (or dying) in a dangerous environment was the central preoccupation of early Canadian writers. Today, the Shield is something of a diminished icon, tamed by a technologically advanced society. It has undergone what Northrop Frye referred to in *The Bush Garden* as "the conquest of nature by an intelligence that does not love it." With the exception of diamonds, the Shield's importance as a source of minerals and lumber is a bit unfashionable for modern urban environmental tastes, and its landscapes are too subtle and on too large a scale for most tourists. In contrast, the Rocky Mountains can be experienced in a few hours (with shopping thrown in) by luxury coach. In fact, these mountains may have already supplanted the Shield in the projection of our national image.

And yet wilderness is in short supply in the modern world. The immensity and solitude of the Shield is increasingly sought after for recreation and enjoyment by people from around the world. Once seen as a demon to be tamed, the Shield's diverse boreal forest and ecosystems are worthy of protection from encroaching humanity. Unfortunately, the Shield now stands between the burgeoning cities of the south and the warming Arctic that is emerging fully from the ice age. The Shield will become a stepping stone in Canada's northward migration, to be criss-crossed by a more extensive system of all-weather, long-distance roads. Development pressures will not only come from greater resource development, but also from the world's thirst for water. Its thousands of lakes, gifted by the glaciers that scoured its surface, contain enormous reserves of fresh water. Eyes from southern nations will turn northward with even more interest than ever as water becomes an international commodity to be bought and sold like Canadian oil.

What once was despairingly called "Last Chance Territory" has become our ticket to the future in a drying, resource-poor world. Unified, informed and ultimately sustained by this massive landform, Canadians are truly children of the Shield.

The size of the rocks on shore along the northern islands were boulders; those in the middle were pebbles; and those on the south, sand.

(right) A sample of niccolite at an occurrence called "Copper Pass", on the East Arm near Utsingi Point, Great Slave Lake.

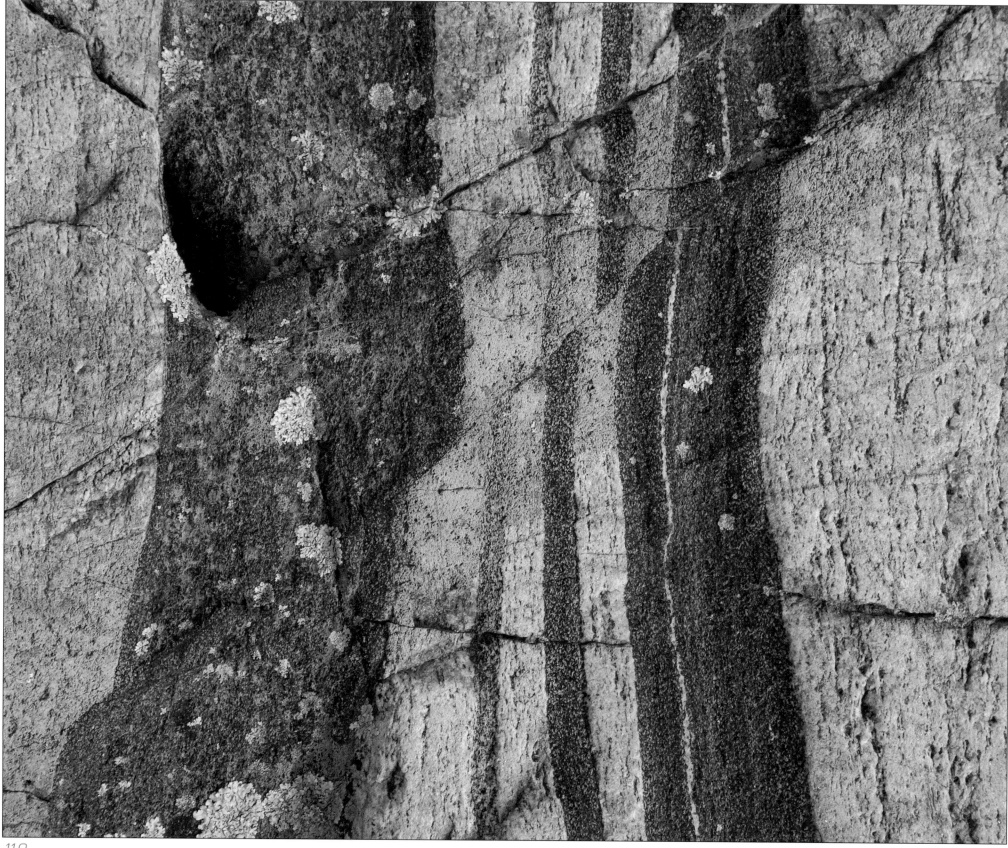

FOOTNOTES

[1]Coleman's words were part of an overview description of Ontario that he prepared for international delegates to the 1913 International Geological Congress in Toronto. The congress was (and remains) a major event (it next came to Canada in 1972 in Montreal) and it was held in Canada in 1913 largely because of the innovative geological work going on across the Shield which received widespread international attention. The mining industry too, was in full swing. See Middleton, G.V. 2007. "The 12th International Geological Congress, Toronto, 1913." Episodes 30: 290-296.

[2]Named after Mount Monadnock in New Hampshire.

[3]D.F. Putnam, *Canadian Regions: A Geography of Canada* (Toronto: J. Dent and Sons, 1965).

[4]Quoted in Moore, C. Adventurers – Hudson Bay Company- The Epic Story, p. 7. Quantum Books. For the Hudson's Bay Company. 2000.

[5]Richard Stengel, 1988

[6]Mcfie, J. *Up The Great North Road: The Story Of An Ontario Colonization Road*. Boston Mills Press 2004.

[7]Cited in Zellers (1987) p. 111.

[8]Cited in Suzanne Zeller's *Inventing Canada* (1987). Zellers has written at length on the central importance of the 1851 Great Exhibition in showcasing the geological resources and potential of Canada, and triggering a growing sense of a distinct Canadian nationality.

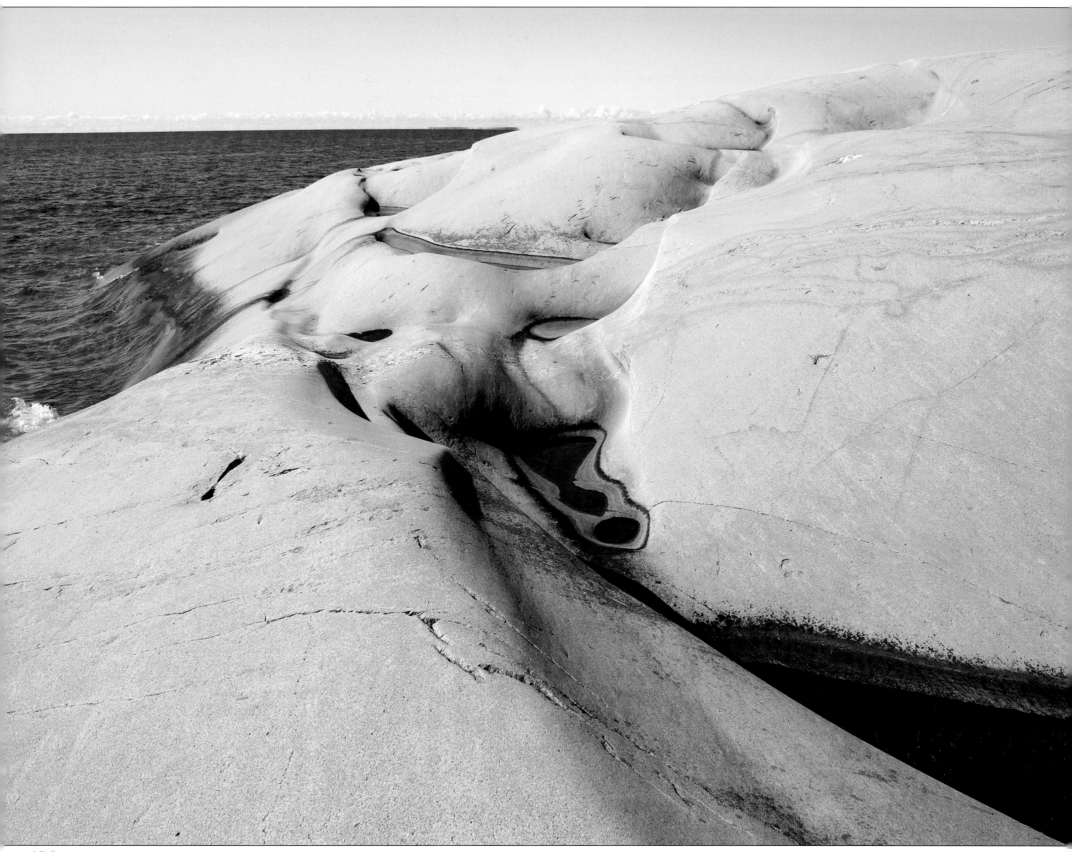

BIBLIOGRAPHY

Adams, F.D. "On the Typical Laurentian Area of Canada." *Journal of Geology* 1 (1893): 325–40.

Ambrose, J.W. "Exhumed Paleoplains of the Precambrian Shield of North America." *American Journal of Science* 262 (1964): 817–57.

Atwood, M. *Survival: A Thematic Guide to Canadian Literature*.Toronto: McClelland and Stewart, 1996.

Atwood, M. "True North." In *Moving Targets: Writing with Intent; Essays, Reviews, Personal Prose*, 43-48. Toronto: House of Anansi Press, 2004.

Bastedo, J. *Shield Country: The Life and Times of the Oldest Piece of the Planet.*
Red Deer Alberta: Red Deer Press, 2002.

Bell, R. "Report on the Country between Lake Superior and Lake Winnipeg". *Geological Survey of Canada Report on Progress*, Ottawa, 1872–73.

———."Glacial Phenomena in Canada." *Geological Society of America Bulletin* (1890): 287–310.

Blanchard, R. "Études canadiennes: Les Laurentides." *Revue de Géographie alpine* 26 (1938): 6–18.

Brown, C., ed. *An Illustrated History of Canada*. Toronto: Lester and Orpen Dennys, 1987.

Brown, R. *Ghost Towns of Ontario*. Langley, BC: Stagecoach Publishing, 1978.

Coleman, A.P. "Geology of the Toronto Region." In *The Natural History of the Toronto Region, Ontario*, edited by J.H. Faull, 51–81. Toronto: Briggs, 1913.

Cooke, H.S. "Studies of the Physiography of the Canadian Shield." *Transactions of the Royal Society of Canada* 23 (1929): 91–120.

———. "Studies of the Physiography of the Canadian Shield." *Transactions of the Royal Society of Canada* 24 (1930):51–87.

———."Studies of the Physiography of the Canadian Shield." *Transactions of the Royal Society of Canada* 25 (1931): 127–80.

Butler, W.M. *The Wild North Land.* Montreal: Dawson Brothers, 1874.

Eccles, W.J. *The French in North America, 1500–1783*. Markham: Fitzhenry and Whiteside, 1998.

Edwards, M.J., Denham, P., and Parker, G., eds. *The Evolution of Canadian Literature in English, 1867–1914*. Toronto: Holt Rinehart and Winston, 1973.

Eyles, N. *Ontario Rocks: 3 Billion Years of Environmental Change.* Markham: Fitzhenry and Whiteside, 2002.

Eyles, N., and Miall, A.D. *Canada Rocks: The Geologic Journey.* Markham: Fitzhenry and Whiteside, 2007.

Fowke, E. *The Penguin Book of Canadian Folk Songs*. Toronto: Penguin Books, 1973.

Frye, N. "Haunted by Lack of Ghosts: Some Patterns in the Imagery of Canadian Poetry." In *The Canadian Imagination: Dimensions of a Literary Culture*, edited by David Staines, 22–45. Cambridge: Harvard University Press, 1977.

Fulton, R.J. "Canadian Shield." In *Quaternary Geology of Canada and Greenland*.175–318.. Vol. K-1, Ottawa. Geological Survey of Canada, 1989.

Gill, J.E., ed. "The Proterozoic in Canada." *Royal Society of Canada Special Publication No. 2* (1957).

Hill, D. *The Opening of the Canadian West*. London: Heinemann, 1967.

Hind, H.Y. *Narrative of the Canadian Red River Exploring Expedition of 1857 and the Assiniboine and Saskatchewan Expedition of 1858*. Edmonton: Hurtig, 1971.

Innis, H.A. *The Fur Trade in Canada*. Toronto: University of Toronto Press, 1956.

James, W.C. *Locations of the Sacred: Essays on Religion, Literature, and Canadian Culture*. Waterloo: Wilfrid Laurier University Press, 1998.

Jackson, L.J., Ellis, C., Morgan, A.V., and McAndrews, J.H. "Glacial Lake Levels and Eastern Great Lakes Paleo-Indians." *Geoarcheology* 15 (2000): 415–40.

Karamanski, T.J. *Fur Trade and Exploration: Opening the Far Northwest, 1821–1852*. Norman, OK: University of Oklahoma Press, 1983.

King, R. *Defiant Spirits: The Modernist Revolution of the Group of Seven*. Vancouver: Douglas and McIntyre, 2010.

Krajick, K. *Barren Lands: An Epic Search for Diamonds in the North American Arctic*. New York: W.H. Freeman, 2001.

Lavallée, O. *Van Horne's Road: The Building of the Canadian Pacific Railway*. Markham: Fitzhenry and Whiteside, 2007.

Lawson, A.C. "Note on the Pre-Paleozoic Surface of the Archean Terranes of Canada." *Geological Society of America Bulletin* 1 (1980): 163–73.

Leggett, R.F. "Early Canadian Record of Glacial Erratics." *Geoscience Canada* 10 (1983):133–34.

Lower, A.R.M. *Great Britain's Woodyard. British America and the Timber Trade, 1763-1867*. Montreal and Kingston: McGill-Queen's University Press, 1973.

Lucas, S.B., and St. Onge, M.R., eds. "Geology of the Precambrian Superior and Grenville Provinces." *Geological Survey of Canada Geology of Canada No. 7* (1998).

Macfie, J. *Up the Great North Road: The Story of an Ontario Colonization Road*. Erin, ON: Boston Mills Press, 2004.

MacLennan, H. *Two Solitudes*. Toronto: Macmillan of Canada, 1945.

Moon, B. *The Canadian Shield*. Natural Science of Canada, 1970.

Moore, C.M. *Adventurers: Hudson's Bay Company, The Epic Story*. Quantum Press for Hudson's Bay Company, 2000.

Morse, E. *Fur Trade Routes of Canada: Then and Now*. Ottawa: Queen's Printer, 1968.

Morton, W.L. *The Canadian Identity*. Madison WI:University of Wisconsin Press, 1961.

Murray, J. *Rocks: Franklin Carmichael, Arthur Lismer and the Group of Seven*. Toronto: McArthur & Company, 2006.

New, W.H.. *A History of Canadian Literature*. Montreal and Kingston: McGill-Queen's University Press, 2003.

Norrie, K., and Owram, D. 1991. *A History of the Canadian Economy*. Toronto: Harcourt Brace Jovanovich Canada, 1991.

Parry, J.T. "Geomorphology in Canada." In *Geomorphology*, edited by J.G. Nelson and M.J. Chambers. Toronto: Methuen, 1969.

Prest, V.K., Donaldson, J.A., and Mooers, H. "The Omar Story: The Role of Omars in Assessing the Glacial History of Western Central North America." *Géographie physique et quaternaire* 54 (2000): 257-70.

Preston, J.L. *The Birch: Bright Tree of Life and Legend*. Granville, OH: McDonald and Woodward Publishing Co., 1994.

Putnam, D.F. *Canadian Regions: A Geography of Canada*. Toronto: J. Dent and Sons, 1965.

Rich, E.E. *The Fur Trade and the Northwest to 1857*. Toronto: McClelland and Stewart, 1967.

Riendeau, R. *A Brief History of Canada*. Markham: Fitzhenry and Whiteside, 2000.

Rowan, J. *The Emigrant and Sportsman in Canada*. London, 1876

Royal Bank. "The Canadian Shield." Corporate Responsibility Letter 62 (December 1981).

United Empire Loyalists Association. *Loyal She Remains: A Pictorial History of Canada*. Toronto: Government of Ontario, 1984.

Silcox, D.P. *The Group of Seven and Tom Thomson*. Toronto: Firefly Books, 2003.

Storck, P.L. *Journey to the Ice Age: Discovering an Ancient World*. Vancouver: University of British Columbia Press, 2004.

Story, N. *The Oxford Companion to Canadian History and Literature*. Oxford University Press, Toronto, 1967.

Thompson, J.E., ed. "The Grenville Problem." *Royal Society of Canada Special Publication No. 1* 1956.

Warkentin, J., ed. *The Western Interior of Canada: A Record of Geographical Discovery 1612–1917*. Toronto: McClelland and Stewart, 1964.

Wilson, A. W. G. "Physical Geology of Central Ontario." Trans. Can. Institute 152, 1901.

Wood, J.D. "The Last Frontier": Rationalizing the Spread of Farming into the Boreal Woods of Canada." *Canadian Geographer* 50 (2006): 38–55.

Zeller, S. *Inventing Canada: Early Victorian Science and the Idea of Transcontinental Nation*. Toronto: University of Toronto Press, 1987.

— — —."The Colonial World as a Geological Metaphor: Strata(gems) of Empire in Victorian Science." *Osiris* (2000): 85–107.

ABOUT THE CONTRIBUTORS

 Nick Eyles is author of *Canada Rocks* (co-authored with Andrew Miall) and *Ontario Rocks*. He is a professor of Geology at the University of Toronto, Scarborough and is host of CBC's *Geologic Journey — World*.

 One of Canada's foremost painters and print makers, **Ed Bartram** has been inspired by the colours, textures, and history of the Canadian Shield. Resident for most of the year in King City, Ontario, Bartram spends his summers chronicling the ever-changing dynamics of his small island just off Parry Sound in Georgian Bay.

 Renowned Yellowknife-based photographer, **Tessa Macintosh**, has depicted the heart and soul of Canada's North on assignment and on personal explorations from the Mackenzie Mountains to the Arctic Coast. She was the official photographer for the government of the Northwest Territories from 1982-1992, and received the Queen Elizabeth II Golden Jubilee Medal in 2002 for her service to the northern communities. Co-author of eight books, her photo library consists of more than 10,000 images.

 Formerly based in Rouyn-Noranda, Quebec, **Arnold Zageris**'s work has explored the art and mystery of the Canadian Shield. His work has been featured in the Canadian Museum of Contemporary Photography, The Rooms of St. John's, and the Canada Pavillion at Expo '92 in Seville, Spain. He lives in Peterborough, Ontario, and his work is currently featured in a wide range of public and private collections.

ED BARTRAM

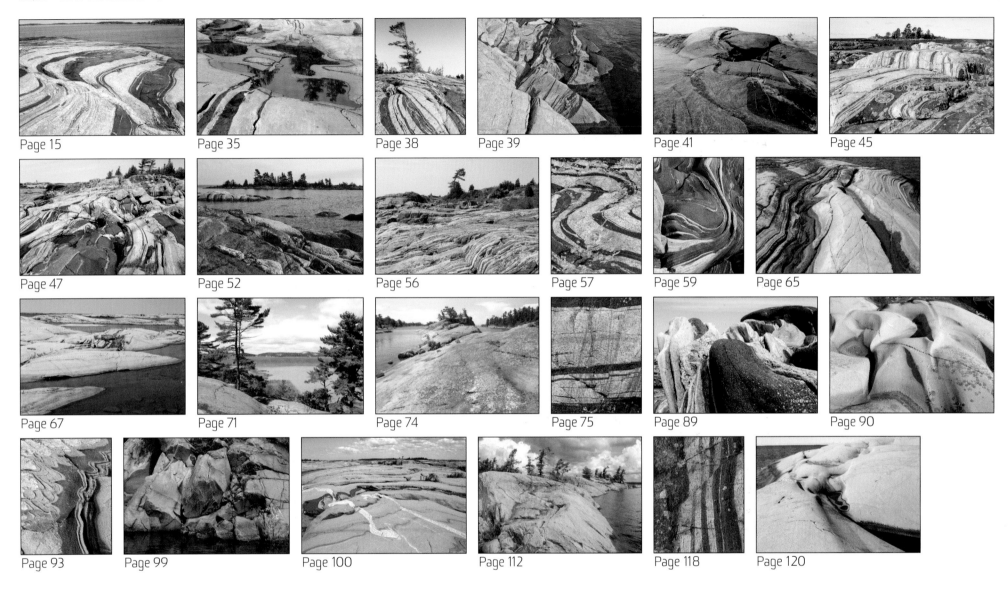

TESSA MACINTOSH

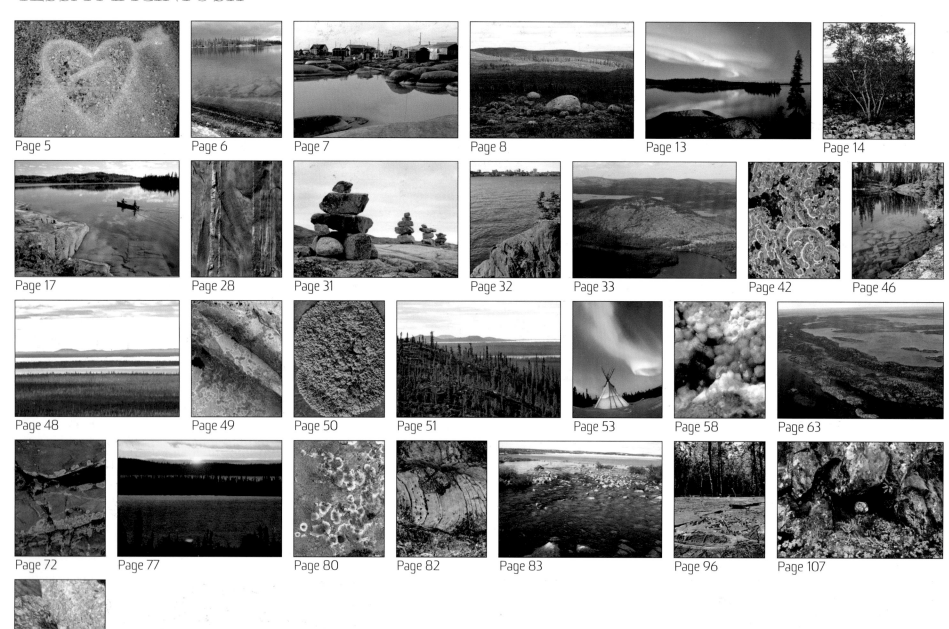

Page 5

Page 6

Page 7

Page 8

Page 13

Page 14

Page 17

Page 28

Page 31

Page 32

Page 33

Page 42

Page 46

Page 48

Page 49

Page 50

Page 51

Page 53

Page 58

Page 63

Page 72

Page 77

Page 80

Page 82

Page 83

Page 96

Page 107

Page 117

ARNOLD ZAGERIS

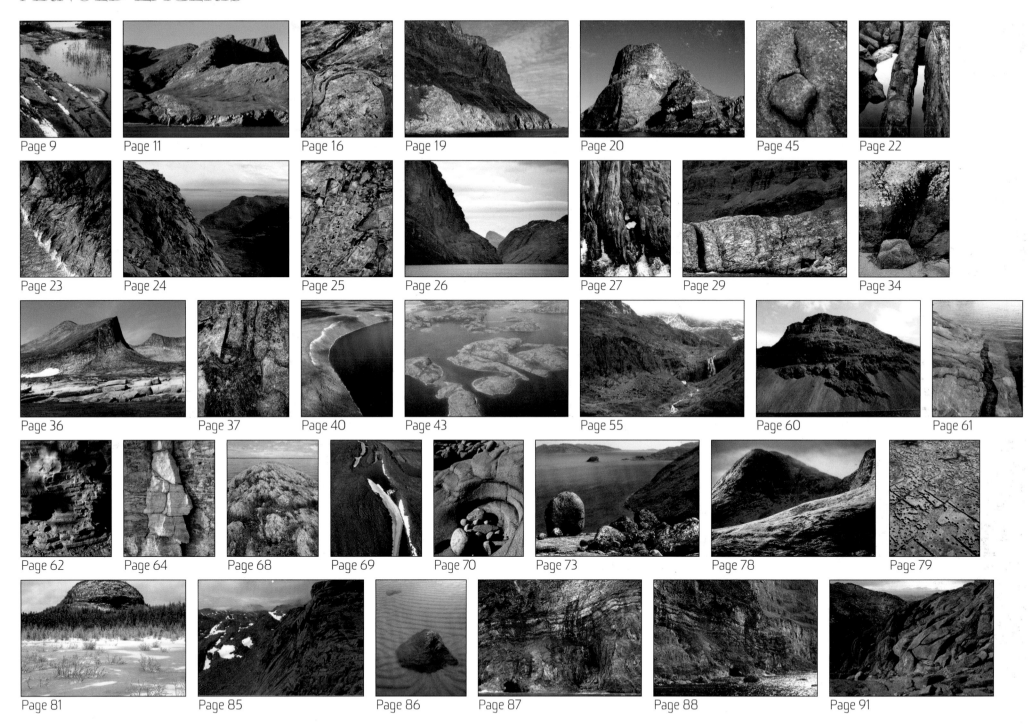

Page 9 Page 11 Page 16 Page 19 Page 20 Page 45 Page 22

Page 23 Page 24 Page 25 Page 26 Page 27 Page 29 Page 34

Page 36 Page 37 Page 40 Page 43 Page 55 Page 60 Page 61

Page 62 Page 64 Page 68 Page 69 Page 70 Page 73 Page 78 Page 79

Page 81 Page 85 Page 86 Page 87 Page 88 Page 91